About this book Steve Baker explores how animal imagery has been used in contemporary art and philosophy to shape ideas about identity and creativity. He considers the way in which postmodern and poststructuralist critiques of human identity offer an imaginative reassessment of the role of animals in human thought. In detailed readings of the works of leading artists, Baker suggests the term 'botched taxidermy' for the postmodern animal aesthetic; conscious of its ethical implications, he examines the use of living animals in some works. Examples range from an early Peter Greenaway film to Damien Hirst's installations, Britta Jaschinski's photographs and Will Self's novel, *Great Apes*.

The book draws parallels between the animal's place in postmodern art and in poststructuralist theory, and explores Jacques Derrida's recent analysis of the role of animals in philosophical thought. Baker offers a lucid account of Deleuze and Guattari's concept of 'becoming-animal', arguing for its relevance both to contemporary art practice and to our understanding of creativity, and he investigates postmodernism's perplexing fear of pets.

About the author Steve Baker is Senior Lecturer in Historical and Critical Studies at the University of Central Lancashire, and a member of the editorial board of *Society and Animals*. His writings on questions of visual identity include *Picturing the Beast: Animals, Identity and Representation* (1993).

The Postmodern Animal

Steve Baker

*To Christopher
with all good wishes
from Steve*

April 2007

REAKTION BOOKS

To Aly
for her unfailing support

Published by Reaktion Books Ltd
79 Farringdon Road, London WC1M 3JU, UK
www.reaktionbooks.co.uk

First published 2000

Series design by Humphrey Stone

Colour printed by BAS Printers Ltd, Over Wallop, Hampshire
Printed and bound in Great Britain by Biddles Ltd, Guildford and King's Lynn

British Library Cataloguing in Publication Data:
Baker, Steve, 1953–
The postmodern animal. – (Essays in art and culture)
1. Postmodernism 2. Postmodernism (Literature) 3. Animals in art
4. Animals in literature
I. Title
704.9′432

ISBN 1 86189 060 5

Contents

I am taking a good firm knot and reducing it to a mess of loose ends.
MARTIN AMIS, *Night Train*

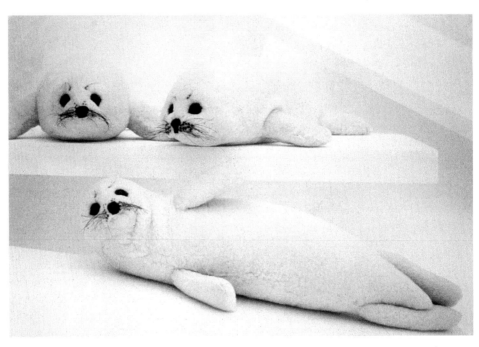

1 Detail of General Idea, *Fin de Siècle*, 1990, expanded polystyrene, three
stuffed harp seal pups (acrylic fake fur, straw); view of installation at Camden
Arts Centre, London, 1998.

1 What is the Postmodern Animal?

De l'animal peut-on parler?
JACQUES DERRIDA, 'L'Animal que donc je suis'[1]

At one end of the deep gallery space, the viewer is allocated a narrow corridor of clear floor across which to move. Beyond this, starting at knee height and rising unevenly like a choppy sea to the other distant end of the gallery, are piled large and impossibly bright white rectangles of polystyrene, in a surprisingly convincing approximation to the look of a cracked Arctic ice floe. There, up at the far end, beached on one of the higher ridges, and visible from either side of a Géricault-like raft of 'ice' in the viewer's foreground, are what appear to be three grubby white stuffed toy seals.

Their appearance is slightly disconcerting, without it being easy to fix on a reason for this. They certainly call to mind the American artist Mike Kelley's views on the uncanny manner in which dirty homemade stuffed toys offend against art's demand for perfect form. At the same time, basking there in the inaccessible distance, they both interrupt and offer a point of focus for any viewing of the piece. It is perhaps no accident that the polystyrene ice floe, each fragile sheet of which could serve in another context as a fair-sized minimalist painting, is somehow sullied by the presence and centrality of these tatty creatures.

Spoiling the view, they are read as out of place. As anthropomorphic and romanticized images of the alienated human (the artist is invariably one such human), the seals invite viewers to stage their own mental confrontation between sentimental compassion and aesthetic satisfaction. Nietzsche, it seems certain, would have relished the sight of this futile battle between polystyrene sheets and stuffed toys, staged in the mock-serious imagery of Caspar David Friedrich and Géricault. This is the strange accomplishment of the piece; viewers *are* moved, even as they see that they are being manipulated. It is as though the artists are offering, ingenuously, the raw materials from which their viewers might care to spin out a meaning.

The effect of the installation, General Idea's *Fin de Siècle* (illus. 1 and 25), is easier to convey in words than in reproduction. This fact in itself reveals something of the awkwardness of thinking about the postmodern animal. This thing, this chosen creature, which is often the image of the artist or viewer at one remove (in this postmodern context the roles of artist and viewer are largely interchangeable), is difficult to reduce to what it looks like. As one commentator has written of *Fin de Siècle*, it threatens 'the disappearance of visibility, the dissolution of bodies'.[2]

There is a widespread perception that life is led differently now, faster and more precariously, both for humans and animals. If in part postmodernism embraces this, in the spirit of Nietzsche's injunction to 'live dangerously!', it also sees the necessity of charting those new dangers, with a view to contesting them. In 1990 the philosopher Gilles Deleuze expressed the view that 'we are at the beginning of something', and that to deal with the new circumstances there was 'no need to fear or hope, but only to look for new weapons'.[3] In art and in philosophy, postmodernism is both a theoretical and a practical enterprise, and its resistance to the dissolution of human and animal bodies often therefore takes the form of what has been called 'an argument for *pleasure* in the confusion of boundaries and for *responsibility* in their construction'.[4]

ENDORSEMENT AND SCEPTICISM

In *What is Nature?*, Kate Soper addresses a distinction in contemporary thinking about 'nature' between the apparently practical concerns of ecology on the one hand, and the more theoretical emphases of postmodernism on the other. The former is concerned primarily with 'the "nature" that we are destroying, wasting and polluting'; the latter with 'the ways in which relations to the non-human world are always historically mediated'. Since in her view both perspectives may have necessary and complementary roles 'in shaping a particular political outlook' on nature, she proposes 'to speak of a contrast between what might be termed "nature-endorsing" and "nature-sceptical" arguments with no presumption being made that these reflect some simple antithesis between a "green" and a "postmodernist" politics'.[5]

8

This promises to be a fruitful basis from which to begin to think more specifically about the diverse ways in which post-modern art has dealt with the animal across a spectrum ranging from the *animal-endorsing* to the *animal-sceptical*. These terms, clumsier than Soper's, nevertheless point to the complexity of what it is that is called 'animal' here. Animal-endorsing art will tend to endorse animal life itself (and may therefore align itself with the work of conservationists, or perhaps of animal advocacy), rather than endorsing cultural constructions of the animal. Animal-sceptical art, on the contrary, is likely to be sceptical not of animals themselves (as if the very existence of non-human life was in question), but rather of culture's means of constructing and classifying the animal in order to make it meaningful to the human.

A comparison of the use of animal imagery in the work of the American artist Mark Dion, and in that of the British artists Olly and Suzi, will help to clarify matters. All three artists admittedly share certain ecological and environmental concerns, but aside form this, their approaches appear to have little in common. Their differing perspectives are evident even in their exhibition titles: Dion's first major British exhibition, in 1997, was called *Natural History and Other Fictions*; Olly and Suzi's, in 1998, was called *Raw*.[6]

Dion is in many respects a typical postmodern artist – the epitome of what the philosopher Richard Rorty has called the postmodern 'ironist theorist', whose responsibility is to call received wisdom into question.[7] Dion engages directly with theoretical perspectives. His interest in nature as 'a constantly reinvented rhetorical construction', and in how such constructions have 'articulated cultural anxieties about difference that separated *Homo sapiens* from other living creatures', is shaped in part by commentators on science such as Stephen Jay Gould and Donna Haraway.[8] He has also expressed particular interest in the social anthropologist Tim Ingold's important book, *What is an Animal?*[9]

The subject common to many of his installations is not so much the animal itself, but rather the attempts of science and philosophy to devise secure hierarchies and taxonomies in which to place it. A typically complex (if visually concise) example of his work, from 1990, is *Taxonomy of Non-Endangered Species* (illus. 2). It places Georges Cuvier, the founder of comparative anatomy, halfway up a ladder in the guise of

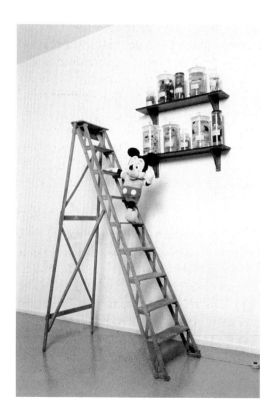

2 Mark Dion, *Taxonomy of Non-Endangered Species*, 1990, toy animals in alcohol, animated Mickey Mouse figurine, ladder, shelves, glass containers, audiotape.

Mickey Mouse. The subject of his monologue – the animated speaking body is activated by a floor button – is to be the two orderly shelves of preserving jars, labelled in Latin, into which have been stuffed the whole and perfect bodies of Pluto, the Pink Panther, Babar the elephant and others.

Conceived in response to the development of the Euro-Disney complex, and exhibited in Paris to coincide with its opening, the piece has been described as 'appropriating Cuvier's theories to expose the authoritarian world of Disney', whose theme parks include their own tableaux in which 'animal characters proselytize about "truths"' concerning the natural world.[10] For Dion the role of the artist as environmental activist is to employ 'the rich set of tools, like irony, allegory and humour', which are less readily or imaginatively employed by the institutions which seek to promote particular 'truths', such as science or the entertainment industry.[11]

Olly and Suzi's work, which principally takes the form of paintings and drawings of wild animals in their natural

habitat, could hardly be more different. They intend their paintings of endangered predators to convey a simple and direct message which is entirely free of postmodern irony: 'the animals are here now, they just might not be for much longer'.[12] Their images attempt to express directly their sense of the beauty and perfection of these animals. This approach, which is perhaps unusually straightforward in the context of contemporary art, undoubtedly prompts the question of whether the naturalistic representation of animals can really be called postmodern. There are compelling reasons for saying that it can.

Since 1993 the artists have sought to make pieces which reflect their immediate encounters and interactions with animals in the wild. The *Raw* exhibition, of work made since 1995, included paintings of lions, zebra, wild dogs and rhinoceros in the African bush, polar bears in the Arctic tundra, tigers and elephants in Nepal, leopards and tigers in India, white sharks in the ocean off South Africa, and ravens, wolves and deer in Minnesota. Often operating in difficult or dangerous circumstances, as close as they can get to these animals, and 'reacting to everything that's around us', they typically work on white or cream paper with materials such

3 Olly and Suzi with Greg Williams, *Shark Bite*, 1997, acrylic and blood on paper.

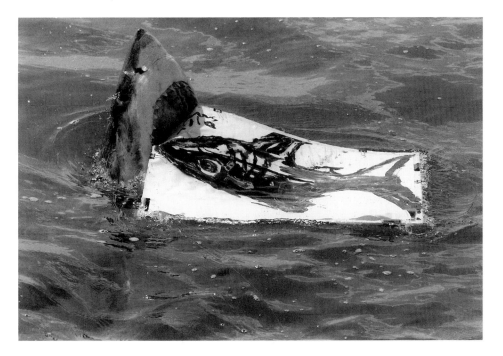

as natural pigments, soil, plant colourings, blood, inks and dyes. The two of them work simultaneously on each image, 'hand over hand'.

Aside from an absence of sentimentality or 'prettifying' in their work, two further features distinguish them from more traditional 'wildlife' artists. One is that the making of the pieces is extensively documented, 'as a performance', by the photographer Greg Williams, who travels with them. The other is that whenever possible the depicted animals are encouraged, without manipulation or coercion, to 'interact' with the work and mark it further themselves. This may take the form of bears or elephants leaving prints or urine stains on the image, or of chunks being bitten off a piece by a wolf or a shark (illus. 3). Exceptional cases, where the 'artistic inter-action' did not go entirely to plan, include a leopard dragging a painting away and destroying it, and a rhinoceros eating a whole piece.

COMMON GROUND: TRUTH AND AUTHORSHIP

The comparison of Dion with Olly and Suzi indicates some-thing of the range of serious contemporary art employing animal imagery. Beyond some level of ecological engagement and an interest in animals themselves, there are, however, sur-prising areas and issues of common concern in their attitudes to art and to the responsibilities of the artist.

The question of truth is one such issue. Postmodern scepticism about the operation of truth and knowledge has undoubtedly complicated any thinking about animals: about what counts as 'authentic' experience, about the experience of wonder or fear as antidotes to anthropocentrism, and about the extent to which it is possible to shed what Olly and Suzi call the 'baggage' of their Western thought. Dion has explained his interest 'in pre-Enlightenment collections like curiosity cabinets and *wunderkammers*' in terms of the way they 'tested reason' and attested to the marvellous. Questioned as to how he might provoke a contemporary sense of the marvellous, he replied: 'One thing is to tell the truth, which is by far more astounding than any fiction. (I cringe as the word "truth" passes my lips, but I always mean it with a lower case "t".)'[13] Olly and Suzi, when specifically asked whether their work sought to communicate a 'truth'

about animals, have been similarly cautious about the word: 'Our way of working aims to express our view of the world, which is our "truth" . . . We can't really say that there is one truth and we're aiming to get at that.'

In the incorporation of marks made by animals in some of their finished pieces, however, there is a very specific attempt to overcome viewers' postmodern sense of not knowing or believing what they are seeing. A work such as *Shark Bite* (illus. 3), exhibited along with the ragged corner ripped off by the shark, spat out and subsequently recovered, attests to the presence or existence of the living animal. The photographic documentation of the event, also exhibited in *Raw*, offers an important but somehow *lesser* – or at least more conventional, familiar, and thus more easily ignored – record of its existence. It is only the painting as object, as thing, marked by the animal itself, which can indelibly record the immediacy and 'truth' of the encounter.

In this respect, as far as the artists' environmental message (as opposed to their aesthetic sensibility) is concerned, it could be said that it hardly matters what the painting looks like. The key thing is its status as the mark of the real, the wound, the touch: 'by the end of the trip this paper's been transformed from its clinical state into a document, it's like a piece of parchment, a genuine artifact of the event'. While an artist like Dion might question the feasibility of any such unmediated communication with the viewer, hedged around as it is by the institutional trappings of its display, he would at least be sympathetic to the attempt to overcome the typically deadening effect of galleries and museums, in which 'the viewer is always passive'.[14]

In addition to the question of truth, there is significant common ground between Dion and Olly and Suzi in terms of how they position themselves as artists. They share an interest not only in Joseph Beuys's use of animals in his art, but in how he drew together the roles of artist, environmental activist and educator. The title of one of Olly and Suzi's paintings, *Deer for Beuys* (illus. 26), is a direct tribute to the artist they see as 'the foremost environmentalist in the art world'. In the educational dimension of their work, and in their field trips, both they and Dion necessarily work closely and cooperatively with individuals who do not see themselves as artists. Dion has said that 'making art is no longer confined to the

institutional spaces that we've created for such activity. It's more in the "field" now. The focus is on relations and processes – an ecology of art if you will'.[15] Much the same could be said of Olly and Suzi's approach: they abandoned studio work in 1993.

Such working procedures are by no means wholly new, of course. In addition to Beuys, Dion is conscious of other influences on his own disruption of 'the notion of an originating author'. They include the activist aesthetics of his former teacher, Hans Haacke, and the example of Marcel Broodthaers's subversion of the authority of both artist and museum in his *Musée d'Art Moderne, Département des Aigles* in the early 1970s.[16] Broodthaers's provocative project included labelling each eagle exhibit with the caption 'This is not a work of art' (illus. 4).

New or not, the kind of unassuming 'complex authorship' responsible for the production of these contemporary artists' work – most strikingly evident not only in Olly and Suzi's collaborative 'hand over hand' technique, but in the occasional participation of animals themselves in the mark-making – has recently been characterized specifically as 'a strategy for the times'.[17]

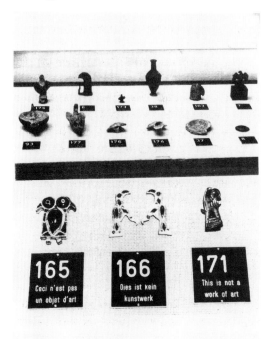

4 Detail of Marcel Broodthaers, *Musée d'Art Moderne, Département des Aigles, Section des Figures*, 1972, mixed media.

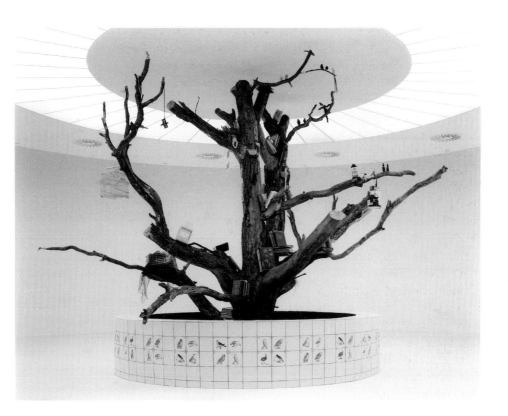

5 Mark Dion, *Library for the Birds of Antwerp*, 1993, birds of African origin, tree, ceramic tiles, pool, books, mixed media.

THE LIVING ANIMAL AS POSTMODERN ANIMAL

A further word must be said about the significance of the living animal for these artists, and the 'use' they make of it. In 1993 Dion made a complex installation entitled *Library for the Birds of Antwerp*, which incorporated eighteen living African finches (illus. 5). The installation was sited in the city's Museum of Contemporary Art, and during the exhibition the finches flew freely around the gallery space, perching on the tree-like structure at its centre. Like much of Dion's work, the piece was both a site-specific response to local history and a commentary on broader ecological issues such as the extinction of bird species.

As Norman Bryson explains in a thoughtful essay on this piece, the birds were purchased in Antwerp's Vogelmarkt, which continues a trade in exotic birds that began in the sixteenth century. The installation included signs of this trade, such as wooden cages, metal traps and cartridges of birdshot, as part of a wider set of references to extinction (the image of

a dodo, books on extinct bird species from the Americas), all wedged into or hung from the branches of the apparently diseased tree. Bryson reads the tree as a 'by now ironic image of man's place at the pinnacle of the evolutionary hierarchy'.

It is the living birds, however, that do the real work of the piece. 'Through the conceit that birds are readers', Bryson writes, the book-laden tree stages an encounter between 'man-made systems of knowledge on one side, and on the other side a realm beyond those systems, a Nature whose properties remain radically unknown and unknowable.' This seems a fair assessment of Dion's approach, which seeks to demystify human blinkeredness rather than human fascination with the non-human world. As Bryson puts it, the birds in the piece mark a reality which exists 'as an excess lying beyond the scope of representation, as a reserve which the production of truth draws upon, but cannot exhaust or contain'.[18]

For Olly and Suzi too, the animal is a reminder of the limits of human understanding and influence, but also of the value of working *at those limits*. The very existence of dangerous wild animals 'keeps us in check', they state, and serves to warn that humans (including artists) are 'not the boss of everything'. The reality of the animals' existence, and the artists' physical proximity to those animals, is central to their work. Whatever else happens, 'we have to have an experience in the bush', and the work emerges directly from that experience. They recognize that the benefits of their experiences and interactions with animals 'are, in the short term at least, in our favour, despite our long-term objectives of helping the animals' predicament',[19] but their work, like Dion's, stands as a marker – a concise encapsulation – of what they perceive as the interdependence of humans and animals in the contemporary world.

The comparison of these artists' work was introduced with Soper's modification of the distinction between 'green' and postmodern priorities. Rather like Soper, though across a wider range of cultural, scientific and political issues, Wendy Wheeler has also recently stressed the common ground here. She describes the postmodern not only in terms of a calling into question of earlier certainties about 'the value of science, rationality and progress' (a familiar enough description), but also as a new sensibility: 'the cartesian dualism which has so

fundamentally structured the modern world is in the process of being replaced by what is, in the broadest possible sense, an ecological sensibility'. In this 'more holistic' new perspective, notions of order, reason and the body are, she contends, being expanded 'through a growing understanding of the creative complexity of the world, and of the creatures amongst whom we move and in whom we have our being – as do they in us'.[20]

Although the implications of this last phrase are not drawn out in detail by Wheeler, it is striking to find an account of the postmodern which alludes so directly to animals, and which proposes that the future of the human in the postmodern world is so intimately and creatively bound up with that of the animal. From this perspective, the classic dualism of human and animal is not so much erased as *rendered uninteresting* as a way of thinking about being in the world.

ART AND PHILOSOPHY

A postmodern artist or writer is in the position of a philosopher . . .
JEAN-FRANÇOIS LYOTARD[21]

Some of the most adventurous and influential developments in recent Western art and philosophy have taken a deeply sceptical view of what has come to be seen as the divisive and defensive 'common-sense' account of identity. Whether described in terms of the heritage of Enlightenment rationalism or liberal humanism, this account of the privileged and empowered individual, often epitomized by the figure of the creative artist or author, has for several decades been the object of a destabilizing rhetoric. In 1966 Foucault had envisaged the possibility of circumstances arising in which 'man's mode of being as constituted in modern thought' might 'crumble'. By the 1990s the rhetoric (not always backed by sound historical argument) proposed that the postmodern should also be considered a *posthuman* condition.[22]

It is in the culture's art forms that the evidence of this changed condition has often been sought. It has been plausibly suggested, for example, that Ted Hughes's poem 'Wodwo' – in which a creature, strange to itself, searches for clues to its possible identity – 'inhabits a world beyond humanism, in which the human can no longer be taken for granted, but must be rediscovered anew in each encounter

17

with a ceaselessly changing reality'.[23] Such views are current in the various manifestations of poststructuralist theory, and in postmodern art's intense and critical focus on the body. The encounters they address will often be difficult or uncomfortable. Donna Haraway gives clear expression to this view. Acknowledging that there seems to be an inescapable need for 'something called humanity', she writes: 'We also know now, from our perspectives in the ripped-open belly of the monster called history, that we cannot name and possess this thing which we cannot not desire'.[24]

Many postmodern or poststructuralist artists and writers seem, at one level or another, to adopt or to identify with the animal as a metaphor for, or as an image of, their own creativity. Whether it connotes a sense of alienation from the human or a sense of bodily freedom and unboundedness, this willing taking-on of animal form casts the fixity of identity as an inhibition of creativity. Is this part of a genuinely open-minded process of thinking anew, or just another badge with which to secure an intelligible identity? Questions of identity on the one hand, and of creativity on the other, represent two major and interlocking strands of *The Postmodern Animal*'s investigation.

In that investigation, art and philosophy offer complementary perspectives; as Mary Midgley neatly expresses it, 'our imagination needs both art and philosophy'. Among some of the more poetic philosophers, at least, there is agreement that art (in the widest sense) offers access to a kind of truth to which a more narrowly defined philosophy is blind. Heidegger writes of there being 'fundamentally different *kinds of truth*', of which art is one, and Adorno specifically suggests that art and philosophy each address gaps in the other's view of the world: 'Only in combination', as Albrecht Wellmer summarizes it, 'are they capable of circumscribing a truth which neither alone is able to articulate.'[25]

Much of *The Postmodern Animal* therefore tries to read examples of the art and the philosophy in relation to each other, looking not only for correspondences but for ways in which each might test the other. The notion of the postmodern adopted here is broadly that envisaged by Lyotard in *The Postmodern Condition*. The postmodern stands for the forms in which imaginative thought necessarily challenges the complacency of the age, an unthinking 'consensus' of politics

and of taste which would prefer 'to put an end to experimentation', 'to liquidate the heritage of the avant-gardes', and instead 'to offer the reader or viewer matter for solace and pleasure'.[26] These remarks have lost none of their relevance in the years since Lyotard made them, and they have a particular pertinence in relation to questions of the animal. No rethinking of human or animal identity is likely to emerge, it is clear, if art and philosophy choose to present the animal primarily as matter for human 'solace and pleasure'.

Briefly, then, the book's scheme is as follows. After a sceptical review of the animal's place in postmodern irony in chapter 2, chapters 3, 4 and 5 go on to draw examples from recent art and philosophy in order to explore three related strategies by means of which the uncreative project of consensus and complacency identified by Lyotard has more effectively been fractured. Without giving names to these strategies themselves, the aspects of the secure sense of the human which they serve to undermine will be termed *expert-thinking*, *hierarchy-thinking* and *identity-thinking*, respectively. If these sound like easy or obvious targets, what is not so obvious is how the animal figures in their elaboration and in their undoing, and it is this which these three chapters seek to address.

Chapter 5, the last of the three, looks in some detail at Deleuze and Guattari's concept of 'becoming-animal', arguing that it offers the most thoroughgoing and imaginative alternative to thinking about humans and animals in terms of their 'identity'. To an extent this sets the agenda for the remainder of the book. Chapter 6 considers a specific problem which the concept of becoming-animal creates for thinking about the visual *form* of the animal in postmodern art, and chapter 7 considers its impact on the status of the artist. The final chapter explores the hostility of many postmodern artists and philosophers, not least Deleuze and Guattari, to the animal whose boundary-blurring role might have been expected to be seen as quintessentially postmodern: the pet.

Before moving on to consider these issues, an unasked question that hangs over the project must be addressed.

WHAT WAS THE MODERN ANIMAL?

Mark Dion and Olly and Suzi share a common perception that their concerns, as artists, have only recently come to be

recognized as serious and valid. Dion notes of his own development that in 'the slick world of Conceptual and media-based art' in the early 1980s, 'no one seemed interested in problems of nature'; Olly and Suzi recognize a continuing widespread reservation over the idea of the animal 'as a serious subject in contemporary art'.[27] If the postmodern animal appears awkwardly to lurch or stumble into being in recent art, this is perhaps because it does not follow in the steps of a modern animal.

The very idea of a 'postmodern' animal, however loosely the term is employed, inevitably provokes the question 'what was the *modern* animal?' *The Postmodern Animal*'s hypothesis is that there was no modern animal, no 'modernist' animal. Between nineteenth-century animal symbolism, with its reasonably secure hold on meaning, and the postmodern animal images whose ambiguity or irony or sheer brute presence serves to resist or to displace fixed meanings, lies modernism at its most arid. This hypothesis, it must be said, is essentially art-historical in its emphases: it is specifically to do with *the look of the animal body*, and with what that look was understood to say about the artist responsible for the representation.

For modern art, the imperatives of formalism and abstraction rendered the image of the human difficult enough. The image of the animal was further hampered by memories of the unashamedly anthropomorphic sentiment of an earlier age, which could hardly have been more at odds with the values of the self-consciously serious modernist avant-gardes. The animal is the very first thing to be ruled out of modernism's bounds. From then onwards it was what a picture must be understood to be 'before being a battle horse' which would count, according to the classic modernist dictum.[28]

There are therefore no animals in major cubist works . . . So might begin a rather tedious listing of the animal's absence from much of the twentieth century's most adventurous and imaginative visual art. Such a list would need to explain that even when the animal was visually present, it could be explained away, and that one function of modernist art criticism was to do so. So the animals in *Guernica* or in Heartfield's photomontages were a necessary part of the political symbolism of those works; those in the paintings of Marc, or of

Pollock, were a mere step on the ladder towards a more mature abstraction; those in Brancusi's sculptures should not be taken too seriously because he was better understood as one of those key modernists who 'derive their chief inspiration from the medium they work in';[29] and so on.

No matter that Brancusi regarded as 'imbeciles' those who called his work abstract; in his own view his realism stemmed from the fact that 'what is real is not the exterior form but the idea, the essence of things'.[30] Modernist criticism had little apparent interest in doing so, but it is certainly possible to read Brancusi's animal motifs (the fish, the turtle, the birds) as examples of the human imagining-itself-other. They represent the dream of unimpeded movement through air or water: a non-human, *non-pedestrian* movement in the strange imaginative spaces of the animal.

Perhaps the most striking example in the art of the early twentieth century of an attempt to think outside the secure perspectives of the human, however, is Franz Marc's 1911 essay 'How does a horse see the world?' Arguing that it was 'typical of our best painters that they avoid living subject matter', Marc outlined his alternative:

> How does a horse see the world, how does an eagle, a doe, or a dog? It is a poverty-stricken convention to place animals into landscapes as seen by men . . . It's the doe that feels, therefore the landscape must be 'doe-like'. That is its predicate. The artistic logic of Picasso, Kandinsky, Delaunay, Burljick, etc., is perfect. They don't 'see' the doe and they don't care. They project *their* inner world . . . I could paint a picture called *The Doe*. Pisanello has painted them. I may also want to paint a picture, *The Doe Feels*. How infinitely more subtle must the painter's sensitivity be in order to paint that![31]

In a matter of a few years, however, Marc had moved away from such exercises in proprioception, and had begun more closely to embrace abstraction as the style appropriate to a heroic conception of modern art. He justified his new priorities as 'nothing other than the highly conscious, action-hungry determination to overcome sentimentality'.[32]

As the example of modernist art history as a whole suggests, the animal comes to be least visible in the discourses which regard themselves as the most serious. The modern

animal is thus the nineteenth-century animal (symbolic, sentimental), which has been *made to disappear*. On the rare occasions it is anything other than the absented image of this earlier creature, it is the proto-postmodern animal of surrealism, for example, and perhaps of some very early Disney animations: that which disturbs.

It is therefore perhaps unsurprising that it is in its less disturbing and more abstracted form that the modernist animal meets with critical success, as in Henry Moore's monumental bronze, *Sheep Piece*, from the early 1970s (illus. 6). This piece has been described as 'a landmark in the evolution of Moore's sculpture', and is said to be regarded by Anthony Caro as one of Moore's finest works.[33] When set alongside a very different rendering of the same animal, Edwina Ashton's 1997 video performance *Sheep* (illus. 27), it offers an opportunity to see what is at stake in the shift from a modernist to a postmodern disposition or sensibility with regard to animals.

Although close in time to Moore's *Sheep Sketchbook*, drawn from nature in 1972, whose animals Peter Fuller has remarked 'could not be more sharply observed', *Sheep Piece* in fact derives from a maquette made in 1969. Like many of his 'animal' sculptures, it owes 'more to the imagination than to observation'. According to one account, at least, the finished bronze acquired its title not from its subject matter but from the fact that it became 'a rubbing and sheltering post for sheep' in the field in which it was first placed.[34] Moore himself admitted 'I can see animals in anything, really.' Commentators have followed him in this, seeing the piece as 'a summing up of his feeling about sheep form', or variously finding in it 'suggestions of a ram mounting a ewe or of a lamb nuzzling its mother'.[35]

The animals in Ashton's *Sheep* are envisaged quite differently. The piece runs for four minutes, and is seen on two adjacent video screens. On the right, a figure dressed as a sheep looks across, as it were, to the other screen, on which an apparently identically dressed figure, in much the same setting, sits at a desk with its script (illus. 27). In a faltering voice, and endlessly, agitatedly wringing its 'hands', this second sheep recites a series of truly dreadful sheep jokes. 'Why do sheep hate pens? Because they can't write.' 'Can you stop making that noise with the paper. Why? Because I hate sheep rustlers.' Most of the jokes are told hesitantly or badly. 'My

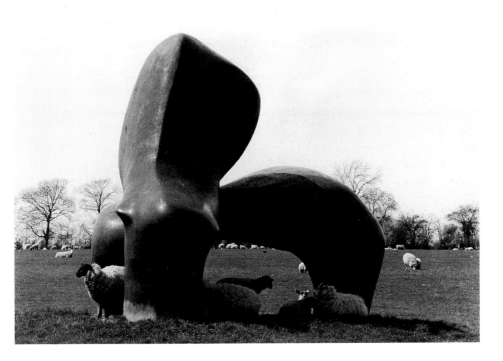

6 Henry Moore,
Sheep Piece, 1971–2,
bronze.

dad, my dad's car got nicked. Oh no – who by? A ram raider.'
'What do you call a lady with a dog on her head? Mutt-on.
Mutton.'

There is a peculiar play of engagement and disengagement
in the piece. Both performers are Ashton herself, but with her
voice disguised: 'I don't want to be in them', she has said of all
her video performances. The animal was chosen not for its
appeal but because, in her view, 'sheep are hideously ugly'. A
long time was spent 'trying to get the faces right' on the hand-
made costumes, to achieve 'a sufficient degree of blankness'
while nevertheless keeping a kind of 'haphazard' look. The
speaking sheep's voice, in contrast, is intended to be entirely
human (but not recognizably Ashton's) rather than attempt-
ing to imitate the animal.[36]

What can be learned from Moore's and Ashton's contrast-
ing takes on sheep form, if read as rather arbitrarily chosen
representatives of modern and postmodern perspectives?
Neither perspective, significantly, need involve a *sympathy*
for the animal: it would be quite wrong automatically to
associate animal imagery in postmodern art with any overtly
pro-animal stance.

23

Nevertheless, there is a proximity to and engagement with the animal in Ashton's video which is absent from Moore's sculpture. For Moore the sheep is always outside, a thing quite separate from himself. It is a thing to be addressed and presented (whether through observation *or* imagination) by means of the authority and expertise of the artist, who surrenders nothing to it. Ashton is literally stuck inside her sheep, uncomfortably so, wringing her hands and disguising her voice, telling bad jokes at the expense of the animal identity she has taken on, which itself is only stated in 'haphazard' fashion. *Sheep Piece* is not about animal identity: the artist secures his own identity by keeping his distance from the animal. *Sheep*, on the other hand, is wholly about problematized identity, about awkward conjunctions of human and animal which seem typical of much postmodern art but which have few parallels in modernism.

There is of course a severe risk of caricaturing the distinction in any such comparison, and of overstating both modernism's concern with purity and wholeness and postmodernism's preparedness to cast aside the secure trappings of human identity. It may also be that such distinctions, to the extent that they are justified at all, can be traced just as readily within differing manifestations of the postmodern itself.

Among the proliferating theories of the postmodern in recent times, there are several instances of the idea of there being two distinct postmodern 'moments'. In the field of art, for example, Hal Foster distinguishes the work of 'early postmodernists' who appeared to 'delight in the sheer image', from that of 'later postmodernists' who sought instead to 'possess the real thing'. This is not presented as an unproblematically good thing – it marks a shift in artists' preoccupations from 'the highs of the simulacral image' to 'the lows of the depressive object' – but Foster's language certainly implies a shift from superficiality to seriousness.[37]

Wendy Wheeler has similarly proposed two distinct stages of the postmodern. The first stage often involved (at a safe theoretical distance from its effect on real lives) an indulgent and rather inhuman celebration of 'the fragmenting of texts and bodies', in forms that were typically 'ironic or parodic'. The second, more constructive contemporary stage she characterizes as 'a "postmodern" rebuilding', oriented towards ways of 'rethinking human beings' and readdressing the

world; it is a wholly serious and creative attempt 'to imagine differently reconstituted communities and selves' and to heal the destructively fragmented experience of the contemporary world.[38]

Foster and Wheeler seem primarily concerned to describe successive stages in the historical development of the post-modern condition: an early superficial postmodernism of the 1970s and 1980s; and a later and more mature post-modernism, the effects of which are still operative at the start of the new millennium. In the following chapter, which considers some examples of both 'delight in the sheer image' of the animal and the 'ironic or parodic' treatment of animal themes in the late 1970s and early 1980s, *The Postmodern Animal* may appear to follow something like Foster's and Wheeler's models. It is important to understand, however, that these two postmodernisms are at the very least *open to being read* as something other than stages in a history which moves from a blinkered 'then' to an enlightened 'now'. They represent alternative dispositions, perspectives or emphases, which co-exist and often compete.

If the book's emphasis, in all but the following chapter, is almost exclusively on the 'second' of these dispositions, this is not because it seems more optimistic, or appears to hold out the prospect of a 'better' future for animals, but because it is more genuinely curious and engaged. It is closer, in other words, to Lyotard's understanding of the work of the post-modern artist or philosopher. Regardless of whether its priorities are judged to be more humane or less humane, it is undoubtedly more serious about the animal, and is just possibly less fearful of it.

2 Animals and Ironies

When he wrote of himself, 'I attract mad people and animals', perhaps he should have added 'and ironies'.
JULIAN BARNES, *Flaubert's Parrot*[1]

Irony, the American artist Mary Lemley has insisted, changes nothing. Even Richard Rorty, writing in its defence, acknowledges that 'irony is of little public use' and that 'ironist philosophy has not done, and will not do, much for freedom and equality'. And it has been said of Mark Dion, who makes conscious use of ironic strategies to raise ecological awareness: 'The question remains whether the activities of an artist can do much to save the Great Auk, the Black Rhino, or *Homo sapiens.*'[2] To the extent that such reservations are justifiable, they immediately pose a dilemma. If the postmodern condition does mark an identifiable (and thus nameable) shift in Western culture's perception of itself – a thinking-differently of its individual inhabitants' selves – how is it that something which allegedly 'changes nothing' found such a privileged place in its stock of strategic moves?

Irony, often regarded as the most complex of rhetorical figures, undoubtedly did play an important part in the self-consciously clever moves of early postmodernism. In her 1988 book, *A Poetics of Postmodernism*, Linda Hutcheon went so far as to write of 'the governing role of irony in postmodernism'.[3] Along with parody and pastiche, irony was certainly one of the characteristics which enabled enthusiastic supporters of the new state of affairs rather glibly to assume its superiority over what was often presented as a high-minded, humourless modernism.

In that moment, early in the 1980s, of what might be characterized as this detached and ironic postmodernism, images of the animal seemed to proliferate across the range of the arts. Three examples of this 'first stage' postmodernism – from the fields of painting, literature and film respectively – will be discussed here in order to get a sense of *how* the newly visible animal got caught up in all this parroting and parodying, and to what effect.

MORLEY'S PARROTS

In 1981 the Royal Academy's exhibition *A New Spirit in Painting* introduced a large British audience to the idea of a 'return to painting' after the various forms of art's dematerialization in the 1960s and 1970s. Viewers walking into the exhibition were immediately confronted by two large, colourful paintings by Malcolm Morley which were quite unlike the earlier photorealist work for which he was perhaps best known. One was called *Parrots* (illus. 7), and the other *The Lone Ranger Lost in the Jungle of Erotic Desires*.[4] The latter had the Lone Ranger on his horse, Silver, surrounded in a jungle setting by objects and creatures none of which seemed to be painted to scale: cacti, a locomotive, a cobra, six female human legs dangling from the top of the painting, and, most startlingly, about a dozen loosely painted very large parrots.

It was less the rather cartoon-like style than the presence of the birds themselves that made the paintings so striking. Here were animals in art – the very phrase is enough to make most art historians cringe – that for once looked neither embarrassing nor kitsch. The imagery in the exhibition was in fact awash with animal bodies, wild and domestic, expressionist and realistic, ranging from Georg Baselitz's inverted eagle to Lucien Freud's *Naked Man with Rat*. Other works offered

27

composite bodies of humans and animals, such as Francis Bacon's portrait of Muriel Belcher in the form of a sphinx.

The presence of animal images in such numbers certainly appeared to mark an end to one particular version of modernism, an 'austere' modernism in which the animal had had no proper place. It was this that Christos Joachimides addressed in his catalogue essay when he wrote, with a somewhat selective art-historical memory, that the avant-gardes of the 1960s and 1970s were 'bound to be self-defeating' on account of their 'narrow, puritan approach devoid of all joy in the senses'.[5]

The idea is echoed in a later essay on Morley by Michael Compton, which describes *Parrots* as a 'feast of the senses' and claims that for the artist 'such a picture approaches the pure pleasure principle'. He suggests more generally that Morley's parrots are 'an image of (partly domesticated) primitive sensuality', and that his 1982 *Macaws, Bengals, with Mullet* 'presents itself as an altar piece dedicated to the senses'.[6] Lynne Cooke has also noted the 'hedonistic' nature of the work, but suggests that it has a critical postmodern edge: 'The deliberative nature of Morley's technique, its detachment, and the constant disruption of the seamlessness of his visions by a humour that ranges from the wry to the caustic and the whimsical invest his version of primitivism with great richness.' The artist has himself acknowledged his work's critical dimension: 'Why do I paint? I do it to get pleasure. But I'm not easy to please.'[7]

To writers sympathetic to Morley, therefore, it seems that his animal imagery has a place both in his 'postmodern' formal experimentation and in his evocation of a sensual 'primitive' pleasure. Why it should be that animals served as such convenient markers of both pleasure and postmodernity remains largely unaddressed in these commentaries.

FLAUBERT'S PARROT

Something similar might be said of Julian Barnes's third novel, *Flaubert's Parrot*, which was published in 1984. To many readers it seemed funny and likeable and adventurous precisely because of its bizarre preoccupation with animal themes in Flaubert's work. The story concerns the quest of a retired English doctor, Geoffrey Braithwaite, to find in France

the actual stuffed parrot that Flaubert had placed on his desk so that he could fill his head 'with the idea of parrothood' during the writing of his 1876 story 'A simple heart'.[8] In Flaubert's story a parrot named Loulou comes to be the final companion of an elderly uneducated servant called Félicité, who has the bird stuffed when it dies and who, in the final moments of the story, has a vision of the parrot when she herself dies. In a letter written the same year, Flaubert says of the story's conclusion: 'When the parrot dies she has it stuffed, and when she herself comes to die she confuses the parrot with the Holy Ghost. This is not at all ironical as you may suppose but on the contrary very serious and sad.'[9]

Barnes's use of his material is playful, complex and clever. The reader is often unsure whether it is Barnes, Flaubert or Braithwaite speaking, and whether or not whoever it is has his tongue in his cheek. Braithwaite has something of Flaubert's bumbling characters Bouvard and Pécuchet about him, chasing after knowledge, reworking old ground, and the novel makes much of the idea of a kind of mindless parroting – and, of course, of its respectable contemporary obverse, postmodern appropriation. Like Bouvard and Pécuchet ('opinionated copyists', he calls them), Braithwaite is himself a ridiculous character on a ridiculous quest: 'Anyone would have thought I was a crank, a senile amateur scholar hooked on trivia', he records. At the same time his concerns, wittingly or not, could be said to be properly and seriously postmodern: 'My reading might be pointless in terms of the history of literary criticism; but it's not pointless in terms of pleasure.' Braithwaite clearly knows his Roland Barthes.[10]

His world is, in his own words, one 'of books, and parrots, and lost letters, and bears'; a world which makes both metaphorical and documentary reference back to Flaubert's world of over a century earlier; a world set in real French and English locations and populated by both fictional characters and real people. These real people are not all tucked safely back in the nineteenth century. The original book jacket reproduces David Hockney's 1974 etching *Félicité Sleeping with Parrot*, one of his illustrations for Flaubert's story, and Braithwaite quotes the reference to it in the artist's autobiography and claims to be awaiting a reply to his own letter to Hockney. He also quotes from a list (one of the book's very many lists) made by Barthes, called 'What I like', which

included *Bouvard et Pécuchet*: 'Good; fine; we'll read on', remarks Braithwaite.[11]

There is also a comment on a lecture he claims to have attended 'by a professor from Cambridge, Christopher Ricks', and of which he generally approved: 'his argument was that if the factual side of literature becomes unreliable, then ploys such as irony and fantasy become much harder to use. If you don't know what's true, or what's meant to be true, then the value of what isn't true, or isn't meant to be true, becomes diminished'.[12] The irony here is that the form of Barnes's novel serves precisely to diminish such certainties.

When Flaubert's animals are drawn into this uncertain textual world of the 1980s, their status – even their rhetorical status – is equally uncertain. Braithwaite hesitates, almost dithers, in his attempt to characterize Madame Bovary's dog: 'This dog is given a passing significance as . . . less than a symbol, not exactly a metaphor; call it a figure.' Of Loulou the parrot, 'representing clever vocalization without much brain power', Braithwaite rather dismissively suggests that 'If you were a French academic, you might say that he was *un symbole de Logos*. Being English, I hasten back to the corporeal: to that svelte, perky creature I had seen at the Hôtel-Dieu.' But hesitating again, he appears to have second thoughts: 'Is a critic wrong to read Loulou as a symbol of the Word? Is a reader wrong – worse, sentimental – to think of that parrot at the Hôtel-Dieu as an emblem of the writer's voice? That's what I did.'[13]

Sometimes the animal rhetoric gets out of hand, as in Braithwaite's summary of the difficulties of historical writing: 'Sometimes the past may be a greased pig; sometimes a bear in its den; and sometimes merely the flash of a parrot, two mocking eyes that spark at you from the forest.' This certainly seems to be an instance of the 'ease of symbolization' of which the literary critic Alan Liu complains in much postmodern theory. For the purposes of such writing, he suggests, 'the irreducible facticity and uniqueness' of the symbolized animal must be 'disappeared'. In such contexts the living animal (or even the stuffed parrot) becomes 'insignificant compared to what we can make it stand for' – this 'we' being any and all postmodern theorists.[14]

Behind Barnes's rhetoric, however, is an attempt to do something genuinely difficult: to consider how Flaubert's

own animal imagery may now be understood. Whatever he wants to say in seriousness about Flaubert has to be filtered through the petty cataloguing mentality of Braithwaite, however. The thing from which Braithwaite enables Barnes to keep a certain cool postmodern distance seems to be the alluring but unfashionably romantic conception of the artist as a being apart: an outsider, rejecting the pettiness of bourgeois culture, closer to the authenticity of an animal world. Flaubert writes in 1850: 'The artist, to my way of thinking, is a monstrosity, something outside nature . . . I am resigned to living as I have lived: alone . . . – a bear, with my bear-rug for company.'[15] Braithwaite pursues the matter with eager pedantry and poor punning: 'Exactly what species of bear was Flaubear?', he begins.

Barnes, however, seems to want (but cannot allow himself) to declare himself to be one of the 'mad people and animals' attracted by Flaubert. What the reader gets instead is Braithwaite imagining Flaubert's own identification with Loulou, 'staring back at him like some taunting reflection from a funfair mirror'. But even that innocent phrase draws together familiar stereotypical elements of a particular idea of art: distortion, madness, the visual, the animal.[16]

A very different reading of Flaubert's parrot is found in Marian Scholtmeijer's essay 'What is "human"?', which describes it as being deliberately presented by Flaubert as 'a most unromantic bird':

> Flaubert goes out of his way to suppress features that might make Loulou attractive . . . He does not detail the parrot's charming quizzical looks or instant responsiveness to his owner's presence. Instead, he touches on raucous noises; feathers and droppings making a mess everywhere; a growth on the parrot's tongue, a growth which Félicité has to remove with her fingernails . . . A reader seeks a way 'in' with Loulou, a way to engage humanly or culturally with the creature, and is thwarted. In this way, Flaubert ensures that Loulou remains animal . . .[17]

This last remark is at the heart of Scholtmeijer's reading of Flaubert's story. It is an account of animal difference which refuses to be reduced to human familiarity, to a figure, to an amusing little postmodern motif, to Braithwaite's '*un symbole de Logos*'. For Barnes the parrot seems often not so much to be

an animal as an absence. Served up as the focus of an undeniably clever literary conceit, the bird has been, to repeat Alan Liu's memorable phrase, 'disappeared'. Its role in *Flaubert's Parrot* is merely to lend the novel a jollity, a frivolity, an edge.

Barnes's intentions are of course quite different from those of Scholtmeijer. His novel only thinly disguises a fascination with the artist's 'animal' identity, 'outside nature' as Flaubert's words have it. (It is notable here that Flaubert's identification with the bear does not place him *inside* nature – the role of the artist is evidently more anomalous than that.) The disguise is nevertheless central to the book's postmodern credibility. Barnes's elaboration of Flaubert's understanding of creative thought is always cloaked in Braithwaite's ridiculous and obsessive listing of his animal references and metaphors. The 'postmodern' form of the novel (in which lists constantly fracture the narrative, and jokiness is more acceptable than seriousness) has its own consequences: some of the ridicule rubs off on the animal itself. Unlike both Flaubert's and Scholtmeijer's birds, there is something knowingly Pythonesque about Barnes's dead parrot.

THE BIRDS OF *THE FALLS*

'Starting at the buzzer, in thirty seconds, name for me as many birds as you can think of.' Corntopia Fallas begins: 'Partridge, parrot, peacock . . .' Her questioner is Erhaus Bewler Falluper, 'a master cataloguer, an ennumerator, and a collector of statistics'. Fallas is one of several interviewees who is seen taking part in a survey on bird knowledge. Falluper had conducted seventeen such surveys but, as a commentator observes, their value was doubtful: 'The results were erratic, and arbitrarily catalogued.'[18]

Birds, lists, and the precariousness of the collection and documentation of knowledge: these themes, already familiar from *Flaubert's Parrot*, are also central to Peter Greenaway's early film *The Falls*, dating from 1980. The simultaneous narrative fragmentation and textual excess of the film are among its most striking features. More striking still is the fact that while it is full of birds and bird references, it would be hard to imagine a less beautiful, less elegant, less poetic film about birds. This is no doubt deliberate. There is a dystopian aspect to the film's vision. Its title suggests that Greenaway may

share something of Georges Bataille's delight in the puncturing of those human pretensions which the fall of Icarus so concisely symbolizes. Alan Woods observes in his book on the director: 'Water, for Greenaway, is what you drown in; air is what you fall out of.'[19]

Woods notes that several of Greenaway's early films 'mock or parody documentary film-making'. Greenaway himself says of the film: 'transparently – it was a fiction. However, such was the plausibility of some of the fictional events in *The Falls* . . . that a confusion of fact and fiction was ever present'.[20] The film is in 92 parts, detailing the biographies of 92 individuals each of whose invented surnames begins with the syllable *Fall* (Musicus Fallantly, Starling Fallanx, Bird Gaspara Fallicutt, Pollie Fallory). A commentator explains at the outset that the names are taken from a directory published 'by the committee investigating the Violent Unknown Event – the VUE for short'. These 92 people represent a cross-section of the nineteen million victims of the VUE. In the course of this long film little is learned about the event itself, but fourteen of the biographies make direct reference to, or suggest that their subjects subscribe to, 'the theory of the responsibility of birds'.[21]

A typical biography begins: 'The Violent Unknown Event had partially paralyzed the face of Afracious Fallows, enlarged his heart, thumbs and genitals, made him scrofulous, softened and widened his feet, and thoroughly wrecked his career as a school headmaster.' Most biographies detail the unpredictable, disruptive and often birdlike changes which the VUE has created in their subjects' bodies, speech patterns and lives. After the event, Squaline Fallaize, 'another bird victim', was found to have 'shining eyes, a yellow skin, and a blaze on her forehead in the shape of the Austro-Hungarian double-headed eagle'. These mutations are in some cases the source of a desire to become yet more birdlike. Castel Fallboys, whose 'gait resembled that of a starling', is one of various subjects vainly striving to perfect human flight: 'To extend his range and his comparability with birds, Castel ruthlessly streamlined his body by excessive exercise and diet, growing very lean in the leg, muscular in the shoulders, long in the arm and short in the neck.'[22]

It is with the theme of the proliferation of language, however, that Greenaway most explicitly creates a sense of

characteristically postmodern uncertainty. Most victims of the VUE are left speaking one or more of the 92 new languages which have been occasioned by the event. Coppice Fallbatteo, an art historian, was an exception in that (to his regret) the VUE had left him speaking his native Italian. He tried to learn one of the VUE languages but had ambitiously chosen the most difficult one, a language 'of unlimited vocabulary and rapidly changing grammar and syntax. As fast as he had mastered one small area of its possibilities, he found that the same small area had developed, realigned itself with a new set of meanings, or had indeed become entirely obsolete'.[23]

The theme of listing – the hopeless attempt to order chaotic language and the knowledge it supposedly embodies – is evident throughout the film. It is there in the random bird lists recited by Falluper's interviewees, and also in a bizarre scene in which Lacer Fallacet's two grand-daughters are seen standing on a beach, taking it in turns to shout bird names out to sea through a megaphone.[24]

Listing comes to the fore in biography 24, of Castenarm Fallast, 'occasional pianist, professional indexer', who has compiled 'a list of ninety-two of the most unfamiliar bird names he could find'. Fallast is seen in profile turning successive index cards with these bird names, sometimes misspelt, hastily scrawled on them, as he begins tunelessly to sing through the whole list of largely unfamiliar names. In three excerpts from the song, the names seen on the cards gradually diminish from four syllables to one: 'capercaillie, lammergeyer, cassowary – accentor, dowitcher, gargany – goosander, bobolink, dotterel . . .'; then 'capercaillie, lammergeyer, cassowary – towhee, bulbul, auklet, noddy, gadwall, pochard, sora, grosbeak, hawfinch . . .'; finally 'skewa, wryneck, firecrest, knot, loon, rail, scalp, guan, smew, stilt, crake'.

The bird list song makes its full appearance in biography 74, that of Pollie Fallory. Her VUE language is one which 'stretched the human tongue and voice box to influence the language of animals rather than the other way around', and she has also relearned English in order 'to make a definitive version of the bird list song'. The high-pitched voice of Lucie Skeaping is heard as Fallory, screeching out the song and standing stock still as the camera slowly pans away from her face. This unexpectedly thrilling moment is the nearest the

film gets to the sense of freedom and liberation which is conventionally associated with flight, and which the film as a whole works systematically to deny.

Nothing else in the film, and in particular none of its bird imagery, is anything like this. There are almost no images of birds in flight; instead there are dead birds, the shadows of stuffed birds (illus. 8), old films of early naive and unsuccessful attempts at human flight (illus. 9), views of pubs and streets with birds' names, stills from *The Birds* (biography 68 tells of Obsian Fallicutt's theory 'that the VUE was an expensive elaborate hoax perpetrated by A. J. Hitchcock to give some credibility to the unsettling and unsatisfactory ending of his film *The Birds*'), statues of storks in the grounds of Fountains Abbey, the names of obscure birds written out either hurriedly or meticulously, and slides of 'black and white photographs of birds kept in zoos'.

In the film's closing credits, where for once the imagery holds its own against the weight of text, birds are finally seen in flight. Over another rendition of the bird list song, a snippet of film of a swirling flock of birds is laid over the faces of some of *The Falls*'s 92 subjects. The effect of the superimposition, however, is to suggest that the birds are metaphorically infesting their thoughts, their minds, rather than representing any image of expansiveness or exultation.

8 Peter Greenaway, Film still from *The Falls*, 1980.

35

FLYING OFF THE POSTMODERN HANDLE

There is little doubt that in terms of the usual criteria – irony,
contradiction, fragmentation, appropriation and the like –
Barnes, Greenaway and Morley employ postmodern strate-
gies in their work. In some sense, however, these strategies
seem to run against the grain of the animal. Consequently
those elements in the works which hint at a rethinking of the
relation of human and animal – Morley's apparently genuine
delight in his imagery, Barnes's fascination with Flaubert's
animalized self-descriptions, and Greenaway's few charac-
ters who direct their new VUE languages back *towards*
animals – are easily overlooked.

To the fore, instead, is a rhetoric of desire either too easily
satisfied (Morley's paeans to pleasure) or endlessly deferred
(as in Braithwaite's hopeless search and Greenaway's
imagery of frustrated flight). Animal identity is not seen here
as something which might have its own imaginative *work* to
do. And if the postmodern condition does indeed signal the
possibility of a shift in attitudes to identity, it might be thought
surprising that its characteristic cultural expression, in works
such as these, finds such easy amusement in the familiar idea
of the animal-as-other.

The present (and admittedly partial) reading of works
by Morley, Barnes and Greenaway as representative of a

hypothesized 'first stage' of postmodernism has argued that they do not attempt to think the animal differently, nor indeed really to think it at all. In the case of Barnes and Greenaway, at least, their calculatedly postmodern stance seems too cool, too ironic and too knowing to permit anything so direct as a genuinely critical or impassioned engagement with the idea of the animal. It is here, around some sense of engagement and purpose, that it may be possible to sketch one important version of the figure of the postmodern animal. It would still be a figure – a rhetorical construction – but the figure of a thing engaged, and even enraged.

There is a fine essay on rage by the British psychoanalyst Adam Phillips. Rage is a reaction to the violation of an often unconscious sense of 'how the world should be'. It is a means of taking revenge, and revenge is called for because the thing that is so humiliating about rage, Phillips suggests, is that in rage 'I expose my furtive utopianism: my horrifying, passionate ideal of, and for, myself'. He is in no doubt as to the necessity of humiliating rage: 'That we can feel humiliated reveals how much what matters to us matters to us. Our rage is itself a commitment to something, to something preferred. Indeed, how would a person immune from, or ignorant of, humiliation know what a good life was?'[25]

In the light of this question, the postmodern animal might productively be thought of as the rhetorical figure of the human, animal, artist or philosopher whose purpose (flawed and vengeful as it may be) is to imagine, and to hold to, the idea of a good life. This would reflect nothing more than the present state of a much older project: although it 'lapsed into intellectual neglect' in the twentieth century, it was 'the teaching of the good life', Theodor Adorno recalls, which 'from time immemorial was regarded as the true field of philosophy'.[26]

Here then is a concise way of expressing the two 'stages' or dispositions of postmodernism: one characterized by an ironic detachment and a freedom from humiliation, and the other vainly (but philosophically) raging about things that 'matter'. Phillips proposes that anger 'is only for the engaged; for those with projects that matter (not the indifferent, the insouciant, the depressed). That is to say, it is for those for whom something has gone wrong, but who "know", in their rage, that it could be otherwise'.[27]

In his essay's only reference to the notion of the animal, Phillips characterizes humans as 'the animals who humiliate, who are so adept at destroying hope; the animals who can take so much pleasure in diminishing another person and, of course, in diminishing ourselves'. As the counterpart of admirable rage, humiliation is so instructive because it combines 'our abjection and our grandiosity'.[28] This sorry state is nevertheless a more promising model for a self thought and seen differently from its superficially more 'postmodern' alternative: insouciance and irony. A 1981 book on postmodernism and irony offered the depressing suggestion that in postmodernism 'a world in need of mending is superseded by one beyond repair'.[29] If, to return to the present chapter's starting point, irony therefore does indeed *change nothing*, it will have little to contribute to the creative work in which the postmodern animal might figure.

3 The Human, Made Strange

It is a hard piece of Work, being a Dog.
KIRSTEN BAKIS, *Lives of the Monster Dogs*[1]

In the introduction to *The Postmodern Condition*, his 'report on knowledge' in the postmodern era, Jean-François Lyotard remarks almost in passing that 'the author of the report is a philosopher, not an expert. The latter knows what he knows and what he does not know: the former does not. One concludes, the other questions . . .' Adam Phillips's more recent book, *Terrors and Experts*, draws a similar distinction. 'Curiosity is endless', Phillips proposes, '. . . in a way that answers are not'. And 'prescription begins when curiosity breaks down'. The psychoanalyst has therefore 'to learn how not to know what he is doing'.[2]

Such ideas are easily extended to art, for example in relation to Marion Milner's book (much admired by Phillips) on the benefits of 'not being able to paint', or Hélène Cixous's confident assertion that 'the painter, the true painter, doesn't know how to paint'. The perceived incompatibility of art and expertise is also behind Michel Foucault's complaint that 'in our society, art has become something . . . which is done by experts who are artists. But couldn't everyone's life become a work of art?'[3]

Postmodern thought, across a range of disciplines, is keen to distance itself from notions of expertise and, more particularly, from the effects of *expert-thinking*. The starting point for the present chapter is the impact of this rhetoric on how the postmodern animal and the postmodern human may now be envisaged. It will serve as the basis for exploring both the aesthetics and the ethics of the postmodern animal. As Phillips intriguingly suggests, the alternatives to expert-thinking might create circumstances in which 'the idea of human completeness disappears'.[4]

In the distinction often drawn between the concepts of creativity and expertise, an *opening up* of the human, the 'self', is associated overwhelmingly with the former. Recent evidence suggests that this perception has wide acceptance, and does not merely reflect the preferred self-image of post-modern practitioners. The evidence appears, in part, in a weighty book by Mihaly Csikszentmihalyi called *Creativity*. It is a fascinating and frustrating study, riven with inconsistencies, not the least of which is Csikszentmihalyi's view that creativity in any given field can only properly be assessed by 'experts' in that field.[5]

Nevertheless, Csikszentmihalyi recognizes that creativity is widely associated with 'the other side of the known', where 'self-consciousness disappears'. The real interest of his project lies in the support given to this view in the interviews he conducted with over ninety well-established and supposedly 'exceptional' individuals working in the arts, sciences, business and politics. It is striking how similarly they approach their work, regardless of their discipline or background. The thing they seem keenest to describe is the enjoyment they derive from *not quite knowing what they are doing*. Of the several interviewees who directly address the idea of not-knowing, the historian Natalie Davis is perhaps the most eloquent: 'At the time I don't know why necessarily it is that I invest so much curiosity and eros into some project . . . I may not know what is personally invested in it, other than my curiosity and my delight.'[6]

Csikszentmihalyi's interviewees have nothing direct to say about the place of the animal in this kind of unselfconscious thinking, but their accounts of creative endeavour are widely echoed in the improvisational aesthetic of contemporary artists, including those making significant use of animals. Joseph Beuys offers the advice: 'Use what you have – don't think you have to wait until you have found the perfect formulation.' Damien Hirst is similarly impatient of expert-thinking, and gives a concise image of the alternative: 'Maybe the tools that you really need for understanding something or the keys sometimes aren't there, but you can always take a screw out with a knife.'[7]

Expertise is not considered creative. It is this which Lyotard's rhetorical opposition of philosopher and expert (on which more weight is put here than he probably intended) helps to articulate with a critical edge lacking in Csikszent-mihalyi's survey. Invention, Lyotard writes, 'is always born of dissension', and this idea is at the heart of 'postmodern knowledge', whose principle 'is not the expert's homology, but the inventor's paralogy'.[8] It is a kind of partisan know-ledge, in other words, which refuses to conform to rules and which may even embrace the apparently fallacious, *not knowing what will follow from that*. Phillips similarly supports the view that 'one must affirm invention at the expense of argument', as does Jacques Derrida in his own essay on inven-tion: 'An invention always presupposes some illegality, the breaking of an implicit contract; it inserts a disorder into the peaceful ordering of things, it disregards the proprieties.'[9]

Lyotard is in no doubt that the thing being described here, and being sharply distinguished from the narrowly propri-etorial concerns of the 'expert', is the attitude appropriate to the postmodern artist: 'A postmodern artist or writer is in the position of a philosopher: the text he writes, the work he pro-duces are not in principle governed by preestablished rules, and they cannot be judged . . . by applying familiar categories to the text or to the work.'[10]

Despite postmodernism's supposed mistrust of dualistic thought, variations on the theme of the opposition of philo-sopher and expert crop up in all manner of broadly con-temporary attempts to distinguish creative practice from a narrower and more defensive 'expert' mentality. The opposi-tion appears in many guises. It is found in Phillips's notion of there being 'two versions of ourselves, the Censor and the Dissident' (which at least acknowledges the difficulty of iden-tifying wholly with the preferred 'creative' version).[11] It is found in the performance artist Matthew Goulish's prefer-ence for the ecstatic viewer over the informed viewer (which itself calls to mind Heidegger's distinction between human attention and animal enthralment).[12] It is there too in D. W. Winnicott's distinction between the conditions of creative living and compliance. Arguing that 'cultural experience begins with creative living first manifested in play', Winnicott saw creative living not as an optional enrichment of ordinary life (and certainly not as the exclusive preserve of artists) but

as a common inheritance whose absence represented 'a sick basis for life'.[13]

In a more specifically philosophical context, it is found in Richard Rorty's distinction between the postmodern ironist-theorist and the more firmly grounded metaphysician.[14] It is also central to Luce Irigaray's distinction between two versions of the philosopher: the familiar (expert) image of 'a learned person who is well dressed, has good manners, knows everything, and pedantically instructs us in the corpus of things already coded', and the alternative image of 'someone poor, dirty, rather down-and-out . . . but very curious, skilled in ruses and tricks of all kinds'[15] – the kind of philosopher who might take a screw out with a knife.

Various conceptions of the animal also find their place in the articulation of this dualism. Flaubert, as Julian Barnes has noted, claimed that he attracted 'mad people and animals', and identified with the bear in order to distance himself from the received ideas of the bourgeois. 'The figurative sense of *ours*', Barnes writes, 'is much the same as in English: a rough, wild fellow.' More explicitly, the animal characters in Jeff Noon's novel *Automated Alice* include the rule-bound 'Civil Serpents' whose authority is undermined by anomalous creatures known as 'wurms', an acronym for Wisdom-Undoing-Randomized-Mechanisms.[16]

Despite an evident postmodern enthusiasm for this basic dualism (in which, typically, the *animal* as well as the artist is 'in the position of a philosopher'), it has an obvious short-coming. This is not so much that it is simply too convenient – though it certainly is – but rather that it moralizes. The pre-scriptiveness of moralizing is uncomfortably close to expert-thinking; Phillips characterizes it as 'a kind of pre-emptive morality born of fear', which prejudges 'in order not to have to think too much'.[17] A less obvious and less moralistic ren-dering of what remains useful in the dualism, however, may be found in the kind of postmodern artworks which explore the relation of the human and the animal as a confrontation between the clashing perspectives of the expert and the philosopher (or which, to be more precise, are open to being read in this way). Here, as elsewhere, the value of the art lies in the manner of its *cutting across* the philosophical distinc-tion, using it and testing it without ever quite conforming to it. Four such confrontations will now be briefly considered.

10 William Wegman,
Video still from
Spelling Lesson, 1974.

In a short 1974 video performance called *Spelling Lesson*
(illus. 10), William Wegman and his Weimaraner, Man Ray, sit
at a table. The artist is supposedly correcting mistakes in a
written spelling test the dog has just completed. The dog
looks at him throughout – wondering, it might be supposed,
why he should want to persist with this charade and make
himself look so ridiculous. Wegman is more adept than most
at quietly taking the mickey out of anthropomorphism. He
clearly plays the expert here, the pedantic instructor ('Well
okay, I forgive you, but remember it next time', he says at the
end).[18] But of course it is he who has created the opportunity
for the dog to look philosophical, and himself to look so
stupid.

Again using a living animal, and at around the same time
as the Wegman video, Joseph Beuys acted out a week-long
performance at the René Block Gallery in New York entitled
Coyote: I Like America and America Likes Me (illus. 11). The
spectacle presented to viewers, through chainlink fencing
separating them from the main space of the gallery, took the
form of the artist's and the animal's continuing interaction

43

with each other as the week progressed. A quarter of a century later, the power of the piece has little to do with the validity or otherwise of Beuys's political analysis (he saw the interaction as a means of addressing the 'unworked-out trauma' of modern America's relation to the American Indian). It is the materialization of that analysis, the week-long confrontation itself, which continues to fascinate – a confrontation of human and animal through which, Beuys suggested, 'the roles were exchanged immediately'.[19]

Jeff Koons has said the following of the stylistically very different confrontation he presents in *Bear and Policeman* (illus. 28), a 1988 polychromed wood sculpture:

> If we look here at the policeman, and we see the night-stick . . . a little symbol of authority, and we look at the bear kind of sexually toying with its whistle there, I mean, he's going to just sexually toy with this policeman. Maybe he's going to blow the whistle. This policeman's impotent, authority's impotent here, and banality and the power of art is shown to be something that can be of political value.[20]

The ambiguity over how to distribute the roles of expert and

philosopher in a piece like this stems both from the preposterousness of the oversized toy animal and from the difficulty of judging the relation of irony and straightfacedness in the artist's comment on the piece.

The last of the four examples is Paula Rego's 1987 painting *Snare* (illus. 12). Continuing the theme of the previous year's *Girl and Dog* series, it presents a meeting of human and animal where it is hard to establish what is happening. The images have typically been read as in some sense menacing, the dogs being only 'temporarily ensnared by domesticity', and the relation of girl and dog seeming to signal an unspecifiable 're-drawing of boundaries within conditions of intimacy'. The roles of philosopher and expert are bound together in a complex 'equivocation between self-determination and dependence'.[21]

This is perhaps even clearer in Rego's 1994 *Dog Woman* series where, either singly or in pairs, the humans have internalized or incorporated something of the animal (illus. 29). For Rego this is not to be read (as some commentators seem to have taken it) as a meditation on the humiliation of the

12 Paula Rego, *Snare*, 1987, acrylic on paper/canvas.

woman, but rather as something far more positive: 'Animals are noble creatures. If women achieve the status of animals they are lucky. To be an animal is an assertion of animality, vigour and vitality.'[22] Adopting the pose of the original *Dog Woman* sketch herself – 'squatting down and snarling' – while working it up into the finished pastel drawing, she suggests that 'the physicality of the picture came from my turning myself into an animal in this way'.[23]

In the confrontations described here, the artists do not try to turn the animals into versions of their own secure human selves, even when an element of anthropomorphism is deliberately engaged. The outcome of the confrontation is left open. In the case of Wegman and Koons, artist and animal teasingly conspire to render human authority ridiculous. Rego's girls and dogs play out a fantasy of control. In *Coyote*, Beuys and the animal act out the limits of the artist's control of the situation, with the coyote figuring for Beuys as 'an important cooperator in the production of freedom'. It seems that each of these artists works with animals at least partly in order to get beyond the pettiness of human authority and closer to something, as Beuys put it, 'that the human being cannot understand'.[24]

These examples have concerned confrontations staged (externally or internally) between the human and the animal. As Lyotard would acknowledge, however, such confrontations attest to a wider incomprehensibility, and to what might be creatively learned or unlearned in the adoption of the 'systematically mad' (because wholly incomprehensible) perspective of *any* being outside the experience of a particular expert self: 'for the bird, the rat that dwells on the plain must also be systematically mad, a landscape-artist, an other alienated, an other estranged'.[25]

ESTRANGEMENT

Lyotard's proposal that the postmodern artist 'is in the position of a philosopher' – free of pre-established rules but not of the responsibilities which that freedom entails – is driven by his pessimistic reading of the times:

> This is a period of slackening . . . From every direction we are being urged to put an end to experimentation, in the

arts and elsewhere . . . What is advised . . . is to offer works which, first, are relative to subjects which exist in the eyes of the public they address, and second, works so made ('well made') that the public will recognize what they are about . . . will be able to give or refuse its approval knowingly, and if possible, even to derive from such work a certain amount of comfort.

This culture of complacency invites the definition of the postmodern as its contrary, its refusal: 'The postmodern would be . . . that which denies itself the solace of good forms.'[26]

Albrecht Wellmer suggests that 'it is in Lyotard's philosophy that the "questing movement" of postmodern thinking has found its most pregnant utterance to date'. This particular conception of postmodernism has much in common with what Wellmer calls 'the rational, subversive and experimental spirit' of modernism, including that of 'modern art'. In fact, he proposes, 'postmodernism at its best might be seen as a self-critical – a sceptical, ironic, but nevertheless unrelenting – form of modernism'.[27] Lyotard would probably find little with which to disagree in this. Both writers appear to echo the priorities for any philosophical reflection on art which were outlined by Theodor Adorno: that it should start not from established or accepted views, but rather from the challenges thrown up by contemporary art practice.[28]

Lyotard's attack on 'slackening' is therefore probably best regarded less as the specific critique of a particular historical moment, and more as an indication of what – in his own rather prescriptive terms – any responsible contemporary artist's priorities should be. It is a matter of articulating a disposition which consistently values the unknown over the known, the difficult over the easy, the inventive over the rule-bound, and creative living over compliance. This, of course, is hardly a very distinctive claim in the context of twentieth- and twenty-first-century art; in Wellmer's words, 'anyone who takes art *seriously*' is more or less obliged to adopt some such stance.[29]

The stance is one which does, however, invite a particular style of engagement with the animal. Lyotard's memorable image of the systematically mad animal as a kind of artist, and as 'an other estranged', finds unexpected correspondences in

13 Jana Sterbak,
From *Absorption:
Work in Progress*,
1995, colour print
and text, each
mounted on
aluminium.

In 1970, nine years before my first
wearable pieces, Joseph Beuys created the
first of his felt suits. I became aware of this
in 1986 and its existence has bothered me
ever since... At the beginning of the nineties
I conceived of a solution: the absorption of
the suit.

To this end I have metamorphosed myself
into a moth, and proceeded systematically to
eat, one after another, the 100 suits Beuys
sold to private and public collections around
the world. In some cases my activity was
temporarily disrupted by misguided
conservation efforts...

Nevertheless, it would not be immodest
or inaccurate to state that I have already put
more than one suit out of its exhibition
condition. My work is not easy, but it's not
without reward, and, what is most important,
it continues.

an essay by Carlo Ginzburg which develops the Russian formalist critic Viktor Shklovsky's notion of *estrangement* as the central purpose of radical art. Writing in the 1920s, Shklovsky argued for art 'to return sensation to our limbs' and 'to lead us to a feeling of things'. One of art's principal means of achieving this goal was by '"estranging" things'.[30]

Many of Shklovsky's and Ginzburg's (primarily literary) examples involve the confrontation or confusion of human and animal perspectives, in order to undermine human complacency and certainty. Estrangement forces the reader into 'a cognitive effort' in order to deal with 'a series of obstacles' to understanding. It is 'a delegitimizing device' employed specifically 'against preconceived formulas, against frozen habits, against "knowing"', because 'knowledge means imposing a blueprint on reality instead of learning from it'. At 'the very core of the notion of estrangement', writes Ginzburg, is the sense that to 'understand less, to be naive, to be surprised – these can lead one to see more, to see something deeper, something closer to nature'.[31]

If the adoption of an animal perspective can itself aid the artist in working against the worst effects of an 'expert' conception of knowledge, the importance of the animal to artists of a postmodern disposition is far from surprising. It figures not only in the limits of their understanding of what they are doing (as in Mark Dion's question to himself: 'My mania for birds, for example – what is that about?'),[32] but also in how they frame their own identities.

These identifications often draw art and the animal together. Beuys's rhetorical assertion – prompted by his use of the animal in works such as the 1965 performance *How to Explain Pictures to a Dead Hare* – that 'I am not a human being, I am a hare' differs more in tone than in substance from Franz Marc's comment about himself and his wife in 1913: 'We are fine, painting, eating, or sleeping all day long, the pure beasts.'[33] These willing identifications with the animal spill over into representations of the artists themselves, from Jana Sterbak's *Absorption* (illus. 13), of which she writes 'I have metamorphosed myself into a moth' – a moth which imaginatively feeds off Beuys's art, as it happens[34] – to Cindy Sherman's more enigmatic photograph of herself with a pig's snout (illus. 14).

The present chapter's focus has so far mainly been with how the artist, through the mediation of the animal, renders

14 Cindy Sherman,
Untitled # 140, 1985,
colour photograph.

himself or herself 'an other estranged'. In the case of the post-
modern animal, however, both the art itself and the situation
in which it is encountered have their own rather different and
less obviously romanticized parts to play in rendering human
experience strange.

ENCOUNTERING THE POSTMODERN ANIMAL

The postmodern animal is a product of postmodern human
thought, and exists only in the forms in which it is either made
or encountered. The forms of its making vary considerably,
and may or may not incorporate living animals: they are
arguably being 'made' in the factory farm and in the scien-
tist's laboratory just as much as in the poststructuralist
philosopher's text or the postmodern artist's studio. But in
considering the animal's relation to creativity, and thus (how-
ever warily) moving towards the question of a postmodern
animal 'aesthetic', the nature of the human's encounter with
the animal is a matter of some importance.

As in the examples already presented in this chapter, that
encounter will be treated here as a kind of confrontation. The
decision to view it in that light has specific consequences,
however, when it is staged not within the work (as in those
examples) but between the work and the person who encoun-
ters it. Because the postmodern animal is most productively
thought of as an embodied thing (in disembodied forms it is
inevitably somewhat remote from the embodiedness of ani-
mals themselves), the confrontation will be most direct when
the encountering human and the encountered postmodern
animal share the same space.

This not only gives the visual arts something of an edge over the textual representations of literature or philosophy, but more specifically gives three-dimensional, 'sculptural' forms the edge over work in two dimensions. This admittedly sounds highly prescriptive: it suggests, for example, that the characteristic form of the postmodern animal will more readily be found in sculpture, installations and performance than, for example, in painting, photography, video or film. Taken too literally, it is of course a preposterous proposal. There can be no sound case for ruling that the animals (or the ideas that inform them) in Mark Dion's installations are 'more' postmodern than those in Olly and Suzi's paintings or Peter Greenaway's films, nor of course that the latter are 'more' postmodern than those in Deleuze and Guattari's philosophy or in the writings of Hélène Cixous.

Nevertheless, the question of the 'space' (literal or metaphoric) of the encounter, the confrontation, is an insistent one, and one which is perhaps *most readily illustrated* in relation to three-dimensional work. Take, for example, the case of Robert Rauschenberg's *Monogram* (illus. 30) which, in its third and final state, dates from 1959. For reasons which will become clearer as the argument of the present chapter develops, *Monogram* may well be art's first convincing presentation of the postmodern animal. The piece incorporates a stuffed Angora goat which Rauschenberg had bought in an office-supply store in New York. Worked on from 1955 onwards, when much of his output consisted of 'combine paintings', the goat – its head daubed in paint – was initially placed on a shelf placed halfway up one of these paintings. By 1959 the piece had become floor-based, and the goat's body was girdled with a tyre and stood on what Rauschenberg called a painted and collaged 'pasture'.[35]

In its final form in particular, the piece exemplifies what Diane Hill has usefully termed the 'mutual trespass' which much of his work at that time involved or invited.[36] Most earlier modernist art (and certainly most earlier animal imagery), no matter how radical its form or content, had tended to keep the observer at a certain conceptual (if not literal) distance. Gallery walls reduced the materiality of painting to a largely visual or intellectual experience; conventional bases did something similar for sculpture. But in a work like *Monogram* – as, increasingly, in other art of the 1950s and 1960s – the art and

the observer trespassed into each other's space. The result was a compellingly direct confrontation.

In works such as this, the subject matter does seem to make a difference. The postmodern animal is an awkward thing: its art and its animality do not sit easily together. It is this tension which prompts the following offbeat reading of an unlikely art-historical text: the American critic Michael Fried's influential 1967 essay 'Art and Objecthood'. Contrary to his intentions, which were to address issues relating wholly to non-representational art, it will be read here for the help it might offer in reaching an understanding of the aesthetic operation of postmodern animal imagery.

Fried's concern was to explain why, in his view, the large-scale 'modernist' abstract paintings made by Stella, Noland and Olitski in the 1960s were more compelling than the contemporary minimalist sculptures of Robert Morris or Donald Judd. It may be, however, that what Fried criticizes in minimalist sculpture can serve in the present re-reading more *positively* to characterize three-dimensional representations of the postmodern animal. This may sound less perverse if it is understood that Fried's concern is not so much with the look of individual works as with the nature of the beholder's encounter with those works, and with the space or 'situation' of that encounter.

Fried prefers to call minimal art *'literalist* art' in order to support his intuitive distinction between art and objecthood. He acknowledges that what he calls objecthood corresponds to what Clement Greenberg, quoted in Fried, had termed 'the condition of non-art', and he is clearly sympathetic to Greenberg's view that in the 1960s 'the borderline between art and non-art had to be sought in the three-dimensional, where sculpture was, and where everything material that was not art also was'. Painting, good or bad, is clearly art; three-dimensional work is much less clearly or dependably so. Fried's formalist stance can also be read as an argument for specialization, for expertise: in the essay's only direct reference to Rauschenberg, the mixing of forms and materials in his work is taken to epitomize the circumstances in which *'art degenerates'*.[37]

For Fried, however, at the heart of 'literalist sensibility' was a concern with 'the actual circumstances in which the beholder encounters literalist work'. He writes: 'Morris makes this explicit. Whereas in previous art "what is to be had

from the work is located strictly within [it]", the experience of literalist art is of an object *in a situation* – one that, virtually by definition, *includes the beholder.*' (As with Hill's notion of mutual trespass in relation to Rauschenberg, this is therefore another case of object and beholder being in the same space, the same 'situation'.) Fried has no doubt that this involves a confrontation: 'the things that are literalist works of art must somehow *confront* the beholder – they must, one might almost say, be placed not just in his space but in his *way*'.[38]

This remarkable observation cannot pass without comment. Whether the thing imagined to be 'in the way' of the beholder is one of Morris's precise geometric fibreglass constructions of the mid-1960s or is a piece more like *Monogram*, the art object is here described in terms of an obstacle. The obstacle's role (a philosophical role if ever there was one) is not to be something it itself, but to do something to the beholder. It 'is *incomplete* without him', writes Fried; and 'once he is in the room the work refuses, obstinately, to let him alone – which is to say, it refuses to stop confronting him'. Unlike the self-contained modernist work, secure and confident in its status as art, this kind of object – despite its insistent physical presence as an object – is 'less self-important' (the phrase is Morris's). Furthermore, the 'situation' it creates is one which appears to incorporate 'the beholder's *body*'.[39]

With one eye once again on *Monogram*, obstinately occupying the centre of the gallery floor in all its gloriously dumb thingness, it is time to summarize what might usefully be taken from this highly selective reading of Fried on minimalism and reapplied to three-dimensional representations of the postmodern animal.

The literalism of the thing matters: its presence, its objecthood. It is in the same space as its viewer; it confronts that viewer as an obstacle. More than this, it *goads* the viewer (the image of a goad, a pointed rod used to urge on an animal, seems entirely appropriate for this thing, especially as it puts the viewer in the position of the animal). And it is an embodied thing, whose space includes and incorporates the viewer's body. Unable quite to contain itself, it creates something (a physical space, a situation) which comprises and binds the bodies of the viewer and of the thing itself to form a new, awkward, and explicitly non-modernist whole; only the viewer's presence completes the work.

This, then, gives some idea of how the postmodern animal might be encountered. But beyond *Monogram* – part goat, part goad – what might other examples of this rough beast actually *look like*?

BOTCHED TAXIDERMY

In exploring the possibility of an 'aesthetic' appropriate to the postmodern animal, in terms of the appearance of that animal, a picture book published in 1998 helps to clarify matters. Called *Zoo: Animals in Art*, and compiled by Edward Lucie-Smith, it describes itself as 'a gorgeous menagerie of animals in art'.[40] It offers a particular conception of the animal as a creature which is comforting, exotic or amusing, but always visually attractive. Although it includes a good deal of contemporary art (Judy Chicago's portraits of her pet cats, for example) it is a very long way indeed from the conception of the 'postmodern animal' which the present book is seeking to outline.

Why? Because the *look* of the postmodern animal – no surprises here – seems more likely to be that of a fractured, awkward, 'wrong' or wronged thing, which it is hard not to read as a means of addressing what it is to be human now. Wendy Wheeler contends that in the experience of most people in the West, 'the word which most adequately describes the period from the 1960s to the 1990s is "fragmentation"'.[41] It is an experience that calls for new vocabularies, and in the more imaginative art of the period since World War II, the post-modern animal appears as an image of difference, an image of thinking difficultly and differently. But like a Deleuzian becoming, this difference is not a solution, an escape. (The animal in Rauschenberg's *Monogram* is not – to borrow Jeff Noon's neologism – an escape-goat.) In contrast, Lucie-Smith's vision of the animal, valid though it is, certainly is escapist. For the most part his contemporary examples are not recognizably contemporary. They don't therefore register, figure, or cut into an ongoing discourse about either the animal or the human. They are untroubling, unthinking, unengaged. They are not 'obstacles'.

Verbal accounts of the kinds of compromised beings which are perhaps closer to a conception of the postmodern animal might include the figure of Erasmus, the unclassifiable ape-

like creature in Peter Høeg's 1996 novel *The Woman and the Ape*. Variously described as 'a non-existent creature ... a hoax', 'horrifyingly close to . . . ourselves', and as 'not what went before' the human but rather 'what comes afterwards', Erasmus serves as a permanent reminder 'that there was something – something or other – very wrong with life today'.[42] Or they might include an observation in Donna Haraway's 'cyborg manifesto': comparing the postmodern human to the salamander, for which regeneration after an injury such as the loss of a limb can take the form of 'potent' but 'odd topographical productions', she proposes of humans too that 'We have all been injured, profoundly.'[43]

The severe disadvantage of such examples is that they introduce a sense of human self-pity (whereas the Nietzschean thrust of much postmodern thought suggests that self-pity should have no place in it). Visual manifestations of these compromised beings manage to convey an idea of fractured-ness and repair in a more matter-of-fact manner. The term 'botched taxidermy' might be suggested – though it should

15 Paul McCarthy, *Cultural Gothic*, 1992–3, metal, wood, pneumatic cylinder, compressor, pro-grammed controller, burlap with foam, acrylic and dirt, fibreglass, clothing, wigs.

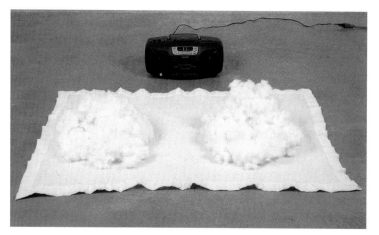

16 Mike Kelley, *Dialogue #1 (An Excerpt from 'Theory, Garbage, Stuffed Animals, Christ' German Version)*, 1991/6, blanket, stuffed animals, CD player, CD.

not always be taken literally – to characterize those instances of recent art practice where things again appear to have *gone wrong* with the animal, as it were, but where it still *holds together*.

Here are some examples, loosely grouped thematically.

Mixed materials: *Monogram*, in its final 1959 version, mixes the results of taxidermic, industrial and painterly processes to present a new baffling whole: a paint-daubed goat, ringed with a tyre, on a raft of post-cubist collage. Paul McCarthy's *Cultural Gothic* (illus. 15), which itself nods knowingly in the direction of *Monogram*, has its own deliberately disruptive formal incoherence. It is a tableau in which, it has been noted, 'each figure embraces a different order of verisimilitude: the father's face is a latex life-cast, while the boy's head comes from a modified department store mannequin and the goat is an actual taxidermied animal'.[44]

'Stuffed' animals not as taxidermy but as toys: Mark Dion's *Taxonomy on Non-Endangered Species* (illus. 2), from 1990, superimposes the received wisdom of Disney's world vision on the old certainties of zoological classification, the toys serving concisely to indict the easy relativism of contemporary claims to truth. The following year Mike Kelley stages a philosophical dialogue between two toy animals, a teddy and a bunny (looking more like undifferentiated furry blobs in the later version illustrated here [illus. 16]), which includes their speculations on their own status. One of them observes: 'Home-made stuffed animals are especially perverse. They are ugly in their specificity. Their individuality is frightening,

an aberration. They cannot become an ideal form.'[45] And in a mockery of ideal form, Jeff Koons's 1986 *Rabbit* (illus. 17) is an inflatable toy with lopsided ears, defiant in modernist chrome. As Robert Hughes puts it, 'It's perverse as to material.'[46]

Three other uses of 'wrong' materials: The body of the mad scientist in John Isaacs's *Say It Isn't So* (1994) is a tailor's dummy with hands naturalistically remodelled in wax (illus. 18). Its head, reminiscent of some kind of farmyard animal, is in fact the wax cast of a frozen chicken. At the centre of Mark Dion's 1995 installation *Ursus maritimus* (illus. 19) is a polar bear stranded in a shallow pool of tar, alongside a broken cup and saucer, on top of a wooden packing crate. The taxidermic bear, for reasons that are less than obvious, has been covered in goat fur. And Hubert Duprat contrives, in the laboratory environment of the gallery, to get living caddis fly larvae to fabricate for themselves new cases from fragments of gold, pearls, opals and turquoise (illus. 31) to replace their natural riverbed cases of bits of gravel and vegetable matter, of which the artist had earlier divested them.[47]

Hybrid forms: Thomas Grünfeld's *Misfit* series (illus. 20) presents accomplished but unlikely taxidermic creations which perhaps pursue something of Charles Waterton's experiments, around 170 years earlier, in taxidermic hybridity.[48] William Wegman's presentation of his dog Man Ray crossing

17 Jeff Koons, *Rabbit*, 1986, stainless steel.

18 John Isaacs, *Say It Isn't So*, 1994, mixed media.

the species barrier (illus. 32) is more transparent, deliberately clumsy, and all the funnier for it.

Messy confrontations: draped in a length of felt and pacing around a space strewn with straw, more felt, ripped copies of the Wall Street Journal and a variety of other stuff (illus. 11), in 1974 Joseph Beuys plays out a week-long mainly improvised encounter with a living, and presumably bemused, coyote.

Taxidermic form reworked: In the late 1980s Bruce Nauman came across a taxidermy shop in New Mexico selling the ghostly polyurethane foam 'forms' over which animal skins are glued and stitched. These disconcerting (but

19 Mark Dion,
Ursus maritimus,
1995, foam body,
fibreglass, glass eye,
clay, goat skin,
wooden base
(pine and MDF).

anatomically precise) objects were incorporated directly into his sculptures, sometimes in dismembered and improbably reassembled form. Some were suspended in mid-air (illus. 21); others dragged across the floor in what has been called 'a more visceral allusion to a slaughterhouse'.[49] Equally uncanny,

20 Thomas
Grünfeld, *Misfit
(St Bernhard)*, 1994,
taxidermy.

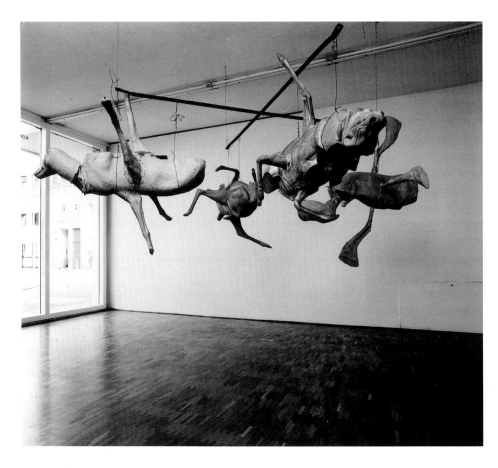

in appearing to represent the taxidermic treatment of the almost human, is Dorothy Cross's 1992 *Amazon* (illus. 21), a tailor's dummy covered in cow hide. This dense and compact image will hardly hold together at all conceptually unless its conflicting elements of human and animal identity can be overlooked.

Finally, tattiness: Some of Damien Hirst's creatures preserved in formaldehyde, notably the famous tiger shark in *The Physical Impossibility of Death in the Mind of Someone Living* (illus. 23), have come to look unexpectedly tatty. Imposing as an idea; tatty as an object. And yet despite Hirst's cryptic remark about what might have been a more perfect form for the piece – 'The huge volume of liquid is enough. You don't really need the shark at all'[50] – he *did* decide to include the shark, imperfect or not.

Fiona Russell has speculated that the experience prompted

21 Bruce Nauman, *Untitled (Two Wolves, Two Deer)*, 1989, foam, steel, paint.

by these tatty and sometimes smelly pieces is one of shame, whether that shame is attributed to the displayed animal or to the viewing human. Such works, by Hirst, Dion and others, undermine any lingering sense of the viewer's omnipotence and point instead to their powerlessness.[51] One problem with such a view, especially if the emotionally loaded term 'shame' is adhered to, is that it seems to introduce an element of *ethical* judgement into the elaboration of this postmodern animal aesthetic. There may be advantages in resisting such a move, with its temptation neatly to divide (on the basis of existing categories, existing knowledge) the ethically sound and unsound, the politically correct and incorrect.

One distinctive feature of what are being called here works of botched taxidermy is that taken collectively, at least, they problematize such categories. Some of the animals they incorporate are living, others are not; it doesn't seem to be a crucial distinction. An artist such as Hirst tends to distance himself from animal rights criticisms of his work, while others of these artists are more directly engaged with the role, or the fate, of the animal in the contemporary world. But across these works, regardless of any ethical stance, *materials count*, materials create knowledge, or at least encourage open and imaginative thought.

22 Dorothy Cross, *Amazon*, 1992, cow skin, dressmaker's dummy.

They do so not by banally symbolizing things already known. Kitty Hauser's suggestion, in an article highly critical of taxidermy called 'Coming apart at the seams', that in the context of contemporary art or photography 'stuffed animals – especially badly stuffed ones – can signify . . . other kinds of contemporary ruination' by offering, for example, 'a dark view of an irrevocably damaged nature',[52] is interesting but seems unnecessarily prescriptive. As Rauschenberg insisted of *Monogram*, in the light of certain reductivist interpretations of that piece: 'A stuffed goat is special in the way that a stuffed goat is special.'[53] If tattiness, imperfection and botched form count for anything, it is that they render the animal *abrasively visible*, and that they do so regardless of how the artist thinks about animals.

This is why Picasso's rough-and-ready *Bull's Head* (illus. 24), though it has little to do with thinking about animals or animal form, is a more convincing precursor for the post-war 'postmodern animal' than any of Brancusi's perfectly worked pieces, for example, despite Brancusi's prolonged and serious

23 Damien Hirst, *The Physical Impossibility of Death in the Mind of Someone Living*, 1991, tiger shark, glass, steel, 5 per cent formaldehyde solution.

engagement with animal form. The idea of the method, the botching, is already there in Picasso's comment on collage: 'We sought to express reality with materials we did not know how to handle, and which we prized precisely because ... they were neither the best nor the most adequate.'[54]

The question of terminology does seem important here. The verb which Deleuze and Guattari use to indicate the dangers of an insufficiently cautious construction of the imaginatively rethought body, which they famously term the 'body without organs', is *rater*: to go wrong, backfire, mess up, spoil, botch or bungle. The translation of *A Thousand Plateaus* gives it as 'to botch': 'you can botch it' (*vous pouvez le rater*).[55] The sense which Deleuze and Guattari seem to want to convey through this term is of something that has gone terribly, totally, disastrously wrong. Psychoanalysis botches the body without organs by insisting on interpreting, Oedipalizing and controlling it, but so too, in their different ways, do the extremes of masochism and drug abuse: these are their key examples of botching, where the body is reworked in a manner drained of creativity or true experimentation.

Botching (and, perhaps to an even greater extent, the related term 'bodging') by no means always has this sense of completely wrecking something. As dictionary definitions suggest, it can also mean sticking or cobbling something

24 Pablo Picasso, *Bull's Head*, 1942, leather and metal.

together in a makeshift way, an 'ill-finished' or clumsy or unskil-ful way, with no attempt at perfection but equally with no implication of the thing falling apart. As Lawrence Alloway noted of *Monogram*'s goat – a defining example of things appearing to have *gone wrong* with an animal which neverthe-less still *holds together* – it is clear that for all the permutations Rauschenberg put the sculpture through over a five-year period, he was concerned throughout 'to present the goat in a form that keeps its integrity as a whole object'.[56]

Relevant here too is the notion of assemblage. Allan Kaprow's 1960s survey of new developments in contempo-rary art (which of course included *Monogram*) noted the char-acteristically open display of '"faulty" technique' in the practice he termed assemblage.[57] Deleuze and Guattari, who also draw on the idea of assemblages, describe them in terms of provisional and informal comings-together, and specifi-cally distinguish these active 'assemblages of desire' from rigid or proprietorial 'organizations such as the institution of the family and the State apparatus'.[58]

Botching is a creative procedure precisely because of its provisional, playful, loosely experimental operation. This point is made forcefully by Phillips in his debunking of the arrogance of professional expertise. Praising 'the fluency of disorder, the inspirations of error', he argues: 'We need a new pantheon of bunglers.'[59]

In this creative encounter, this botching, the animal seems to play its own distinctive part. One of the alternative French verbs for to botch, or to bungle, is *cochonner*, a word which brings to mind another English expression for botching something: making a pig's ear of it. This train of thought might also offer a loose but convenient link between botchery and butchery.

In Jeff Noon's *Automated Alice*, that link is made explicit. The artist whom Alice encounters on the outskirts of Manchester is called Pablo Ogden, whose sculptural materials include 'bits of old sideboards and pencil-cases and various pieces of string and wire and shoelaces'. The sign outside the dilapi-dated garden shed that serves as his studio reads 'Ogden's Reverse Butchery', and typical of his work is a 'lumbering sculpture' which 'looked like a pile of rubbish assembled into the vaguest resemblance of a man'. He explains to Alice: 'I used to be a real butcher . . . but I became tired of simply

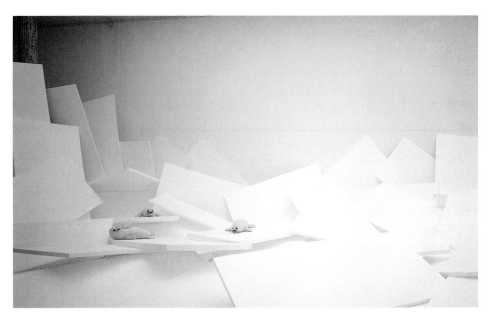

25 General Idea, *Fin de Siècle*, 1990, expanded polystyrene, three stuffed harp seal pups (acrylic fake fur, straw); view of installation at the Württemergischer Kunstverein.

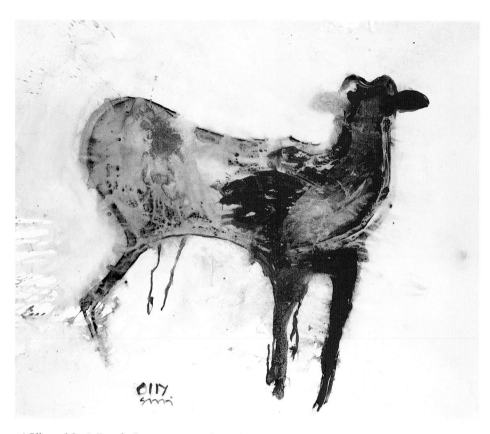

26 Olly and Suzi, *Deer for Beuys*, 1998, acrylic and ink on paper.

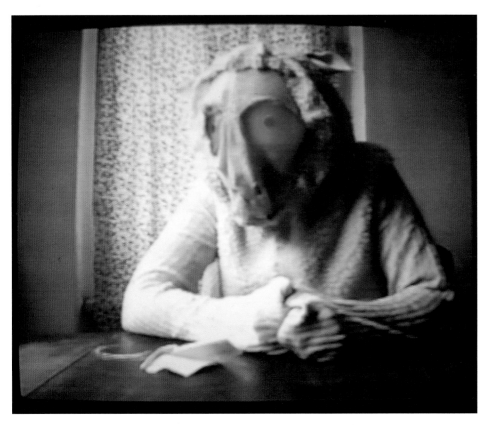

27 Edwina Ashton, Video still from *Sheep*, 1997.

28 Jeff Koons, *Bear and Policeman*, 1988, polychromed wood.

29 Paula Rego, *Dog Woman*, 1994, pastel on canvas.

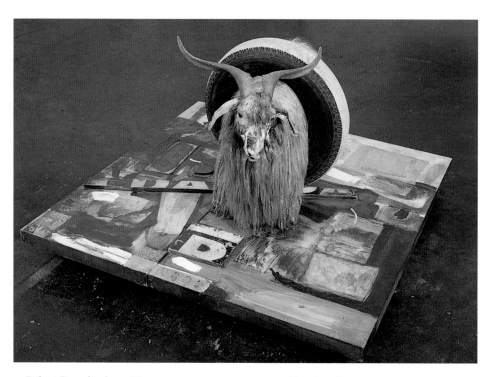

30 Robert Rauschenberg, *Monogram*, 1955–9, angora goat with painted nose and ears, painted tyre, painted hinged wood, tennis ball, collage and newspaper.

31 Hubert Duprat, *Caddis Fly Larvae with Cases*, 1980–99, caddis fly larvæ with cases made from gold, pearls and precious stones.

32 William Wegman, *Frog/Frog II*, 1982, polaroid photograph.

cutting up creatures so I became a reverse butcher instead . . . an artisan of the flesh who reconstructs creatures out of their butchered parts.' Calling the style of his current practice *skewedism*, he recites a long list of his previous styles including *gluedism*, 'where all the parts are glued together', *zoodism*, 'because by then I was making creatures out of creatures', and *cluedism*, 'where I had only the faintest clue as to what I was doing'.[60]

In the negotiation of such conflicting techniques in the real world, the case of Emily Mayer is a particularly interesting one. Operating both as a professional taxidermist and as a sculptor, and undertaking taxidermic commissions for Damien Hirst, among others (she made the apparently rotting cow's head in his *A Thousand Years*, for example), she does not see the two branches of her work as particularly compatible. The precision of taxidermic practice is for her not easily reconciled with the free arrangement of materials which her sculpture incorporates, even if the anatomical knowledge required by the one technique does seem to inform the other.[61]

Her 1995 sculpture *Corvus corium* (illus. 42), an unlikely addition to the *Corvidæ* (rooks, jackdaws, crows and ravens – the raven's Latin name is *Corvus corax*), is cobbled together from various found objects and materials: leather, steel, wood and rubber. In line with its punning title (*corium* means hide, skin or leather), the most prominent constituent part of the bird's head is an old leather boot. The botching is quite deliberate. In a statement closely echoing Picasso's comment on collage, she writes: 'Using materials that do not conform to every whim – indeed often seem to have a life of their own – has broadened my imaginative scope . . .' What the use of scrap materials opened for her was 'a way of working that was an exploration', a form of almost necessarily 'not knowing' how the work would develop.[62]

Taking the botched taxidermy pieces discussed here as a whole, they might be said neither to be like what viewers *do* know nor to be like what they *do not* know about animals. To borrow a term from Derrida (a term he in fact applied to humans), these pieces might be called '*questioning* entities'.[63] In a field with many competing forms of knowledge and expertise – zoological, historical, anthropological, taxidermic and more – these works are perhaps most usefully regarded as improvised knowledges, *inexpert* knowledges of the animal.

Their value may lie precisely in their direct acknowledge-ment of absent or fractured knowledges. As one commentator writes of Mark Dion's polar bear covered in goat fur, in a culture 'whose knowledge about the animal world' comes largely through the mass media, 'it is precisely this "wrong" fur which would induce most viewers into thinking that they are before a "real" stuffed Polar bear'.[64] The botched taxi-dermy pieces might even be seen as the nearest thing to an authentic expression of the state of the public's necessarily fractured, inexpert postmodern knowledge. But this is neither wholly new, nor a cause for particular concern, and it applies to the artist as much as to anyone else. As Dion notes of the varied forms of his own practice, 'it may lead to a kind of dilettantism ... But for me, the dilettante is a much more inter-esting character historically than the expert'.[65]

NEW THINGS: *ANIMOTS* AND THE NON-SPECIFIC HUMAN

Derrida's recent work on the animal, in 'L'Animal que donc je suis', has some parallels with the idea of botched taxidermy. Acknowledging the awkward combination of competing expert knowledges (of the animal, and of writing) in his own inescapably knowledgeable attempts at thinking the other-than-human, he fittingly describes the botched outcomes as exercises in 'zoo-auto-bio-biblio-graphy'. Believing that human conceptions of the animal are stuck in a language which generally does animals few favours, Derrida puns *animaux* into *'animots'*, presenting these language-laden composite creatures as something close to the philosophical equivalent of the botched taxidermy examples. In place of *ecce homo*, behold the man, Derrida proposes *ecce animot*, its ungainly singular form being one where things sound to have gone wrong, but (as in botched taxidermy) just about hold together.[66]

He goes on to examine the component parts of this hetero-geneous 'verbal body', comparing it to that of a chimera (a mythological creature traditionally comprised of a lion's head, a goat's body and a serpent's tail). The fact that Descartes's description of the chimera apparently omits or 'forgets' the serpent's tail seems to cause Derrida particular delight – the thrust of the essay is strongly anti-Cartesian – leading him to call this part of the chimera the evil or artful

genius of the animal.[67] It is tempting to read this as a wilful attempt on Derrida's part to bring the role of this botched animal close to the preferred identity – a fractured, botched, inexpert identity – of contemporary artists and philosophers.

A more general question remains. What kind of thing, what kind of being, is a 'botched taxidermy' animal? Even in the case of works which incorporate living animals (Wegman's dog, the coyote used by Beuys, Beuys himself in that piece, and the caddis fly larvae used by Duprat), a botched taxidermy piece might be defined as referring to the human *and* to the animal, without itself being either human or animal, and without its being a direct representation of either. It is an attempt *to think a new thing*. The same is true of Derrida's *animot*, that awkward living word-thing which can really only be given a negative identification: 'Ni une espèce, ni un genre, ni un individu.'[68] Both botched taxidermy and the *animot* preposterously occupy a space which will not readily distinguish art and the animal. Neither species, nor genus, nor individual, each one is open both to endless interpretation and, more compellingly still, to the refusal of interpretation.

They are perhaps things with which to think, rather than themselves being things to be thought about. Being so difficult to fix, they are not readily available to the categories and classifications of expert-thinking. For some of the artists dealing in botched taxidermy, this is in any case close to their intentions. John Isaacs – much of whose work addresses the impact of science on society at large – emphasizes the importance of 'the confrontational aspect' of his work.

The whole point of the life-sized figure in *Say It Isn't So* (illus. 18), for example, is to 'force the viewer from their intelligence', to take them unawares. Not wanting to be judged a 'sculptor', his interest is in using his 'Madame-Tussaud's-like presentation' to prompt a moment of perplexity and non-recognition, of genuine thinking. Scientists seeing his work sometimes 'just scoff with laughter', unable to figure out what sort of thing or being it is supposed to be: 'Hopefully that uncertainty allows the work into their consciousness. If people look at a premeditated thing, and it's clearly "painting", or "sculpture", then they're already kind of *cataloguing* and referencing it to other things.'[69] In 'Art and objecthood', Fried makes a similar point about the viewer's first encounter with 'literalist' works. If they are come upon unexpectedly, for

example in a darkened gallery space, they can be as uncannily anthropomorphic as 'the silent presence of another *person*'.[70]

The idea that the botched taxidermy pieces could collectively be regarded as '*questioning* entities' (as Derrida called humans) also finds some support in Isaacs's view that much of his work 'comes from trying to fit together different information sources – art, science, whatever – and allowing them to cohabit, coexist, to form more of a question than an answer'. On the relation of his animal imagery to notions of the human, Isaacs is quite explicit: 'For me the animal plays the role of the non-specific human.' He explains, in relation to *Say It Isn't So*, that because the figure has an anonymous chicken's head 'it's potentially you or I':

> So this is where the animal *works*, for me. It has this ability to *be* the viewer, for the viewer to project into it . . . Identity is something that I don't want for something like this, I don't *want* it to be a man with a moustache, or glasses, or no hair, I want it to be the person who's looking at it. So it has to be without an identity.[71]

It is the figure of the animal – that new botched thing which is somehow still recognizably animal, or at least not wholly and complacently human – which forces both artist and viewer from their intelligence, their expertise, and their defensive self-concern.

THE INCALCULABLE

'Cheers', she said.
 There was a fleeting instant of pleasure in knowing that one could not be understood. Then she met the ape's gaze.
 It was open, incalculable.
PETER HØEG, *The Woman and the Ape*[72]

The main concern of the present chapter has been a cautious exploration of the aesthetics of the postmodern animal, and of its effect on the human. In this concluding section, some problems associated with the idea of a corresponding ethics – already implicit in Lyotard's and Phillips's critiques of expert-thinking – are considered more directly.

A long interview with Derrida was published in 1991 under the title '"Eating well", or the calculation of the subject'.

It is a particularly important statement of his thinking on the question of animals, and on philosophy's responsibilities in relation to that question. It is the animal, he suggests, which more than anything else prompts a rethinking of what it is to be a human 'subject', and which points to the shortcomings of earlier philosophical accounts of the human. Humanist philosophy had constituted the subject – the very centre of its concerns – as what Derrida calls 'a principle of calculability'. Although it stressed an individual subject's responsibility to others, other subjects, for humanism only other humans *counted* as subjects: 'The other . . . is indeed the other man.'[73]

That, for Derrida, is a notion of responsibility which is 'deaf to the injunction of thought', and which neglects its obligation 'to protect the other's otherness'. Responsibility to the non-human can therefore only be thought of as excessive and incalculable: 'I believe there is no responsibility, no ethico-political decision, that must not pass through the proofs of the incalculable or the undecidable. Otherwise everything would be reducible to calculation.' This, he says, is at the very heart of a more creative, open and generous conception of the human subject, the philosopher: 'responsibility is excessive or it is not a responsibility. A limited, measured, calculable, rationally-distributed responsibility is already the becoming-right of morality; it is . . . the dream of every good conscience'.[74]

If there is, as he believes, 'a duty' in deconstruction's reconsideration of the human subject, it is to oppose anything which serves primarily 'to give oneself a good conscience'. Good conscience is rather like expert-thinking: altogether too sure that it has the right answers. It is for this reason, above all, that Derrida insists in the interview that his philosophical purpose is not 'to start a support group for vegetarianism, ecologism, or for the societies for the protection of animals'.[75]

It is over precisely this that he has been taken to task by his friend and fellow philosopher, David Wood. Wood accepts that responsibility entails 'a response or openness to what does not admit of straightforward decision', and he agrees entirely that animals open the human to 'a responsibility that *exceeds* all calculation'. What he rejects is Derrida's view that *acting* on this 'post-humanistic responsibility' – by for example becoming vegetarian – is *too easy* an option, an act of calculation in itself, which can only lead to the complacency of good conscience. Wood comments ironically that Derrida

4 The Unmeaning of Animals

Is it possible to make a poetics of spleen kidney and tongue?
DEBORAH LEVY, *Diary of a Steak*[1]

In 1969 Jannis Kounellis staged an exhibition at the Galleria L'Attico in Rome which consisted of twelve live horses tethered to the walls of the otherwise empty gallery (illus. 33). The piece is illustrated in Germano Celant's book *Art Povera*, published the same year, which collected together examples of work associated with the Arte Povera movement of the late 1960s. Of this art as a whole, Celant wrote: 'What the artist comes in contact with is not re-elaborated; he does not express a judgement on it, he does not seek a moral or social judgement, he does not manipulate it.'[2] The horses exhibition, which gave the clearest expression to Kounellis's move away from pictorial representation at that time, has since been described as 'the emblem of a profound transformation and awareness of the very means of the artistic task'.[3] Even if that overstates the case, the opacity of this simple display certainly raises with singular force the question of how art handles the relation of animals and meaning.

33 Jannis Kounellis, *Horses*, as installed at Galleria L'Attico, Rome, 1969.

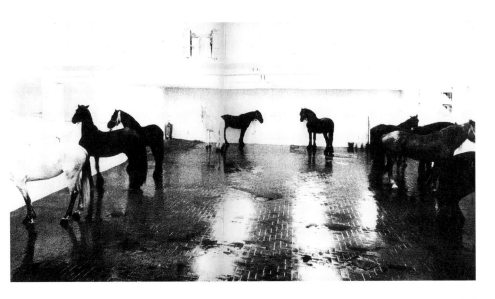

In postmodern imagery, it has been suggested, 'no "literal surface of meaning" exists'.[4] This is not to say that meaning is absent, but that it is a problem, and this problem is one which the animal frequently exacerbates. If little has been written about some of the most extraordinary and compelling postmodern animal imagery – Nauman's suspended taxidermic moulds (illus. 21), for example – it is perhaps because it is by no means clear what can usefully be said about these baffling subjects. The problem is that if anything, they *signify too much*.

Openness of meaning creates its own difficulties, as in cases where critical interpretations conflict with an artist's intentions. Louise Bourgeois's stunning installation called *Spider* (illus. 34) is seen by the artist as carrying a set of maternal associations of a wholly positive kind, drawing on autobiographical references to connote shelter and protection. It is, however, undeniably open to being read entirely differently. One critic has suggested that only an arachnophobe could have made such a piece, 'and then only as part of some private exorcism'.[5]

A more dramatic critical over-riding of the artist's intentions is seen in Robert Hughes's readings of Rauschenberg's *Monogram* (illus. 30). In *The Shock of the New* Hughes read the goat as a metaphor of 'priapic energy', its penetration of the tyre constituting 'one of the few great icons of male homosexual love in modern culture'. Rauschenberg is said to have 'totally dismissed this interpretation', stressing instead the object's literalism: 'A stuffed goat is special in the way that a stuffed goat is special.' Despite this, in the late 1990s Hughes continued more explicitly than ever to read it 'as a sexual fetish', 'an image of anal sex, the satyr in the sphincter'.[6] It is a classic example both of how specific interpretations frequently impoverish the experience of works of art, and of how such interpretations of animal imagery usually return the works to the familiarly human.

Artists' own interpretations can of course have a similar effect. Jordan Baseman's *The Cat and the Dog* (illus. 43), for example, is a powerful example of 'botched taxidermy' which, in its stark and troubling physical presence, resists any obvious single interpretation. To learn that the piece is, according

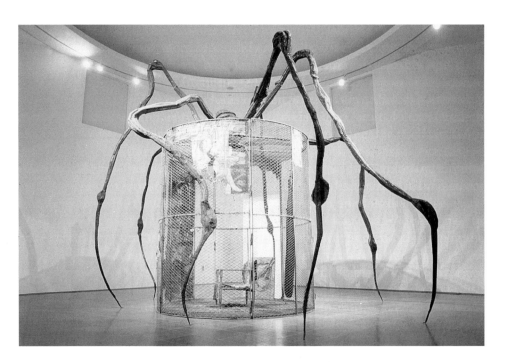

34 Louise
Bourgeois, *Spider*,
1997, steel and
mixed media; view
of installation at
Serpentine Gallery,
London, 1998.

to the artist, a metaphor for marriage and a response to his own unhappy childhood experience of family life, is to know too much, and to reduce to mundane knowledge the effect of this far from mundane image.[7]

It is of course worth heeding Joseph Beuys's cautious words about the postmodern preference for 'openness': that the notion that 'everything is possible' is of little use to the artist, who must work to arrive at 'a precisely worked-out form'.[8] That is what Rauschenberg did with *Monogram*: worked out a form for the animal, but without seeking to restrict it to an expression of his own intentions. He has spoken specifically of 'letting . . . meaning take care of itself' in his works from the 1950s. His concern in such pieces was to explore the possibility of making things which would not be merely 'an illustration of my will'.[9] This is perhaps the most radical postmodern option: the animal as a strange being encountered and experienced, rather than rendered familiar through interpretation.

If the animal is to figure in the art at all, of course, it is impossible for the artist wholly to stand back from its interpretation or manipulation. Kounellis's live horses, Beuys's live coyote (illus. 11) and Dion's live African finches (illus. 1 and 5)

were *put into* their gallery settings, and Rauschenberg's tyre-ringed goat is an entirely deliberate construction. Some of the examples of botched taxidermy discussed in the previous chapter make more open use of manipulation. In *in vitro* conditions, Hubert Duprat offers the caddis fly larvae he has previously stripped of their natural protective cases the opportunity to manufacture new ones from the jewels and precious metals he has provided, and 'exhibits this "factory" . . . as a work of art' (illus. 31). Christian Besson's claim that in this process each glittering larva is itself 'elevated to the rank of artist', the 'deputy producer' of the work,[10] does little to disguise the fact that these creatures have been brought into meaning by the artist, and appear to be exhibited principally as the living display of that meaning. By comparison, Mark Dion's decision to recoat his stuffed polar bear with goat fur (illus. 19) looks like a model of restraint.

Nevertheless, non-manipulation of the animal can perhaps be seen as one postmodern ambition or ideal. In the case of Kounellis's horses, Rauschenberg's goat and even Dion's polar bear, the postmodern animal is there in the gallery not *as a meaning* or a symbol but in all its pressing thingness. Symbolism is inevitably anthropomorphic, making sense of the animal by characterizing it in human terms, and doing so from a safe distance. This may be the animal's key role in postmodernism: too close to work as a symbol, it passes itself off as the *fact* or reality of that which resists both interpretation and mediocrity. As Milan Kundera writes (though not with animals in mind), 'interpretation kills off works of art . . . It throws a veil of commonplaces over the present moment, in order that the face of the real will disappear. So that you shall never know what you have lived'.[11]

The postmodern animal is just this 'face of the real'. It does not so much set itself against meaning as operate independently of it. Humans have typically wanted things of animals, wanting them to be meaningful, and wanting to control and to be consoled by those meanings. Postmodernism mistrusts this comfortably centred self's desire, but so too in fact does contemporary animal advocacy, which frequently stresses the need to undermine the persistence of Western culture's anthropocentric priorities and, as one such advocate puts it, 'to speak honestly of the loneliness and isolation of anthropocentric society'.[12]

Anthropocentrism, however, may be the wrong target, and the productiveness of the idea of the postmodern animal may lie in its pointing to the *unavailability* rather than the inescapability of an anthropocentric perspective. The very idea of anthropocentrism, after all, 'presupposes that we know what the essence of man or *anthropos* is'.[13] While poststructuralist philosophers have generally looked to a more imaginative or poetic use of language as a means of offering access to the other-than-anthropocentric, postmodern artists – necessarily having to address the appearance of the animal body – have explored more varied and vivid ways of taking the animal (and the human) out of meaning.

SOUND BEFORE MEANING

One good sound is the sound of nature occurring
At the flayed edge of the idea's ear.
W. S. GRAHAM[14]

'Music comes before meaning', writes the philosopher Luce Irigaray.[15] In the ways in which contemporary art stages a stand-off between the animal and meaning, sound (if not necessarily music) assumes a role of surprising importance. Here are three representative examples.

In Siobhán Hapaska's *Mule* (illus. 35), the amputated shell of a mid-1960s Ferrari is cast in fibreglass, its grille, wheel

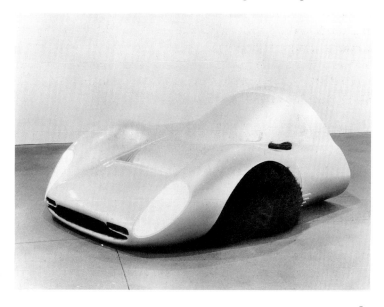

35 Siobhán Hapaska, *Mule*, 1997, fibreglass, two-pack acrylic lacquer, upholstery, electronic and audio components.

arches and hollow interior sprouting coarse fake donkey hair. The thing which troubles any simple dualistic reading of its two-way pull – metal and fur, machine and nature, sleek speed and stubborn slowness – is the sound emanating from it and enveloping it: loud, rumbling, thunderous noises of what might be a bombing raid, occasionally interrupted by neighing or other animal sounds, though these are too faint to judge whether or not the animal is in distress. The noises obscurely extend the piece's range of reference, but the sound gets in the way of thinking straight.

This is more dramatically the case in Bruce Nauman's *Learned Helplessness in Rats (Rock and Roll Drummer)*, from 1988 (illus. 36). A yellow plexiglass maze is placed in the middle of the unlit gallery space, as video images are projected on one of the gallery walls. The images show either a rat racing through the yellow maze, or the amateur drummer of the work's title. The drumming is heard throughout, relentless and seemingly pointless, its volume effectively deadening any reaction to the piece, any desire to make sense of it or to think about the rat's circumstances. The juxtaposition of silent animal and noisy human has the effect, because of the noise, of taking away meaning from both juxtaposed beings.

The third example concerns the juxtaposition of two pieces by Damien Hirst in a darkened gallery space in the Royal Academy's 1997 *Sensation* exhibition. The better known work, *A Thousand Years* (1990), appeared to involve flies feeding off a

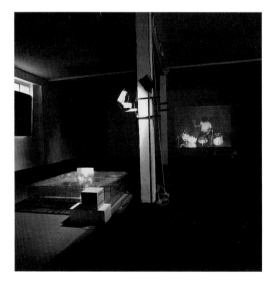

36 Bruce Nauman, *Learned Helplessness in Rats (Rock and Roll Drummer)*, 1988, installation (plexiglass maze, closed-circuit video camera, scanner and mount, switcher, colour monitor, black-and-white monitor, video projector, two videotapes [colour, sound]).

rotting cow's head and subsequently dying as they flew into the insect-o-cutor which was also installed in the glass cabinets which encased the whole piece. Hirst's formal sculptural intention had been to create, with the living flies, 'an empty space with moving points within it'.[16] At times, however, few insects were actually moving, and the floor was a thick carpet of dead flies. The memorability of the piece came more from the fact that any viewing of it was continuously interrupted by a grinding, sawing noise.

This came from the operation, across the gallery, of the other sculpture, Hirst's 1996 *This Little Piggy Went to Market, This Little Piggy Stayed at Home* (illus. 39). In it, a pig had been sawn in half and preserved in formaldehyde in a matching pair of steel and glass cases so that viewers could see both the inside and outside of its body. The cases were mounted on a short track, driven by an electric motor, so that the two halves of the body, with meticulous slowness, ground back and forth past each other, perfectly re-joined and re-formed for an instant, then cut apart again for the long remainder of the cycle; 'I like the way that one half moves like a bacon slicer', the artist remarked.[17] These two pieces reinforced the commonplace truth that art needs to be seen and experienced directly. If reproductions tell little of use about them, it is largely because in that darkened room the inescapable grinding noise *was* the experience.

At one level such examples may seem to correspond to Deleuze and Guattari's uncharacteristically utopian invocation of 'the power of music' (which they associate with art and nature) against 'the machines of human beings, the roar of factories and bombers'.[18] In these examples, however, that clichéd dualism is itself undone: it is the dehumanizing noise which does the creative work of undoing meaning. In this sense they recall Beuys's view 'that sculpture is heard before it is seen: the vortices formed by running water, the rhythm of the heartbeat, are movements that create sculpture'. In Rosalind Krauss's opinion, such signs (and *sounds*) of life are exactly what the modernist control of meaning erased. Meaningful as the drear remainder of its art may have been, it heard 'no scream of birds across open skies, no rush of distant water'.[19]

If putting sound before meaning can be a way of undoing the ability to think straight, putting meat before meaning is a way of undoing the body itself. Meat has figured in postmodern art in a wide variety of ways. For Francis Bacon, his various images of animal carcasses evidently conveyed a sense of the precariousness of human existence. He famously said: 'Well of course, we are meat, we are potential carcasses. If I go into a butcher's shop I always think it's surprising that I wasn't there instead of the animal.'[20]

Hirst shares with Bacon a fascination with the beauty of the opened body, describing paintings such as Chaïme Soutine's *The Skinned Ox* as having 'a fantastic beauty', and photographs of human wounds as 'completely delicious, desirable images of completely undesirable and unacceptable things'.[21] Helen Chadwick's series of *Meat Abstracts* (illus. 37) seem to share something of this aesthetic. So too does Kounellis's untitled 1989 installation for the Espai Poblenou in Barcelona, which included rows of carcasses hanging from iron panels around the gallery walls, the distribution of these organic formal elements indirectly echoing that of the live horses he had exhibited in Rome two decades earlier.

37 Helen Chadwick, *Meat Abstract No. 6*, 1989, polaroid mounted on silk mat and framed.

38 Emily Mayer
with erosion cast of
severed cow's head
made for Damien
Hirst's *A Thousand
Years*.

Meat, as much as sound, is a knowingly staged effect in this art. Hirst is at times especially adept at provoking viewers to confuse their attraction and their repulsion through the staging of his displays. Although his installation *A Thousand Years* originally included a real rotting cow's head, which was replaced by a fake skinned head which the artist found unsatisfactory, the head now used in the piece is the work of Emily Mayer (in her role as taxidermist), and nothing but its hair, horns and teeth are real, let alone rotting.[22] To demonstrate the point, Mayer has a photograph in her portfolio showing her making light of the gruesome object by licking the apparently open 'wound' of the severed head (illus. 38). It is a useful reminder of the extent to which viewers' readiness to be shocked is an unthinking readiness, eager for the confirmation of meanings they have already put in place.

These examples from the last ten years or so limit the delight they take in meat to a predominantly visual experience; in doing so they may mark the passing of the apparently more innocent 'flesh jubilation' which Carolee Schneemann wrote of in relation to her 1964 performance *Meat Joy* (illus. 39). She described the piece (for nine performers, including herself) as having 'the character of an erotic rite: excessive,

indulgent, a celebration of flesh as material: raw fish, chickens, sausages, wet paint, transparent plastic, rope, brushes, paper scrap. Its propulsion is toward the ecstatic – shifting and turning between tenderness, wildness, precision, abandon.' Part of the prologue read by Schneemann indicated meat's distance from meaning: 'raw meat raw fantasy . . . not as things are wished but how they feel . . . no justification / no impulse censor . . . no explanation'.[23]

Jana Sterbak's 1987 *Vanitas: Flesh Dress for an Albino Anorectic* also draws meat's lack (or excess) of meaning close to the body. It is a garment made of decaying flank steak, and has been read as contesting meaning in a more contemporary and critical spirit: 'as a plea for animal rights, for animals as something like non-signifying, but significant others, the victims as material of and for "our" processes of significa-

88

tion'.[24] From one point of view, the ambiguity of this work's use of actual meat may be read as its strength. Other more direct critiques of meat production and meat-eating – from one-off images such as Barbara Kruger's 1988 *Untitled (God Sends the Meat and the Devil Cooks)* to the several years' worth of work in Sue Coe's book *Dead Meat* (which will be discussed in later chapters) – cannot avoid drawing meat back into meaning. Whether or not this invites the moralizing dangers of 'good conscience', as Derrida believed, it certainly does reinstate a sense of a 'proper' relation between humans and animals.

ABJECTION BEFORE MEANING

I was there with two pigs . . . I wanted to debase myself and call myself a pig before the viewer had a chance to, so that they could only think more of me.
JEFF KOONS[25]

If putting meat before meaning is a way of undoing the bounds of the body, putting abjection before meaning is more specifically concerned with the artist's undoing of the self-respecting, proper self.

The use of the term abjection in contemporary art stems principally from the 1993 *Abject Art* exhibition at New York's Whitney Museum, which featured work by Kiki Smith, Cindy Sherman, Mike Kelley and others. One catalogue essay directly identified the 'scatological assemblages, bodily fragments and base materials' of that art as reconfigurations of ideas developed in Julia Kristeva's *Powers of Horror*.[26] Kristeva had characterized the abject as 'neither subject nor object', and as that which 'draws me toward the place where meaning collapses'; as Hal Foster wryly remarked, 'hence its attraction for avant-garde artists who want to disturb these orderings of subject and society alike'.[27]

Kiki Smith wrote of 'the abject loss of selfhood' and of 'recognition' in this art's dismantling of the body and its functions. Much the same idea was explicitly addressed by Kristeva in an interview about the influence of her ideas on the art of the 1990s. Speaking of abjection as a 'crisis of the person' and 'a state of dissolution', she speculated that 'we have never been in such a state of crisis and fragmentation, in terms of both the individual – the artist, and the aesthetic object'. Later in the interview she clarified the nature of 'our

crisis' as one 'in which human behaviour has attained an extreme degree of baseness and animality'.[28]

The explicit association of baseness and animality can hardly be said to be one of Kristeva's major themes, but there is no shortage of expressions of this kind of hierarchy-thinking in the visual arts. As early as 1962, Hermann Nitsch wrote this of his ritual dismemberment of dead animals in his performances: 'I take upon myself the apparent negative, unsavoury, perverse, obscene, the passion and the hysteria of the act of sacrifice so that YOU are spared the sullying, shaming descent into the extreme.' Similarly, in the catalogue of Mike Kelley's 1994 exhibition at the Whitney, the year after the *Abject Art* show, his use of animal imagery was described in the following terms: 'He adopts the lowly animal and the animal states of human life (crime, debased physiological states – ingestion, digestion, excrement) as tropes of degradation.'[29]

Kelley's work itself, however, explores this hierarchy far more subtly. His photograph from 1990 (illus. 40), variously reproduced either as *Nostalgic Depiction of the Innocence of Childhood* or (in the *Abject Art* show) as *Manipulating Mass-Produced, Idealized Objects*, has become something of an icon of abject art.[30] Despite its ubiquity, commentators on the image have been highly elliptical in their descriptions of what the naked man and woman are doing with the stuffed toy animals which they bestride. The absence of colour increases the ambiguity of what is seen: the stuff smeared on the man's body might be read as blood, faeces, oil, paint or something else entirely. A performance staged by Kelley the following year as a dialogue between two stuffed animals explicitly recognizes the power of this kind of material uncertainty: 'undifferentiation is understood as picturing something unpleasant, fearful', says the teddy bear to the bunny. Elsewhere in the dialogue, as a possible nod in the direction of the 1990 photograph's title, the bunny remarks 'we don't subscribe to an appreciation of the wonder of innocence'.[31]

It is as undoers of hierarchy-thinking, however, that these animals appear at their most radical. In contrast to Hal Foster's value-laden reading of the kind of stuffed toys seen in the 1990 photograph as 'nasty shapes', things which 'resist formal shaping, let alone cultural sublimating or social redeeming', the teddy's and bunny's exchange proposes a quite

40 Mike Kelley,
*Nostalgic Depiction
of the Innocence of
Childhood*, 1990,
sepia photograph.

different (and far from abject) reading of the postmodern animal's relation to the authority of the postmodern artist: 'We will soften the edge of the authoritarian voice; we will call it something else'; '. . . parallel rather than hierarchical'.[32]

When contemporary art does associate the animal with baseness, it renders its own concerns paradoxically *proper*. The abject leads not to the place where meaning collapses but to the place it is fixed, and the animal – even the real animal – figures as no more than its meaning. Here the authoritative

artist, as Kelley perhaps saw, risks coming across rather like the child-god in Peter Greenaway's film *The Baby of Mâcon*, who passes sentence on the ox in the stable: 'kill that animal . . . That animal is only the instrument. I am the message.' Kristeva appears to read such developments, however, as an understandable response in a time of crisis: 'The reality of the world and even our own reality is slipping out of our grasp . . . We cannot express our anxieties in signs – they seem too insubstantial – so the whole burden of aggressivity is borne by the body . . . It is in this context that artists use the body – or something close to the body; as a sign.'[33]

HIERARCHY-THINKING

As has been seen, in attributing an important place to animals in the development of postmodern art, artists by no means always manage or even seek to remove the animal from its traditional hierarchical relation to the human. Questioned about the significance of animals in his work, in a 1971 interview, Beuys responded: 'If I want to give man a new anthropological position, I also have to attribute a new position to everything that concerns him. To establish his downward ties with animals, plants, and nature, as well as his upward links with angels and spirits.'[34] It may be that a sense of connectedness to a wider world was indeed new there, but the location of the animal as rhetorically below the human was not.

It can only be a matter of speculation whether Beuys might have addressed the 'position' of humanity differently had he been speaking thirty years later. The view that hierarchical models of thought tend to privilege the group constructing the hierarchy, and that animals are thus typically assigned a lesser or lower significance than humans, is certainly not easily displaced. Even the animal rights philosopher Peter Singer, for example, has argued that 'there is a basic biological substratum that affects the way we are, and that isn't going to be changed just by what's fashionably called cultural constructions'. This leads him to the uncomfortable conclusion that 'you're not going to be able to get rid of hierarchy simply by changing culture and society'.[35]

Further support for this idea comes from research in the mid-1990s which compared the views of animal rights campaigners and of scientists working with animals on the subject

of animal experimentation. Both groups of interviewees, it emerged, 'agreed on the existence of a phylogenetic hierarchy' in the mental capacity of animals and in their ability to suffer, with the interests of 'higher' animals (primates, and mammals in general) being of greater concern to both than those of 'lower' ones such as insects or worms.[36]

One of the most fascinating (but frustratingly flawed) attempts to think *non-hierarchically* about the relation of humans and animals occurs in Heidegger's philosophical investigation, in the late 1920s, of the question 'what is world?' This is pursued 'via the question of the animal', Will McNeill has proposed, because for Heidegger the animal was 'a particularly striking figure of otherness'.[37] Heidegger outlined three related theses: '1. The stone is worldless; 2. The animal is poor in world; 3. Man is world-forming.' These constitute three quite distinct possible ways of knowing or of having access to the experience of the world. He addresses the second of these theses at considerable length, treating it as a provisional and exploratory tool, and explicitly acknowledging after eighty-five pages that it 'goes too far'.[38]

None the less, the controversial thesis that 'the animal is poor in world' has been extensively and justifiably criticized in the 1980s and 1990s, especially in Derrida's writings. Heidegger runs together all varieties of animal experience into a single, zoologically absurd form of non-human sentient being, Derrida objects, thus inscribing 'not *some* differences but an absolute oppositional limit' between the human and the animal,[39] and effectively (if unintentionally) giving new life to the classic Cartesian dualism.

Another of Derrida's objections to Heidegger's 'poor in world' thesis has a more direct bearing on the problems of hierarchy-thinking. He writes 'whether one wishes to avoid this or not, the words "poverty" and "privation" imply hierarchization and evaluation'. Heidegger, however, was absolutely explicit about his own intentions: the relation between the animal's alleged poverty in world and human world-formation 'does not entail hierarchical assessment'. Odd as the choice of term 'poor in world' (*weltarm*) may seem, it is the fact that Heidegger can use it while explicitly acknowledging the great 'discriminatory capacity of a falcon's eye' or of 'the canine sense of smell' – *and* while arguing that 'amoebae or infusoria' are no less perfect and

93

complete than 'elephants or apes' – which leads him to insist that poverty in world 'must not be taken as a hierarchical evaluation'.[40]

What Derrida and other critics of Heidegger seem barely to acknowledge is that his peculiar argument nevertheless offered a rare and necessarily difficult attempt to think outside familiar human experience of the world, and to find a way of characterizing a non-human experience in non-hierarchical terms. Flawed as Heidegger's thesis undoubtedly is, it was a serious attempt – as McNeill notes – to understand the animal 'as other, in its otherness', and to let that otherness be. This understanding was to be achieved, Heidegger proposed, through an imaginative human transposition into an animal. In this 'self-transposition', 'the other being is precisely supposed to remain *what* it is and *how* it is. Transposing oneself into this being means . . . being able to go along with the other being while remaining *other* with respect to it'.[41]

The notion of letting the animal's otherness be has clear links to those postmodern conceptions of the animal which try to avoid forcibly rendering it meaningful in human terms (and also to Deleuze and Guattari's concept of becoming-animal, which will be discussed in some detail in the next chapter). What is far from postmodern, however, is what Derrida rightly calls Heidegger's most 'seriously dogmatic' sentence, which proposes – as part of an ongoing effort to characterize human and animal difference – that apes 'have organs that can grasp, but they have no hand'.[42] Derrida offers his own persuasive critique of this misguided notion, but it is perhaps contested equally effectively (if unknowingly) in postmodern art's renderings of the handedness of animals.

For many artists the animal stands in as a new form of being, a creative postmodern being, and it emphatically does have hands. From Paula Rego's vision of the animal as artist in *Red Monkey Drawing* and *Monkeys Drawing Each Other* (both 1981), to Edwina Ashton's hand-wringing sheep (illus. 27) or Isaacs's gesticulating chicken-headed scientist (illus. 18), these new imaginative creatures rely in no small part on their handedness. There is no need to restrict this to artists' imaginings. The living apes whose handiwork is recorded in Thierry Lenain's survey, *Monkey Painting*, bring Rego's image of the monkey painter (an old theme, in any case) to life. No matter

that Lenain insists that the work of these creatures is not in fact 'art' in any usual sense of that word.[43] Many contemporary artists, Isaacs included, are keen to distance themselves from just the kind of activities and objects traditionally understood to be art.

If the distinctly 'handed' ape continues to serve as one rather useful model of the postmodern artist (Lenain notes that the apes' interest is only in the 'pure disruptive play' of active image-making, and not at all in the finished product), this identification may be largely opportunistic. Heidegger's more preposterous and dogmatic claims about animality may well have stemmed from the fact that his interest in animals was mainly (as already noted) in their happening to offer the philosopher a striking image of otherness. It is salutary to note, of course, that this is still what the animal is for the majority of postmodern artists and philosophers when they employ it as a means of addressing imaginative thought, or of signalling their own creativity.

HOLDING TO FORM

It was too dead. Just so much
A poundage of lard and pork.
Its last dignity had entirely gone.
TED HUGHES, 'View of a pig'[44]

The animal reduced to meat is in an important sense no longer an animal – it is mere material, virtually interchangeable with human meat – and it therefore explains rather little about postmodern art's fascination with the animal. For that fascination to operate, the distinct form of the animal has still to be recognizable. This recognizability of form, no matter how provisional, has both aesthetic and ethical dimensions of some importance.

In the middle of the dialogue on the subject of identity staged by Mike Kelley between the teddy bear and the bunny (illus. 16), the teddy bear – a more than able postmodern theorist – sums up their argument: 'The best way to fuck something up is to give it a body.'[45] As far as the animal in postmodern art is concerned, this both is and is not the case. The previous chapter described the characteristically postmodern 'botched taxidermy' animals as those with which something seemed to have *gone wrong*, but which nevertheless *held*

together. It can now be added that no matter how 'wrong' such animal bodies may look, they need only to be *read as a body* to resist their reduction to undifferentiated meat.

The bodies in *Monogram* or in Dion's *Ursus maritimus* (illus. 30 and 19) – but equally those in Kounellis's exhibition of horses – may seem in their dumb solid physical presence, their obstinate thereness in the gallery, to have gone a long way towards shunting out meaning, symbolism and anthropomorphism from postmodern aesthetic experience. As distinct from the aesthetics of meat, discussed briefly above, it is meaning, not form, which is undone here. Taken out of human meaning, the animal still holds to form; this is the critical aesthetic tension of these works.

Holding to form is perhaps the clearest way in which the postmodern animal's *unmeaning thereness* can be expressed. There is, to use an uncomfortably judgemental term, a dignity in this. An example which shows that this can be achieved in two dimensions, as well as in three, is provided by the German photographer Britta Jaschinski's large-scale black and white prints, individually untitled, from a 1996 series called *Animal*. In each print the animal's looming presence bludgeons the viewer but holds something back, keeping its identity to and for itself (illus. 41). By means of that very reserve it offers something close to what Luce Irigaray calls *wonder*. This is the wonder experienced by individuals when faced with the unbridgeable distance between themselves and another (any other): 'Wonder being the moment of illumination . . . between the subject and the world.' In the recognition of wonder, the human is not able to assimilate the animal, nor to make it wholly meaningful in human terms: 'an *excess* resists', as Irigaray puts it.[46]

Holding to form is the means by which the animal in postmodern art maintains its difference. The artist's allowing the animal recognizable form (even if that recognition is sometimes neither easy nor immediate) therefore constitutes a kind of respect for the otherness of the animal, its non-human-ness. Words such as respect and dignity are unfortunate insofar as they imply a moralizing approval of specific aesthetic strategies, but respect seems the right descriptive term here.

It is a matter, rather as Heidegger saw, of leaving something other *as it is*, of presenting it without manipulating it, without meddling, without assuming an artist who *knows best*

41 Britta Jaschinski,
Untitled (1996), from
the series *Animal*,
photograph.

and who, in the certainty of that expert knowledge, reduces otherness to sameness, or wonder to familiarity. As already noted – and as examples of both botched taxidermy and animal handedness in art make abundantly clear – this non-manipulation is never wholly achievable. And recognizability of form, as the example of Jaschinski's elephant shows, is not aesthetically simplistic. It might even be said to be addressed most seriously when it is put under the greatest strain. Hapaska's *Mule* pulls itself in opposite directions. The botched taxidermy pieces have the feel of things taken apart before being haphazardly or improbably reassembled. Sometimes the botched reassembly doesn't work quite well enough: Charles LeDray's 1993 *Untitled/Broken Bear*, for example, strings the snapped limbs, head and torso of a teddy bear back together in a single continuous line which refuses to re-form as any kind of animal.

It is as limit-cases of holding-to-form that Hirst's butchered animals take on their most interesting and imaginative aspect. The butchered cows in formaldehyde in the Turner Prize-winning *Mother and Child Divided* (1993) and the multi-cut *Some Comfort Gained from the Acceptance of the Inherent Lies in Everything* (1996), as well – most dramatically – as the

being-cut form of the machine-driven pig (illus. 44), brings animal form and meat form into spectacular tension. Hirst's comment on his own work – 'Animals become meat. That's abstract'[47] – underestimates the complexity of these particular pieces, which resist that uninteresting becoming by the slimmest of margins.

The very idea of holding to form, even when pushed to such limits as these, might seem to imply that postmodern art clings to the notion of there being such a thing as *proper* animal form, which is what renders the postmodern animal recognizable as such. The challenge, on the contrary, is to hold open the question of form. This might profitably be thought of in terms of the creative patience described in the psycho-analyst Marion Milner's book *On Not Being Able to Paint*. She criticizes the 'sense of false certainty' that comes with creating 'a recognizable object too soon': it is likely to be 'at the cost of something else that was seeking recognition, something more to do with imaginative than with common sense reality'.[48]

In this strange fusion of the unknown and the recognizable, the disorienting lack of context in the white space of the gallery may be a positive advantage. Part of what postmodern art may be able to do with the animal is to take both it and the viewer out of their familiar meaning-laden contexts. The point is made by Hirst in relation to his tiger shark (illus. 23). When the viewer gets close enough to the shark, 'you get a feeling of what it would be like to be in the water with it ... Being in water with a shark you're out of your element. So I liked the idea of bringing that into a gallery, so you're in a gallery and you're out of your element.'[49] Whether or not Hirst's shark itself manages to create this effect, the general point is well made. The thing seen is recognized as an animal; the nature of the experience may be less recognizable.

5 Leopards in the Temple

We believe in the existence of very special becomings-animal traversing human beings and sweeping them away, affecting the animal no less than the human.
GILLES DELEUZE AND FÉLIX GUATTARI [1]

A familiar feature of the rhetoric of much recent art and philosophy has been the characterization of the human self or body as impure, hybrid or monstrous, in contrast to the allegedly uncreative propriety of modernist and humanist accounts of subjectivity. Neither the aesthetics of modernism nor the philosophical values of humanism, it is believed, can cope easily with hybrid forms which unsettle boundaries, most especially the boundaries of the human and the non-human. In the values of modernism and modernity, it is now felt, there was a widespread urge to homogenize and systematize, to render the world intelligible by eliminating or suppressing inconsistencies, impurities and dissimilarities.

Developments in the sciences, just as much as post-structuralism's and postmodernism's influence in the arts and humanities, made those values ever less credible to writers in the later 1990s, for whom there were typically two aspects to their exploration of the hybrid and the monstrous. The first was a description of the problem. Nina Lykke was persuaded that modernity was a repressive 'process of purification' which worked to ensure 'that any monster or hybrid that threatens to transgress the border' between the human and non-human 'is reclassified and ascribed to *either* the human *or* the non-human sphere'. However, in 'the cyborg world of post-industrial society' such creatures or creations 'are becoming more and more common, and their repression, conversely, less and less successful'.[2] A study by Birke, Michael and Brown noted similarly that 'while modernist Western discourse has attempted to keep separate the human and the nonhuman, there has been a concurrent proliferation of nonhuman–human hybrids'. (They were thinking in particular of the development of xenotransplantation – the use of animal organs for transplant surgery.)[3]

The second aspect of these explorations, however, went

99

some way beyond the assertion that a postmodern perspective consists in throwing off modernism's fear of contamination by that which is other, such as the animal. It suggested, in various ways, that the embracing of impurity, hybridity and monstrosity could be seen as a positively *creative* move. Margrit Shildrick argued that 'What monsters show us is the other of the humanist subject'; she was keen to explore the ways in which 'a humanist politics of norms and identity' might give way to 'a politics of hybrids'. Lykke contended that the postmodern world she described created particular opportunities for feminism advantageously to employ the monster, the hybrid and the cyborg as 'evocative and open-ended' metaphors. And in the editorial introduction to a special issue of *Angelaki* on 'Impurity, authenticity and humanity', Mozaffar Qizilbash chose to designate as 'impurists' those fearless contemporary philosophers and artists whose boundary-crossing work was both rigorous and 'antidisciplinary'.[4]

Common ground for several such writers was the work which Donna Haraway had undertaken in the 1980s and 1990s on the idea of the cyborg. Haraway stated uncompromisingly: 'Humanity is a modernist figure.' Her own concern was to consider the place of 'the human in a post-humanist landscape'. The contention of her famous 'cyborg manifesto' was that in the world of the late twentieth century 'we are all . . . theorized and fabricated hybrids of machine and organism; in short, we are cyborgs'.[5]

Where the cyborg, or 'cybernetic organism', has so often been misread in popular culture as a mere science-fictional hybrid mix of the human and the machine, Haraway always saw it as a more subtle and complex compound 'of the organic, technical, mythic, textual and political'. To the extent that she saw herself as describing an actual historical shift, it was always to be understood as an ethically complex one. Cyborg-status was more than a simple and joyful release from anthropocentric values, for as Haraway herself noted, laboratory animals were cyborgs too. (The 'first being to be called "cyborg"' was a white laboratory rat which had an osmotic pump implanted in its body at a New York hospital in the late 1950s.) The figure of the cyborg nevertheless had a subversive power for Haraway; she called it 'my blasphemy', and argued that cyborg imagery was the source of 'a powerful infidel heteroglossia'.[6]

Notions of the monstrous figured in similar ways in discus-

sions of art in the late 1990s, notably with Mark Hutchinson's proposal that the art of the time might be understood in terms of 'a monsterology'. In his view the art of young British artists – John Isaacs was one of his examples – was 'full of monsters'. He argued that 'the monster might prove to be a more complete idea of subjectivity than the rational, moral western subject', and that the monstrous work of these artists was 'a way of escaping the law of morality'. Monsterology was a means by which to explore pleasure and intensity, free of aesthetic and moralistic judgement: 'The monster has a bad sense of aesthetics.'[7]

Common to a number of these explorations of the creative redescription of subjectivity was a positive identification with these new forms. Haraway concluded her cyborg manifesto with the words 'I would rather be a cyborg than a goddess', and observed in a more recent book that the 'biotechnical, bio-medical laboratory animal is one of the key figures inhabiting my book, world, and body'. More concisely, she wrote: 'OncoMouse™ is my sibling.'[8] Lykke also asserted 'I am on the side of the monsters', and Hutchinson stated 'I'm writing this from the point of view of a monster who makes art.'[9]

These particular attempts to reconfigure the human by thinking the inhuman reflected, in their different ways, a more general 'postmodern' resistance to the worst excesses of identity-thinking. As Juliet Steyn argued in the introduction to the 1997 collection, *Other Than Identity*, identity-thinking may be regarded as philosophically conservative and politi-cally hazardous, with 'life-and-death struggles' continuing to be 'mobilized and legitimated in the name of identity'. Seeing the 'single unitary subject' as the 'cornerstone of the Western philosophical tradition', she intended the book 'to disturb the identification of subject and identity'.[10]

The positions outlined in this brief overview are not, however, those to be explored in more detail in the present chapter. Instead, Deleuze and Guattari's slightly earlier but significantly more radical concept of 'becoming-animal' is to be its focus. There are several reasons. 'Becoming-animal' shares something of Lykke's, Shildrick's and Hutchinson's concerns with creativity, but gives a creative role to the animal rather than the 'monster'. In doing so it usefully avoids casting the animal, as an instance of the non-human, as automatically 'monstrous'. (Read positively or not, monstrosity suggests a

transgression of human identity rather than an alternative to it.) As to its radicalism, instead of seeing the 'rethinking' of identity in terms of Steyn's 'desire for identifying different ways of thinking being',[11] becoming-animal charts the possibilities for experiencing an uncompromising sweeping away of identities, human or animal.

The close reading of the concept which follows, and which aims to explore how becoming-animal might offer a real alternative to identity-thinking, is intercut with three fairly detailed commentaries on how the concept might apply to recent art practice, 'traversing' certain self-centred conceptions of the artist and 'sweeping them away'.

WHAT IS BECOMING-ANIMAL?

Deleuze / Guattari

The concept of 'becoming-animal' (*devenir-animal*), which Deleuze and Guattari elaborate in their 1975 book *Kafka* and then, in more detail, in the substantial 1980 volume translated as *A Thousand Plateaus*, is a particularly complex example of philosophical thought about the relation of humans and animals. In *Kafka*, they state that one of the things which happens in the peculiar 'metamorphosis' which constitutes becoming-animal is a 'deterritorialization', a kind of un-humaning of the human, and that this is something 'which the animal proposes to the human by indicating ways-out or means of escape that the human would never have thought of by himself'.[12] It is clear from the development of the concept in *A Thousand Plateaus* that becoming-animal is something which happens in many areas of human experience, and is certainly not specific to the production or consumption of certain literary fictions, such as Kafka's short stories.

That idea of the introduction into human thought of options or alternatives 'that the human would never have thought of' relates closely to other poststructuralist declarations concerning thinking at the limit, such as Cixous's 'thinking is trying to think the unthinkable: thinking the thinkable is not worth the effort',[13] or Foucault's various comments on thinking 'differently'. The value of Deleuze and Guattari's treatment of the theme in the present circumstances is not simply their remarkable assertion that these alternatives are somehow *proposed by the animal*, but lies rather in the fact that in their elaboration of the often baffling concept of becoming-

102

animal they go beyond merely calling for the unthinkable to be thought: they offer a detailed model of how it might be done.

Becomings are always, in Deleuze and Guattari's words, 'a political affair';[14] to understand them is to understand something about lived experience in the world, and about the scope for shaping that experience. The becoming-animal which appears here in *The Postmodern Animal*, therefore, is not exactly the postmodern animal itself, but it will shape the ways in which both the human and the animal forms of the postmodern animal may be understood.

Ronald Bogue's useful introduction to Deleuze and Guattari's philosophy suggests that it builds on a 'Nietzschean conception of the cosmos as the ceaseless becoming of a multiplicity of interconnected forces', which 'admits of no stable entities' and which must therefore 'be understood in terms of difference rather than identity'.[15] *Becoming* is, therefore, one of their major concerns, and of the various becomings in *A Thousand Plateaus* (which include becoming-minoritarian, becoming-woman, becoming-molecular and becoming-imperceptible), becoming-animal has a claim to particular importance. In a 1980 interview in which Deleuze described various 'experiments in concepts' in that book, 'becoming-animal' was the only instance of becoming to figure in his list.[16]

Deleuze and Guattari use the concept in order rigorously to avoid describing modes of thought, action and experience in terms of identities and subjectivities; 'the becoming-animal', they write in *Kafka*, may be thought of as a process or method that 'replaces subjectivity'.[17] This is more than just their own variation on the poststructuralist theme of the decentring of the subject; it is a full-blown doing away with the subject and all of its associated philosophical and psychoanalytical baggage.

They begin with the numerous becomings-animal in Kafka's short stories. As their examination of what they call Kafka's 'writing machine' also includes discussion of his novels and his letters, and as they wish to examine this phenomenon without getting enmeshed in traditional questions of an author's subjectivity and individuality ('We believe only in a Kafka *experimentation* that is without interpretation or significance'), it is not surprising that the life and the writing are presented as a continuous becoming rather than as distinct realms of operation. The writing sweeps across into

103

the writer's modes of becoming; a writer, they propose, is 'an experimental man (who thereby ceases to be a man in order to become an ape or a beetle, or a dog, or mouse, a becoming-animal, a becoming-inhuman . . .)'.[18]

Three significant themes are already apparent here. One is the contrasting of interpretation and meaning on the one hand, and experimentation on the other (with a high value seeming to be accorded to artistic experimentation). Another is a characteristic awkwardness in phrasing which results from the avoidance, at all costs, of the language of subjectivity, individuality or selfhood. The third is the role of artistic production and artistic discipline (their examples are drawn mainly from writing, painting and music) in the creative transformation of experience: it is 'through a style that one becomes an animal, and certainly through the force of sobriety'.[19] A particular conception of the artist and of the animal are, it seems, bound up with each other in some manner in the unthinking or undoing of the conventionally human.

The importance of writing and of the writer are explained by Deleuze and Guattari in terms of what they call 'minor' literatures, the modified popular forms of expression of relatively marginalized peoples around the world, which do not necessarily respect the sense-making structures of the languages which they modify. These are seen by Deleuze and Guattari as representing a more general opportunity for political subversion. One of their most direct and generalizable statements about becoming is that 'all becoming is a becoming-minoritarian . . . Becoming-minoritarian is a political affair and necessitates a labour of power (*puissance*), an active micropolitics.'[20]

The very notion of becoming is thus, in a sense, a postmodern phenomenon. It appears to correspond to Lyotard's emphasis on moving away from grand narratives: micropolitics is 'the opposite . . . of History, in which it is a question of knowing how to win or obtain a majority'. More interestingly, in *Kafka* a micropolitics is close to Lyotard's conception of the artist's, writer's and philosopher's responsibility to resist the complacent certainties of the expert: it is 'a politics of desire that questions all situations'.[21]

Becoming-animal, then, is implicated in a more widespread becoming-minoritarian, in which one of the things questioned and resisted is any authoritarian imposition of

42 Emily Mayer, *Corvus corium*, 1995, leather, steel, wood, rubber.

43 Jordan Baseman, *The Cat and the Dog*, 1995, skinned cat and dog with modelled heads.

44 Damien Hirst, *This Little Piggy Went to Market, This Little Piggy Stayed at Home*, 1996, steel, GRP composites, glass, pig and formaldehyde solution, electric motor, two glass tanks.

45 Julian Schnabel, *Untitled*, 1990, marker, oil and photograph by Jean Kallina on paper.

Stärken des Netzes durch Entwicklung eines öko-urbanen Saumes, wo Wildnis sich mit wachsenden urbanen Formen vermischt.

46 Helen Mayer Harrison and Newton Harrison, Installation shot of 'The Eco-Urban Edge', from *Casting a Green Net: Can It Be We Are Seeing a Dragon?*, 1998, mixed media.

47 Sue Coe, *Modern Man Followed by the Ghosts of his Meat*, 1988, gouache, watercolour and graphite.

48 John Isaacs, *Untitled (Dodo)*, 1994, fibreglass, silicone rubber, electric mechanism, glass, acrylic paint.

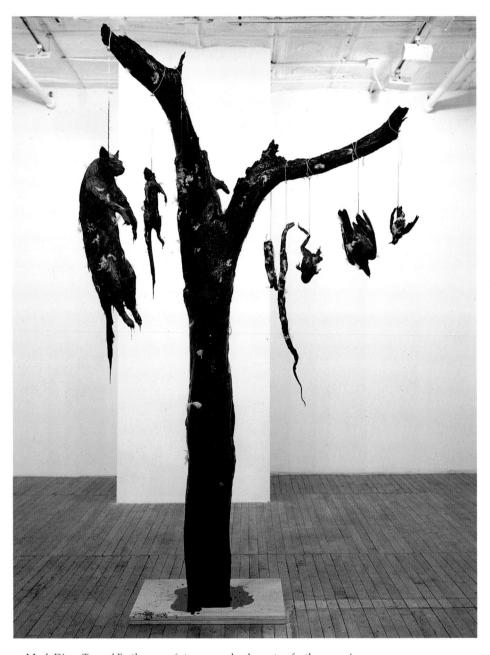

49 Mark Dion, *Tar and Feathers*, 1996, tree, wooden base, tar, feathers, various taxidermic animals.

sense or meaning, and any officially sanctioned forms of inter-
pretation or representation. Psychoanalysis, which 'has often
encountered the question of the becomings-animal of the
human being', is in Deleuze and Guattari's view especially
guilty in this respect. Psychoanalysts 'see the animal as a
representative of drives, or a representation of the parents.
They do not see the reality of a becoming-animal, that it is
affect in itself, the drive in person, and represents nothing'.
The imposition of interpretation is always contrary to creativ-
ity and experimentation: 'you don't know . . . So experiment.'
This is the responsibility of the artist and the writer, expressed
rhetorically in the imperative: 'either stop writing, or write
like a rat'.[22]

$\left(to\ 117 \right)$

A BODY TO BE TRAVERSED

Writing like a rat. With writing, artists put themselves in a
particular proximity to the animal, investing or inscribing
unmistakably human words over or around what is animal in
the image, in a bid to free up that image, to push the writing
into an asignifying becoming. The image may show or the
writing may name the animal, but in its traversing the image
the writing itself makes of that image *a body to be traversed*, a
becoming-animal, a possibility of being swept away.

Julian Schnabel's *Untitled* (1990) features a very large,
creased, grainy black-and-white photograph, with a pool of
paint spilling over into it at the upper left, and across which a
scrawl of text has been inscribed in silver marker, reading
'There is no place / on this planet / more Horrible / than a FOX
FARM / during / Pelting Season' (illus. 45). In sharp focus in
the foreground of the photograph is the upholstered back of a
dining chair; behind it, rapidly losing focus, are four round
tables and another chair, all unoccupied, and on the back wall
an image, possibly a reproduction of an eighteenth- or nine-
teenth-century landscape. It is difficult, in the light of the text,
to read the paint spill other than as a reference to spilt blood.

It is a peculiarly unstable image. At one level its impas-
sioned text and symbolism are comparable to the kinds of
blood-splattered campaigning imagery produced by anti-fur
groups – imagery which is direct, propagandistic, worthy,
and wholly visually obvious. The photograph, however,
seeming uncannily unconnected, is not easily assimilable to

this reading. And leaving the splash of paint aside, it is almost as though the text has been scrawled out in anger, with no thought of what it was written on or over. (This is in fact most unlikely; another version of the piece uses the same text, a different photograph of the same setting, and instead of the splash has two thin horizontal bars of paint running across the whole image like the bars of a cage.) The text gives the piece the sense of a memo the artist has scribbled to himself; it *commits* him to its subject matter in a very particular way.

Take two further examples which run text across bodies: an image by Sue Coe, from a sketchbook (illus. 50), and an image by Valerio Adami, *of* a sketchbook or exercise book (illus. 51). The Coe sketchbook page is from what she calls her 'slaughter-house journals', the result of six years' work travelling the United States and Canada visiting meat-packing plants wherever she could gain access. Extracts were published in 1996 in her book *Dead Meat*. This page juxtaposes notes and

114

sketches made on the spot in a Montreal abattoir in 1991, showing a handler and a skinner dealing with veal carcasses. The Adami, a far more studied and self-consciously inter-textual image, is reproduced and discussed in Derrida's *The Truth in Painting*, and it incorporates text from Derrida's earlier book, *Glas*.

There are chance correspondences between the two images. Vertical motifs (a suspended chain, a spiral binding) separate part of the text from the rest of each image; both depict a creature caught on a metal hook ('the hooked, steely violence of a capture', in Derrida's words); and both juxtapose text and animate forms, with the text written across these forms in places. One text records particular conditions of

slaughter; the other includes fragments of what reads, at least out of its original context, as a meditation on mortality ('the angle is always for me the edge of a tomb').[23]

Linking both images to the Schnabel is the question of how to draw an image into telling an urgent truth. Coe and, it appears, Schnabel are concerned in these images to record and to provoke. (Coe's concern is truthfully to record the humanity of exploited workers as much as the inhumanity with which the work obliges them to treat the animals.)[24] At a greater philosophical remove, Derrida's concern is also with 'the truth in painting', and with its articulation across the visual and the verbal. The painter 'does not promise to *paint* . . . truths', but 'he commits himself to *saying* them: "I owe you the truth in painting and I will tell it to you"'.[25] Like Coe's and Schnabel's images, Derrida too explores an aesthetic of seriousness and sobriety – that 'force of sobriety' which becoming-animal demands.

Is there anything else here of the becoming-animal, anything in these image-texts traversing their artist-writers and 'sweeping them away'? There is certainly a play of identities. Derrida, describing 'the fish drawing which I shall baptize *Ich*, without the author's authorization', punningly distances himself from it at the same time: 'I'm talking here of *Ich* and exhibiting it *as an other.*' Coe is said to disown the designation 'artist' in favour of the self-deprecating term 'gutter journalist'. Schnabel runs his graffiti across someone else's photograph (the photographs used in both versions of his piece are by Jean kallina). There is also a kind of tentativeness in marking out the animal. Schnabel avoids it completely. Derrida notes of Adami's drawing: 'Everything here is marked *scarcely.*' And Coe apparently prefers to the originals of her works their newspaper reproductions, where 'everything is a little smudgy'.[26]

In these different forms of the problematizing of identity, the artist-writer's subjectivity is diverted or put at a distance. It is drawn into concern with an animal's fate or even, in a sense, drawn into the animal's body. Derrida for example identifies 'Adami's signature, or rather his acronym' stuck in 'near the fish's tail', where it is caught 'in the links or the angled scales of the *ichthys*', and the inverted V and the A themselves 'make up a shoal of fish'.[27] In a broader sweep, however, a sober writing traverses all three bloodied and

absented or absenting images, making of the foxes, veal calves, workers and fish a becoming-animal both singular and multiple, and inscribing individualities as shoal, band, pack or multiplicity, so that (to anticipate Deleuze and Guattari's words) there is 'no longer man or animal'.

LINES OF FLIGHT

Kafka's short stories, according to Deleuze and Guattari, refuse 'an author's or master's literature' and articulate a movement 'from the individuated animal to the pack or to a collective multiplicity'. The result is this: 'There isn't a subject; *there are only collective assemblages.'* In becomings, things 'tend toward the assemblage ... even if this collectivity is no longer or not yet given'.[28] The movement of the animal, the becoming of the animal, may be understood (in and beyond the Kafka experiment) to tend in this direction: away from the subject and, which is perhaps to say much the same thing, away from meaning.

The writer's ability to put words in movement, to free them from the constraints of imposed sense, allows the writing itself to enact, for example, 'the becoming-dog of the man and the becoming-man of the dog, the becoming-ape or the becoming-beetle of the man and vice versa':

> We are no longer in the situation of an ordinary, rich language where the word dog, for example, would directly designate an animal and would apply metaphorically to other things (so that one could say 'like a dog') ... Kafka deliberately kills all metaphor, all symbolism, all signification ... Metamorphosis is the contrary of metaphor. There is no longer any proper sense or figurative sense, but only a distribution of states that is part of the range of the word ... There is no longer man or animal, since each deterritorializes the other ... in a continuum of reversible intensities ... there is no longer a subject ... Rather, there is a circuit of states that forms a mutual becoming, in the heart of a necessarily multiple or collective assemblage.[29]

There appear to be two interconnected (albeit still rather opaque) proposals here: that *signification may be undone,* with both literal and metaphorical attempts to fix meaning giving way to 'a distribution of states'; and that *individual identity*

may be undone, with both human and animal subjects giving way to 'a circuit of states'.

This hardly amounts to a definition of becoming-animal, but it is already clear that Deleuze and Guattari, sceptical of fixity, will not be providing a definition as such. What might be sought, however, from their spiralling descriptions, is the answer to a more modest question: what are the key concepts which cluster around the becoming-animal, or which ally themselves with it? One such concept is that of *une ligne de fuite,* translated in *Kafka* as a 'line of escape' and in *A Thousand Plateaus* as a 'line of flight'. (Brian Massumi helpfully notes that the term *fuite* 'covers not only the act of fleeing or eluding but also flowing, leaking, and disappearing into the distance', and that it 'has no relation to flying'.)[30]

Deleuze and Guattari write that in Kafka's short stories it is the role of the animal 'to try to find a way out, to trace a line of escape'. There is at the very least an implicit parallel between the animal's line of flight, or metamorphosis, and the artist's creative production, in forms such as writing: 'What Kafka does in his room is to become animal and this is the essential object of the stories. The first sort of creation is the metamorphosis.'[31]

Both artist and animal are concerned, above all, to escape a condition which Deleuze and Guattari call 'Oedipalization': a form of pettiness and conservatism and control which was the object of their antipathy in their earlier book *Anti-Oedipus.* Oedipalization is evident in the figures of all those forces which are *certain that they know best:* the father, the family, the state, the institution of psychoanalysis, and so on. The alternative is 'the possibility of an escape, a line of escape':

> To the inhumanness of the 'diabolical powers', there is the answer of a becoming-animal: to become a beetle, to become a dog, to become an ape, 'head over heels and away', rather than lowering one's head and remaining a bureaucrat, inspector, judge, or judged.[32]

The most Deleuzian moment in Peter Høeg's novel *The Woman and the Ape* traces just such a line of flight. On the run from the Oedipal forces of 'the System', Erasmus the ape, with Madelene Burden wrapped up in one arm, makes an escape through the night: 'The only sound was of the traffic beneath them and the wind whistling in the telegraph wires along

which the ape was travelling.' Climbing higher across cables and scaffolding, the ape picks out a path 'invisible to human eyes, cutting across the city at third-floor level'. It was 'as though the animal itself were creating the world through which it moved', revealing the city to be only a 'sorry machine … full of blind spots and flat points, and criss-crossed by the forgotten tracks along which the woman and the ape were now travelling'.[33]

The line of flight, however, is no easy escape from the considerable forces of Oedipalization; one of its characteristics is that it often fails. In Kafka's story 'Metamorphosis', where Gregor Samsa 'awoke one morning from troubled dreams' to find himself 'transformed in his bed into a monstrous insect', Deleuze and Guattari choose to read what they call his becoming-beetle as his (only briefly successful) line of flight from the stifling effects of his Oedipalizing family and job. His metamorphosis turns out to be 'the story of a re-Oedipalization that leads him into death, that turns his becoming-animal into a becoming-dead'. They are very clear that it is on finding himself re-Oedipalized 'by his family' that Gregor 'goes to his death'. But this is not the result of Oedipal guilt. As they write earlier, and in more general terms: 'One allows oneself to be re-Oedipalized not by guilt but by fatigue, by a lack of invention.'[34]

Their text seems to propose its own distribution of states: on the one hand, Oedipal control, human identity and, ultimately, death; on the other, invention, experimentation and becoming-animal. Is this a case of *the Oedipal human versus the creative animal*? Certainly these forces seem to pull against each other, and this perhaps *is* the work of becoming, its political operation, its 'labour of power'. (This has an unexpected consequence. In putting the animal to work against the forces of Oedipalization, Deleuze and Guattari's writing reserves particular contempt for those upsetting aberrations, *pets*: 'Oedipal animals with which one can "play Oedipus", play family, my little dog, my little cat'.[35] This will call for detailed consideration in a later chapter.)

They note that for Kafka the role of the animal in metamorphosis is precarious: 'We saw how the animal oscillated between its own becoming-inhuman and an all-too-human familiarization.' They see metamorphosis itself as a pull of opposing forces which can be turned to good effect:

119

> the metamorphosis is a sort of conjunction of two deterrito-
> rializations, that which the human imposes on the animal
> by forcing it to flee or to serve the human, but also that
> which the animal proposes to the human by indicating
> ways-out or means of escape that the human would never
> have thought of by himself.

Because 'everything in the animal is a metamorphosis' which is part of 'the becoming-animal of the human' (and vice versa), the becoming-animal must be understood as 'an *absolute deterritorialization* of the man'. Again linking the animal, creativity and asignification, they call the becoming-animal 'a map of intensities' which is 'grafted on to the man insofar as he is searching for a way out. It is a creative line of escape that says nothing other than what it is.'[36]

THE 'REALITY' OF BECOMING-ANIMAL

A peculiarity of becoming-animal is that it must be under-stood as a 'reality', but as a reality which has no 'character-istics'. In the shift from the primarily literary concerns of *Kafka* to the wider concerns of *A Thousand Plateaus*, how is this matter of 'reality' handled? There is, unsurprisingly, no sharp distinction. The latter book's 'becoming-animal' chapter in fact opens with an account of another fictional example: the 'becoming-rat' of the central human character in Daniel Mann's 1972 film *Willard*. Fictional or not, the animal is assigned a relatively constant role in the human making and unmaking of sense in the world: as Willard discovers, the 'irresistible deterritorialization' of becoming-animal 'disrupts signifying projects as well as subjective feelings'.[37]

In relation to Kafka's metamorphoses Deleuze and Guattari had insisted 'There is nothing metaphoric about the becoming-animal. No symbolism, no allegory.' They object to metaphor because of 'its whole anthropocentric entourage', its tendency to liken the animal to the human, to familiarize, to disallow difference. In *A Thousand Plateaus* they write more directly of 'the reality of a becoming-animal' as a non-metaphoric condition, and are equally insistent that it 'repre-sents nothing'.[38]

They also dismiss several misleading ways of thinking about the 'reality' of a human's becoming-animal: a becoming

120

is not 'a resemblance, an imitation, or . . . an identification'. (This unambiguous statement throws a rather different light on any positive reading of postmodern artists' apparent identification with their animal subject matter.) They continue: 'becoming does not occur in the imagination . . . Becomings-animal are neither dreams nor phantasies. They are perfectly real. But which reality is at issue here? For if becoming animal does not consist in playing animal or imitating an animal, it is clear that the human being does not "really" become an animal any more than the animal "really" becomes something else'.[39]

Becoming-animal is therefore in no sense necessarily a matter of some kind of preposterous bodily metamorphosis, natural or unnatural, utopian or dystopian. It has to be thought differently, outside of the production of identities, meanings, and the categories and distinctions on which they depend. 'Becoming produces nothing other than itself. We fall into a false alternative if we say that you either imitate or you are. What is real is the becoming itself'.[40] The reference to a false alternative is less a matter of taking a theoretical stand against the stupidity of binary thought than of believing that such distinctions simply will not hold up.

Becoming is not, therefore, a matter of moving from one distinct state into another, from a point of origin to a point of arrival, both of which must have their independent realities. It is entirely possible, Deleuze and Guattari imply, to become-vampire, become-dragon or become-dodo: 'The becoming-animal of the human being is real, even if the animal the human being becomes is not . . . This is the point to clarify: that a becoming lacks a subject distinct from itself.'[41]

(to 125)

BECOMING-DRAGON

In 1998, a large-scale art project called *artranspennine98* sited the work of fifty artists in a range of rural and urban locations across the north of England. It included a gallery installation by Helen Mayer Harrison and Newton Harrison, American artists known for their ecological concerns. The installation, consisting mainly of wall-mounted texts and a series of very large Ordnance Survey maps of the Pennine region which had been modified by the artists, was called *Casting a Green Net: Can It Be We Are Seeing a Dragon?* (illus. 46).

121

One of the kinds of work sometimes undertaken by post-modern art and philosophy is to establish connections with older perspectives and techniques discredited or marginalized in the rise of the well-formed 'modern' subject. The Harrisons' piece consciously engages with a storytelling tradition: 'All art bubbles up from storytelling with people.'[42] Few artists talk, as part of their work, about how they arrive at their animal imagery, but the storytelling dimension of this piece (in the wall-mounted texts) allows the Harrisons to do so. It is this aspect which is of particular interest here.

Invited, on the basis of their earlier work, to make a piece which in some sense traversed the Pennines, they began their research:

> honoring the request for scale and connectivity
> we traveled the Pennines
> the farms and the cities
> the villages and the moors.[43]

Taking the outfalls of the rivers Mersey and Humber as the western and eastern limits of the project, 'we decided to rhyme the estuaries / and concern ourselves with the space between'. The next stage of the work involved a conscious imaginative projection; they describe imagining a giant standing at the estuary of the Mersey,

> who
> holding a magical green net
> cast that net across the land
> and wherever the threads of the net touched the earth
> there was, had been or could be
> a life web.

The idea of the project, potentially affecting about nine million people who would fall within the range of this 'life web', was to consider how 'all the activities of people / could be contained and sustained / within a green, mostly biodiverse network' of which it would form the basis. To establish the precise northern and southern boundaries of the web, the Harrisons engaged in a further imaginative traversal of the land:

> looking forward and back across times and cultures
> we located the Roman roads

interesting because they were
the first continuous hard markings on the landscape
which cross it from east to west

In their own animistic words, 'the web / almost with a mind of its own / seated itself upon those roads'. They then set about marking out the Roman roads and the boundaries of the Pennine parks on a map measuring three metres by five: 'And when these marks had been made / we stood back startled':

Having cast this green net
having established its boundary conditions
having marked them on a map large enough
to give a sense of the terrain itself
we asked,
"Can it be we are seeing a dragon?"
And had to answer, "Yes."

Without their having intended it, their work on the map, removing contemporary roads and brightening the rivers, 'appeared to delineate the skin / of that strange sort of dragon / that we were seeing'.

The far from fanciful ecological concerns of the project, which involved extensive discussions with individuals in the region including town planners, geographers, geomancers, farmers, social historians, artists, foresters, earth scientists and others, aimed to explore the kinds of small practical changes 'that would invite permit and value / such an entity as a biodiversity net / to come into existence'. The first section of the exhibition text concludes:

And so you and I
with the help of many
began to imagine a new space
which in our minds became
the domain of the Dragon.

The work of Elizabeth Mayes on the construction of modern subjectivity may help to put the strategies behind the Harrisons' piece into context. Discussing the 'transformation of the subject in the transition from premodern to modern', Mayes notes that the individual came to be seen as 'increasingly self-contained and self-containing', and that for Freud this could be characterized as an 'opposition between the

123

externalizing primitive and internalizing civilized'. It was a 'historical process of internalization that produced the modern subject'.[44]

This work by the Harrisons engages with both internal and external dimensions of subjectivity. They are *making* something from inside their imaginations (the giant's net), but *finding* in that making something they had not imagined: the externalized image of the dragon. (Thereafter, they can establish more explicit links with older traditions in which 'the body of the land was seen as a dragon', prior to its being turned by later cultures into 'a symbol of the enemy and evil'.) The better model for what they are doing is therefore not Freud's notion of 'spirits and demons' being 'nothing but the projection of primitive man's emotional impulses' on to 'the outer world', but rather D. W. Winnicott's observation about the parent's responsibility to support the imaginative freedoms of childhood play: 'we agree never to make the challenge to the baby: did you create this object, or did you find it conveniently lying around?'[45] Childhood play, for Winnicott, was the very basis of cultural creativity.

Instead of seeing the animal as either a thing out there with its own reality, or else as a private imagining with no impact on a world out there, the Harrisons' dragon is openly acknowledged as their projection and is then employed precisely to try to shape the possibilities open to other people. By its very form it invites a way of thinking about the space on to which it has been projected. In recasting an image of the land, they confirm Michel de Certeau's reading of their earlier works:

> The technical representation of an area is a tool the artist uses to see it as it will be, or as it could be. To see things in that way, in the movement that opens up another space for them, is to see them metaphorically … Metaphor is above all the mutual work of one space on another.[46]

Deleuze and Guattari may not care for the term metaphor itself, but the 'mutual work' de Certeau describes is not far at all from the mutual deterritorializations that constitute becoming-animal, in which there is 'no longer man or animal, since each deterritorializes the other'. In both its collaborative aspects and its externalization of an animal image which sets in motion (and creates, makes 'real') a variety of possible

becomings, the Harrisons' dragon can stand as an example –
to borrow Mayes's wordy phrase – of the 'perforation of the
singularized psyche in postmodern postindustrial culture'.[47]

AN ALLIANCE WITH THE ANOMALOUS

Becoming-animal is a human being's creative opportunity to
think themselves other-than-in-identity. This is where the
question of characteristics comes in, and it can be explained
by reference to Deleuze and Guattari's idea of there being
'three kinds of animals', only the last of which really interests
them. The first, 'individuated animals, family pets', are seen
by them as altogether too close to human subjectivity. The
second, 'animals with characteristics or attributes', are seen to
serve the purposes of state, of myth, and of science, where
their characteristics may symbolize or represent the preferred
meanings of particular institutions. The third kind, and the
only kind to exemplify the potential for becoming, are those
they fascinatingly call 'more demonic animals ... that form a
multiplicity, a becoming'. The distinction between the second
and third kinds is explained further:

> Animal characteristics can be mythic or scientific. But we
> are not interested in characteristics; what interests us are
> modes of expansion, propagation, occupation, contagion,
> peopling. I am legion ... The wolf is not fundamentally a
> characteristic or a certain number of characteristics: it is a
> wolfing. The louse is a lousing, and so on ... every animal
> is fundamentally a band, a pack ... it has pack modes,
> rather than characteristics.[48]

It goes without saying that Deleuze and Guattari are not
concerned here with matters of scientific verifiability; their
three-part classification of the animal world is a provocative
combination of political, representational and other concerns.
It is more a matter of asking what kind of animal serves imag-
inative human thought. The animal which is too much like a
human will not do. They noted that for Kafka's experiment,
for example, there were times when 'the animal was still too
close, still too perceptible, too visible, too individuated', and
that in order to serve his anti-Oedipalizing purposes the
becoming-animal had no choice but to 'open up and multi-
ply'. Similarly, they argue, it is in its pack modes that the

125

animal is creatively encountered by the human being: 'We do not become animal without a fascination for the pack, for multiplicity.'[49] The animal shows the human how not to be a subject, how to operate other-than-in-identity.

What is the relation of the human and the animal in becoming-animal? It is one of alliance. Its 'reality' is in the nature of an alliance. This, for Deleuze and Guattari, is what distinguishes it from what they variously call a relation of 'descent and filiation', of 'filiation by heredity', or of 'filiative production or hereditary reproduction'.[50] Alliance is a fully anti-Oedipal relation.

There is one particular example, to which they refer on several occasions, which seems for them to exemplify the kind of unlikely alliance which can be struck in becomings. It concerns the relation of certain orchids with wasp-like markings to the pollen-bearing wasps through whose mediation they reproduce:

> The orchid seems to form an image of the wasp, but in fact there is a becoming-wasp of the orchid, a becoming-orchid of the wasp, a double capture since 'that which' each becomes changes no less than 'the one which' is becoming. The wasp becomes part of the reproductive apparatus of the orchid, at the same time that the orchid becomes a sexual organ for the wasp. A single and same becoming, a single block of becoming . . .

This 'block of becoming' is one 'from which no wasp-orchid can ever descend'. The block does not merge the two, producing a single hybrid, lessening the differentiation of the two, but instead 'runs its own line "between" the terms in play'. In doing so it is, in their words, 'creative' rather than regressive.[51]

It is a creative alliance, then. They offer two significant elaborations of this idea, and both are somewhat unexpected. The first is the suggestion that there are certain beings which, or who, have a particular openness to and understanding of becoming-animal. With charming eccentricity, and without ever declaring the extent to which the term applies to the two writers themselves, Deleuze and Guattari name these privileged beings 'we sorcerers'. For example: 'A becoming-animal always involves a pack . . . a multiplicity. We sorcerers have always known that.'[52]

126

The power and the threat of the band or pack comes from its spreading by contagion (rhetorically, the *wolfing*, not the wolf): 'We oppose epidemic to filiation, contagion to heredity ... Bands, human or animal, proliferate by contagion.' But the second important elaboration of the idea of an alliance between the human and the animal concerns the knowledge 'we sorcerers' have of the distinctive make-up of packs:

> Our first principle was: pack and contagion, the contagion of the pack, such is the path becoming-animal takes. But a second principle seemed to tell us the opposite: wherever there is multiplicity, you will also find an exceptional indi-vidual, and it is with that individual that an alliance must be made in order to become-animal.

The film *Willard* offers an example: 'Willard has his favourite, the rat Ben, and only becomes-rat through his relation with him, in a kind of alliance of love, then of hate.' Willard is eventually lured into the basement of his family house by Ben, where he is torn apart by the pack of rats: 'There is always a pact with a demon.'[53]

There is always a favourite. An anecdotal but authentic example: late in November 1997, trailing through the huge Rauschenberg retrospective in New York's Guggenheim Museum, a boy, around eight years old, stops halfway down the famous spiral ramp in front of *Monogram* (illus. 30). Without doubt or hesitation, he is overheard to declare to his father: 'This is my favourite one.' For Deleuze and Guattari, children exhibit a particular 'proximity' to becoming-animal: 'all children ... bear witness to an inhuman connivance with the animal', and a corresponding disregard for Oedipal expectations.[54] *Monogram*'s goat is unquestionably the exceptional individual in the pack of Rauschenberg's animals; it is unsurprising that this is the animal with which the boy chooses to make his alliance.

The privileged animal, the exceptional individual, is termed by Deleuze and Guattari the 'anomalous'. It is part of every pack, and perhaps also, to the extent that every so-called 'demonic' animal is already a becoming-pack, it is part of every animal: 'In short, every Animal has its Anomalous. Let us clarify that: every animal swept up in its pack or multiplicity has its anomalous.'[55] All this detail may seem increasingly arcane and fanciful, with little apparent relation

to even the more imaginative realms of human experience of the animal, so it must be emphasized that the anomalous is one of the ideas put in place by the authors in order to think their way out of subjects and identities.

Specifically, they introduce the idea of the anomalous by contrasting it with that of the abnormal. 'The abnormal can be defined only in terms of characteristics': the characteristics by which it may be judged to have failed to reach or conform to 'perfection' or a 'standard'. In their analysis (an analysis of surprisingly conventional political correctness) it is the 'white, male, adult, "rational"' subject, the 'average European' man, who constitutes that standard. Of all possible becomings, there is 'no becoming-man', precisely because 'man' is the dominant, majoritarian, and apparently fixed identity away from which all becomings must pull.[56]

The anomalous, having neither identity nor characteristics, is a phenomenon which cannot be judged by its relation to a standard. Impartial (owing no loyalties) and inhuman, it is a threat to all identity-thinking: 'Human tenderness is as foreign to it as human classifications.' Furthermore, it is 'a phenomenon of bordering', an edge, the word *anomalous* itself carrying for Deleuze and Guattari the sense of designating 'the cutting edge of deterritorialization'. It is a way of thinking of each animal, and of a particular animal within the pack, and of the pack as a whole as a border, its own border, its edge, a centre-less thing: 'all that counts is the borderline – the anomalous'. As with other senses of the cutting edge, it is a phenomenon of the limit, the 'farthest dimension' of a multiplicity.[57]

To know this, to have access to this limit-knowledge, is of course to be a sorcerer. It is sorcerers who know that it is always 'with the Anomalous . . . that one enters into alliance to become-animal'. They are in a sense already exceptional beings who are primed for such becomings: 'Sorcerers have always held the anomalous position, at the edge of the fields or woods. They haunt the fringes.' Encountering the animal at the border, it is therefore, it seems, as a sorcerer that a human being makes an 'anomalous choice', strikes a creative alliance, and thus 'enters into his or her becoming-animal'.[58] These descriptions make it difficult to think of the sorcerer, the human who is able to make an alliance with the animal, other than as an artist.

(to 132)

CAGEDNESS AND CREATIVITY

A cage went in search of a bird.
FRANZ KAFKA, *Collected Aphorisms*[59]

For Kafka, Deleuze and Guattari suggest, the animal indicates 'the way out, the line of escape, even if it takes place in place, or in a cage. *A line of escape, and not freedom.*' Cagedness is a condition of art, an expression of art's entanglement with desire, and a means of addressing that desire. The fact that this may be a desire to control does not make it any less desiring. Deleuze and Guattari describe becoming as 'the process of desire', and in that openness to becoming in which 'experimentation replaces interpretation', they write that 'desire directly invests the field of perception'.[60] Freedom is not the issue here. Those familiar comparisons, charged with a certain guilt or embarrassment, between the presentation of artworks in galleries and the presentation of animals in zoos (as instances of the control of looking), therefore rather miss the point. The relation of cagedness and desire to the experimental practice of becoming is located elsewhere.

It is a matter of an intensive and inventive looking, a rigorousness of investigation, which has to be coldly unapologetic in its attitude to the looked-at thing, the caged thing. This is what art does. As W. S. Graham writes in his poem 'The beast in the space', of the 'great creature that thumps its tail' on the silence on 'the other side of the words':

> If you do not even hear that
> I'll give the beast a quick skelp
> And through Art you'll hear it yelp.[61]

Cagedness is an effect of art, a means of rendering the animal evident. Francis Bacon was quite clear about the aesthetic function of the cage structures which enclose the figures in many of his paintings. It was a means of focusing in, concentrating the image down: 'Just to see it better.'[62]

Similarly, Damien Hirst's steel and glass cases, used throughout the *Natural History* series (illus. 23 and 44) – the animals preserved in formaldehyde – were initially made for the earlier living fly pieces in order to achieve a particular effect, a particular look: 'Formally, I wanted an empty space with moving points within it.' His method in relation to the

Natural History pieces (which 'will come to look like a zoo. The zoo of dead animals') is also described in terms of the isolation of appearances: 'I like ideas of trying to understand the world by taking things out of the world. You kill things to look at them.'[63]

In what Deleuze and Guattari call 'the flow of desire itself', the direction of that flow is not prescribed ('Everything is allowed').[64] What would it be to reverse the usual movement and direction of cagedness, to put the artist in the place of the animal, the place habitually occupied by the animal? To reverse, to put it concisely, art's animal movement?

September 1997: in the ocean at Dyer Island, five miles off the coast of Cape Town, two comparatively flimsy constructions of metal, wire and chain were suspended below the water from the side of a catamaran. Three people were in these two shark cages: the artists Olly and Suzi in one, painting white sharks in their natural habitat at the closest possible quarters, and the photographer Greg Williams in the other, documenting the work 'as a performance'.

The project was undertaken with the help of conservation-

ists from the White Shark Research Institute. During a concentrated week of diving, staying underwater for an hour at a time in extremely cold and turbulent conditions, they worked with over thirty sharks, which were lured with a mixture of blood and sardines. Able to swim at thirty knots, some of them more than five metres long and weighing over two tons, the sharks would frequently head directly for the cages before veering off at the last minute.

Quite apart from the cold and the danger, working conditions were not easy. The cages were cramped – measuring only 1.2 m in diameter (illus. 52 and 53) – and smaller sharks had no difficulty getting their heads through the dividing bars. (Their interest in doing so came from the fact that nudging and biting are the means used by sharks to investigate things.) When Williams wanted to get close enough to photograph the paintings as they were being made, he could only do so by reaching out from his own cage to hang on to the bars of Olly and Suzi's with his left hand, while holding the camera in his right.

53 Olly and Suzi at work in the shark cage (ii), 1997.

The paintings themselves were made in just about the only practicable way in the circumstances: using non-toxic paint,

graphite and oil sticks on thick hand-made paper which had been mounted on polystyrene boards (illus. 3). The look of the paintings – the attempt 'to take away all fussiness' – was a necessary response to the artists' themselves being '*in* this brutal world, this hostile place', and finding themselves unexpectedly scared. Having gone out with some of the usual cultural baggage, 'having seen *Jaws* and all the rest of it', they found that once there, along with the fear, they were overwhelmingly aware of the shark's form and beauty: 'you see it buoyed up in its own environment, and there it's perfection'.[65]

Comparisons between this project and Hirst's tiger shark are perhaps inevitable. While in no sense directly critical of Hirst's work, Olly and Suzi do suggest that his strategies of distancing himself from the living creature ('I'd like to be able to order one over the phone . . . That would be perfect')[66] mean that he necessarily misses something of what they call 'the wonder, the horror' in the encounter.

The shark cage is just a means of getting at that wonder and horror. Like Deleuze and Guattari's anomalous animal itself, the cage is no more than 'a phenomenon of bordering', a flimsy edge, a means of physically rendering what Olly and Suzi most value in art – its 'ability to make us think'. The cage is the marker of what binds the artists (and the photographer) to the depicted animal, the anomalous of the 'pack', in a temporary and precarious alliance, a momentary block of becoming, bound by fear and excitement on one side, and by curiosity on both. Here, in a manner quite unlike Bacon's or Hirst's caging strategies, cagedness does not mark off an inside from an outside, nor a looking subject from a looked-at object, but instead constitutes a phenomenon which enables the animals as much as the artists to get a good look at the other: 'to see it better', as Bacon has it.

LEOPARDS IN THE TEMPLE

Becoming-animal's importance lies in the opportunity it offers to think differently about humans and animals, and that different thinking will take unpredictable forms. More specifically, however, and in contrast to some recent theoretical work on cyborgs, hybrids and monsters, it describes an experience of the world which does not *dissolve* bodily identity, but which means that identity is not the thing to which

Becoming animal vs. cyborgs, hybrids, monsters

the participants in the alliance of becoming-animal attend.
Separate bodies enter into alliances *in order to do things*, but are
not undone by it. The wasp and orchid, after their becoming,
are still wasp and orchid; Madelene and Erasmus, after their
flight across London, are still woman and ape. Ironically, even
Haraway's chosen image of the cyborg (illus. 54) is of the still-
distinct forms of woman and animal in alliance.[67]

Something similar may be said of Kafka's parable
'Leopards in the temple', which reads: 'Leopards break into
the temple and drink the sacrificial vessels dry; this is
repeated over and over again; finally it can be calculated in
advance and it becomes a part of the ceremony.'[68] Adam
Phillips offers an interesting commentary:

6 The Animal's Line of Flight

We need animals. Animals don't need us, but we need them. We constantly look for any kind of connection we can possibly get to them.
BRITTA JASCHINSKI [1]

Here is a complex and initially perplexing image, focused and yet at the same time obscure. A creature of broadly elliptical shape swims across the lower half of the image, a trail of air bubbles running off its back. Behind it, a column in the cloudy water; above it, the glint of the water's surface, the shallow ellipse of the platform on top of the column, just clear of the water, and in the background the hint of a line of trees beyond the water's edge. The detail above the water is obscured by a dripping field of condensation on the glass or perspex separating the viewer from this creature and the symmetry of its habitat. The sleek form of the thing itself reads almost like a fish by Brancusi which has somehow managed to swim free of its pedestal, except for the fact that this fishlike swimmer is (the mind running quickly through the options) neither fish, nor turtle, but a bird: a black-footed penguin photographed by Britta Jaschinski in a zoo in Hanover (illus. 55).

The image will serve to introduce a very specific problem arising from the previous chapter's discussion of the process of becoming-animal. The problem is this: for postmodern artists dealing with animal imagery, and engaging critically with the relation of that imagery to questions of (human or animal) identity, how is the *form* of the animal to be represented? Using examples drawn principally from the work of Jaschinski and of Francis Bacon, this is the issue to be explored here, tracing a movement (in the work, or project, of animal representation) from animal 'form' to what Deleuze and Guattari would call the animal's 'line of flight'.

ANIMAL FORM VERSUS BECOMING-ANIMAL

Previous chapters have drawn attention to specific characteristics of the representation of the postmodern animal in art: notably its awkward but tenacious holding-together, holding-

135

to-form, holding to visibility and recognizability *as some kind of animal*. This ability to hold-to-form has been of importance for a wide variety of artists – 'we need animals', as Jaschinski concisely puts it – whether to express and represent ideas about the condition of being human or, on the other hand, about the condition of being animal.

55 Britta Jaschinski, *Spheniscus demersus* (1994), from the series *Zoo*, photograph.

This project, if such a diverse range of practices may be so called, is thrown into serious question by Deleuze and Guattari's comments on *form* in relation to becoming-animal. Not unreasonably, they take the view that it is subjects which have forms, and if there is one thing which the becoming-animal works against it is the whole 'anthropocentric entourage' of the individuated subject.

In *Kafka* they had proposed that to become animal is 'to find a world of pure intensities where all forms come undone', as do all meanings. This accounts for their fascination with 'pack modes' and other forms of animal multiplicity: individual, recognizable animals are 'still too formed, too significative, too territorialized'. In *A Thousand Plateaus* they go on to define bodies not in terms of their forms but in terms of what they can do. 'We know nothing about a body until we know what

136

it can do, in other words, what its affects are.' In a counting of affects, they propose, for example, that a racehorse 'is more different from a workhorse than a workhorse is from an ox'. They seek a way of describing bodies in terms of elements which, rather than having form, 'are distinguished solely by movement and rest, slowness and speed'.[2]

Speed and movement are in fact crucial to their thinking, and are closely caught up in the affects of art: to 'make your body a beam of light moving at ever-increasing speed' is something which 'requires all the resources of art, and art of the highest kind'; the kind of art, that is to say, through which 'you become animal'.[3] This emphasis on movement may already offer a clue that a rethinking of animal form might happen not so much *within* a particular representation, but rather in a movement *across* images, across species, across the process of viewing – in just the kinds of traversal that constitute becoming-animal, in other words.

Deleuze and Guattari's interest is in 'intensities, events and accidents that compose individuations totally different from those of the well-formed subjects that receive them'. Their examples are suitably unbodylike: 'A degree of heat, an intensity of white, are perfect individualities.' Individuations experienced as 'speeds and affects' are of a quite different order from those of 'forms, substances and subjects'. They are not subjects but *events*. It is a matter of moving from one perspective to the other: 'It is the wolf itself, and the horse, and the child, that cease to be subjects to become events.' Like a work of art, this alternative to identity and to identity-thinking is a willed thing, a worked-on thing: 'You are ... a set of nonsubjectified affects. You have the individuality of ... a climate, a wind, a fog, a swarm, a pack ... Or at least you can have it, you can reach it.' Art's rethinking of the body therefore necessarily includes a rethinking of the artist's own body.[4]

Admirable and imaginative as such creative practices may be, they fail wholly to address the problem they create for artists whose concern is to represent animals. What is left of the *look* of things if form itself really is bound up with negative or reactionary thinking about identity? If postmodern art can address becoming-animal, as much art which deals critically with identity may wish to do, what could the animal in such art possibly look like? How could it be recognizable as animal, without resorting to form?

The movement of becoming which Deleuze and Guattari describe (and appear to recommend) is given concisely in the words of their chapter title: 'becoming-intense, becoming-animal, becoming imperceptible . . .' Movements, becomings and affects 'are below and above the threshold of perception'.[5] In order to get to something more practical than this rhetoric of the imperceptible, however, it will be worth pursuing the parallels between art and becoming as forms of creative practice.

For Deleuze and Guattari, *what becoming-animal does is close to what art does*. In becoming-animal, certain things happen to the human: becomings-animal may be thought of as 'traversing human beings and sweeping them away', and the 'reality' of these becomings-animal resides 'in that which suddenly sweeps us up and makes us become'. Of any becoming, they write: 'We can be thrown into a becoming by anything at all, by the most unexpected, most insignificant of things'; becoming is a deviation from the 'majority', prompted by 'a little detail that starts to swell and carries you off'.[6]

This being swept up, swept away, suddenly, unexpectedly, with which the human nevertheless goes along, as if willingly, resembles some of what Deleuze and Guattari say about art. They are concerned, of course, that their position should not be mistaken for a depoliticized latter-day romanticism, insisting for example that for them 'Art is a false concept, a solely nominal concept', and elsewhere that 'art is never an end in itself'. Nevertheless, art has its proper (but selfless) politicized work to do:

> it is only a tool for blazing life lines, in other words, all of those real becomings that are not produced only *in* art, and all of those active escapes that do not consist in fleeing *into* art, taking refuge in art, and all of those positive deterritorializations that never reterritorialize on art, but instead sweep it away with them toward the realms of the asignifying, asubjective . . .

Art is a means of getting to the animal, getting to asignification, getting beyond meaning, by means of 'sweeping', 'blazing', 'becoming'. The various arts 'have no other aim' than to 'unleash' becomings. Art, it seems, consists in letting fearsome things fly.[7]

This is very much how Hélène Cixous also describes the

exhilarating and selfconsciousness-erasing force, or 'breath', which unexpectedly launches the writer into writing:

> Because it was so strong and furious, I loved and feared this breath. To be lifted up one morning, snatched off the ground, swung in the air. To be taken by surprise. To find in myself the possibility of the unexpected. To fall asleep a mouse and wake up an eagle! What delight! What terror. And I had nothing to do with it ...[8]

Part of Deleuze and Guattari's particular concern about form is their suspicion that in handling animal form, artists are merely *imitating* the animal from a safe distance. Mere imitation has nothing to do with the intense and thorough-going experience of becoming-animal. Artists cannot remain detached, but (as the example of Cixous suggests) are caught up in the lines of flight their work initiates: 'The painter and the musician do not imitate the animal, they become-

56 Lucy Gunning, Video still from *The Horse Impressionists*, 1994.

139

animal at the same time as the animal becomes what they willed.'[9]

Despite the insistence that becoming 'is never imitating', art's 'imitation' of the animal may nevertheless on occasion subversively establish its own proper relation to becoming-animal, its own affirmation of involvement. In Lucy Gunning's video *The Horse Impressionists* (illus. 56), the four women imitating the sound and movements of horses cannot stop laughing. Deleuze and Guattari themselves recommend that art be approached with 'a great deal of involuntary laughter and political shuddering'.[10]

The avoidance of imitation is, however, the rule, and art's audience is inhabited by becomings-animal as much as is the artist, as in this example: 'Becoming is never imitating. When Hitchcock does birds, he does not reproduce bird calls, he produces an electronic sound like a field of intensities or a wave of vibrations, a continuous variation, like a terrible threat welling up inside us.'[11]

It is a matter of recognizing and accepting the full extent to which this asubjectivity applies to everyone. This is not an altogether unfamiliar picture: art as, and at the cost of, a letting go of identity and of certainty. Adam Phillips expresses something very similar in a remark which links art with everyday experience, and which acts as a reminder of the intimate connection of identity-thinking and expert-thinking: 'only by absolutely losing something – "an image that you will never retrieve" as Bacon says – do you get the surprising thing'.[12]

THE FIGURAL

Bacon, of course, is himself the subject of Deleuze's (still untranslated) 1981 book *Francis Bacon: Logique de la sensation*. The book adds little to the picture of becoming-animal which was developed in *Kafka* and *A Thousand Plateaus*, but it does offer a possible way forward on the question of how artists might deal with animal imagery, without resorting to the identity-based conception of form which Deleuze and Guattari would see as contrary to the work of becoming-animal.

Deleuze proposes, with regard to Bacon's paintings, 'to oppose the "figural" to the figurative'. This important distinction has been very clearly summarized by Ernst van Alphen:

140

Bacon does not pursue the figurative in his work. He does not paint characters, but *figures*. Figures, unlike characters, do not imply a relationship between an object outside the painting and the figure in the painting that supposedly illustrates that object. The figure *is*, and refers only to itself.[13]

Bacon's 'figural' figures therefore have at least three things in common with the becoming-animal. In not being characters, they do not have the characteristics of a subject. In simply dumbly existing, they are not aiming to set up meanings, references or interpretations. And most importantly, in being neither characters nor representations, these figures (which certainly *have* a pictorial form – it would be absurd to deny this) are not echoing or representing the form of an individual subject with a reality outside Bacon's art. They correspond to Deleuze and Guattari's example of the entirely real possibility of becoming an animal that does not itself exist: dragon, chimera or whatever.

The figural is Deleuze's way of describing *what the body does* in Bacon's paintings, almost all of which include body images, most of which are human. For all their non-referential *there-ness*, these bodies are certainly read by Deleuze as active things with work to do. They have to find a way to constitute themselves within the picture: 'the body . . . expects something of itself, it makes an effort to become Figure'. The body is thus both 'a source of movement' and an 'event'. Echoing the importance of lines of flight to the becoming-animal, the body's work in Bacon's paintings is also to be understood in terms of escape (from itself or from the cage-like structures which often confine it). 'The body endeavours precisely . . . to escape'; 'the Figure is . . . the deformed body which escapes'.[14]

For Deleuze, then, the figural accounts for the 'look' of the body in Bacon without its in any sense being the representation of that Oedipal *bête noire*, the 'well-formed subject'. It attempts to describe the painting of a becoming rather than of a body with a fixed identity. In this respect it does offer an answer of sorts to the question of how the imaginative postmodern artist might present the animal in whole and recognizable form (thus affording it the 'dignity' of resisting the dissipation of abjection, of becoming-meat, becoming-undifferentiated) without resorting to an uncreative identity-thinking. The answer is that there can be a holding-to-

recognizable-animal-form in art, but it is one which *presumes nothing* about a correspondence between that form and that of any particular 'real' animal subject.

To the extent that the postmodern animal can be thought of in terms of 'botched taxidermy', as an earlier chapter suggested, this solution works perfectly well. It remains to be seen whether or how it can usefully be extended to the very different circumstances of, for example, Jaschinski's photographic representation of a particular living black-footed penguin. Bacon's and Jaschinski's dealings with animal form will now be addressed in turn.

THE FORM OF BACON'S ANIMALS

At the level of form, of course, there is a significant distinction to be drawn between Deleuze's account of 'the Figure', which is mainly concerned with the look of the *human* body in Bacon's work, and *The Postmodern Animal*'s account of holding-to-form, which is mainly concerned with the look of the *animal* body in recent art.

That these two bodies traverse each other constantly in the way artists address 'becoming' is not in contention. But if becoming-animal is really to be understood as something which affects 'the animal no less than the human',[15] the small number of unambiguously animal bodies in Bacon's own paintings may be of particular interest. They feature in less than a dozen paintings, which include *Figure with Ape* (1951), a couple of versions of *Dog* (1952), *Man with Dog* (1953), *Study of a Baboon* (1953), *Chimpanzee* (1955), *Two Studies of George Dyer with Dog* (1968) and the two versions of *Study for a Bullfight no. 1* (both 1969). Leaving aside a more extensive list of animal references in Bacon (bat-like shadows, ambiguous bird-like forms, and composite figures such as sphinxes, for example), this select group of mainly very early images are those which include named and recognizable animals.

A generalization might be hazarded about these animals. It is based on an impression left in the mind after looking at them, rather than on detailed formal scrutiny of the works. In contrast to the painterly violence done to most of the human figures in Bacon's work, in the early paintings as much as the later ones, these animals hold-to-form to a considerable degree. The animal holds-to-form; the human does not.

142

Animal form is allowed to be and to stay what it is. Circumstantial support for the idea may be drawn from a book owned by Bacon. Contrary to the evidence of a frequently reproduced single grubby paint-splattered photograph of a rhinoceros recovered from the floor of Bacon's studio, his copy of V. J. Staněk's photographic survey *Introducing Monkeys* is in good clean condition, the photographs all unmarked. Although Bacon used this book as a notebook of ideas for future paintings – several of them unrealized animal paintings ('camel lying down in middle of circle of sand', 'chimpanzee standing in middle of carpet', 'owls with meat in circle', 'chimpanzee moving through long grass'), the ideas dating from December 1958 – his notes are scrupulously kept to either end of the book, well clear of the reproductions.[16]

The animal holds-to-form; the human does not. In Bacon this is even true of the animal *as meat*. The animal carcasses in *Painting* (1946), *Figure with Meat* (1954), and the *Second Version of Painting 1946* (1971) each hold their shape, hold-to-form, whereas the peculiar (and presumably human-of-sorts) crucified carcasses in the right-hand panel of *Three Studies for a Crucifixion* (1962) or in the central panel of *Crucifixion 1965* are deformed and mutilated in much the same way as so many of Bacon's 'living' human figures.

If there is anything in these distinctions, it is not registered by Deleuze, whose principal concern is with the fluidity or insubstantiality of form. Thinking of the *Two Studies of George Dyer with Dog*, he writes: 'It can happen that an animal, for example a real dog, will be treated as the shadow of its master.'[17] This is fair comment (though in fact the sprawling form of the sleeping dog takes on increasing solidity as the eye follows it away from Dyer's feet), but it is hardly representative of Bacon's animals.

In the case of the 1953 *Man with Dog* (illus. 57), for example, which Deleuze also illustrates, the painting seems to show quite the opposite: the man's legs scrubbed out, rendered insubstantial, a human 'shadow' cast off or sloughed by the painting's undoubted 'Figure', the dog. The upper part of the man's body has in addition been obliterated, swept away, by a swathe of paint at the top of the painting; all that remains is the pale memory of the legs and (in the absence of a hand to grip it) a lead which will no longer hold the dog.

It is in any case hard not to read this whole painting, to

57 Francis Bacon, *Man with Dog*, 1953, oil on canvas.

Bacon's credit, as a kind of act of revenge for the indignity heaped on the animal in the painting's absurd precursor by some forty years, Giacomo Balla's *Dynamism of a Dog on a Leash*. In place of the sentimentality of Balla's dachshund is the seriousness of Bacon's mastiff, reworked from a Muybridge photograph. To say this, of course, is a judgement neither on the breeds of dog nor on the respective sexes of the humans walking these dogs. The sentimentality and seriousness are all in the *painting* of these animals, in the handling of the material, in the dogs' very styles of holding-to-form. Bacon's dog is, so to speak, sober; and for Deleuze and Guattari it is precisely 'through the force of sobriety' that 'one becomes an animal'.[18]

Far from being 'treated as the shadow of its master', the dog in *Man with Dog* has held its form almost exactly from the previous year's *Dog* paintings. Together they trace a movement, a line of flight, in their own constitution of the figure of the dog. In sloughing the adjacent human form this last dog could even be viewed – if Bacon's work is to be treated, somewhat cavalierly, as a repository of proto-Deleuzian becomings-animal – as the figure of the anomalous animal with which the man has struck an alliance, leaving behind his human 'form' as no more than a hazy shadow as he is swept up into becoming-animal.

THE FORM OF JASCHINSKI'S ANIMALS

Movements, trajectories or lines of flight can be traced in the form of the animal in Jaschinski's photographs as much as in Bacon's paintings.

The images collected in her book *Zoo*, which date from 1992 to 1995, are varied in style and composition but frequently show the animal in the artificiality of its surroundings (illus. 55). Her own brief comments in the book refer to the child's instinctive recognition of 'the unnatural minutiae of incarcerated life' in the zoo. She suggests that her photographs, while far from being didactic, may embody something of the 'strains of unease' felt by many zoo visitors. Reflecting 'the dark and fetid corners' of the animals' enclosures,[19] the *Zoo* photographs themselves are overwhelmingly dark, drawing the eye to the animal itself as the object of display. A 1995 photograph taken in a New York zoo, for example, shows the bright white head of a beluga whale peering through a gap between the geometrical rigidity of what appear to be two huge sheets of corrugated iron, which fade into darkness at either side of the image.

Jaschinski's subsequent animal images are significantly different. A sequence of photographs from 1996, collectively titled *Animal*, present the animal as an obscure dark presence in the centre of a field of unfocused light, or surrounded by a halo of it (illus. 41 and 58). The artist herself is not especially keen on comparisons of her earlier and more recent work, but in fact something important seems to happen in that broad shift from *Zoo* to *Animal*, from dark to light, from the animal sharply illuminated to the animal in hazy silhouette.

In both cases, it might be suggested, power resides in darkness. In the earlier photographs, the only instances of the animal having, as it were, any real say in how it is seen are those in which it hides away in an obscure corner, frustrating expectations of the viewing experience. In the *Animal* images, the aesthetic experience is of the creatures drawing that power into their own dense black centres, internalizing it, incorporating it, keeping knowledge of their bodies to themselves, and refusing to be drawn on what it is that they are. The elephant only slowly takes shape as such; the gorilla virtually refuses to do so at all. In contrast, those of the *Zoo* photographs which most clearly spotlight the animal – pinning it down as an object of visual knowledge – may well serve to highlight the melancholy of its captive life but may contribute less to Jaschinski's longstanding fascination with 'how mysterious animals are'.[20]

The shift from *Zoo* to *Animal* might equally be read, in terms of the present chapter's epigraph, as a shift away from the exploration of humanity's need for animals and towards finding a visual vocabulary with which to address animals' unconcern with humans. This is even more markedly the case with the large body of animal photographs, provisionally entitled *Beast*, on which the artist has been working since

58 Britta Jaschinski, *Untitled* (1996), from the series *Animal*, photograph.

1998. Many of these again make use of extensive empty white space around the animal (illus. 59).

Questioned as to how she regards the status of the animals in these images, Jaschinski explains: 'Initially the idea was not even representing a species, but just a creature – anything but the human being, basically; *anything.*' In not wanting these works to be 'in any way to do with human beings', they continue a move away from the human which is evident throughout her animal imagery. It is generally only in the earliest of the *Zoo* photographs that stray humans (keepers or visitors) are occasionally glimpsed. The work since *Zoo* is increasingly determined to remove all trace of human architecture, in an attempt to focus solely on 'the actual existence of the animal': 'This is what the work is really about, saying look at them, they've got their own existence and personality and they've got their dignity and their beauty. It's just about their rights, really.'

Although this determination to address the specificity of the animal means that some of the images which make up *Beast* are regarded by Jaschinski as portraits ('it's about that very gorilla'), others are openly ambiguous. In one, the body of a zebra could almost be mistaken for that of an exotic translucent fish; in another, the ears of a llama have more than

147

a passing resemblance to the wings of a butterfly. She says of her gibbon photograph, *Hylobates lar* (illus. 59), that 'it really doesn't matter' that it is sometimes mistaken for a frog.

Some of the images are deliberately disorienting: 'That's what I'm interested in – on first glance you don't even recognize it as an animal.' In this sense they come close to Deleuze's account of the figural in Bacon's paintings, displaying exactly that lack of concern with whether or how the imaged body corresponds to that of an actual being with a life outside the image. The work of the image lies elsewhere, and its ability to convey information or ideas about bodies, without those bodies necessarily matching recognizable categories of zoological classification, is precisely what interests Jaschinski so much in Francis Bacon's work: 'I think it's the rawness, and the fleshiness . . . Really it's the rawness: you see a lump of something and you don't even know what it is, but there's so much pain in it.'

FORM AND FLIGHT

It was suggested earlier that the animal's (or indeed any body's) holding-to-form in postmodern art might be at odds with that represented body's ability, as Deleuze and Guattari understand it, to become-animal, to be swept up out of its Oedipal identity.

Deleuze's partial solution to this, as has already been seen, is the idea of the figural. And the figural depends, quite importantly, on the *isolation* of the 'Figure' in space: without it, the depicted body would inevitably take on a '*figurative, illustrative* and *narrative* character'.[21] Deleuze simply follows Bacon's own views in proposing this. Jaschinski's *Beast* photographs move towards isolating their animal figures in empty space for a similar reason: to distance the animal from clues in its surroundings which would make it more readily meaningful in human terms. Form and flight are not at odds here: the animal's isolated form is the means by which it aspires to its flight from meaning.

Deleuze's alternative solution, which he admits is of less use to artists who want to deal with the body, is to move 'towards pure form', towards abstraction.[22] Such a strategy would in fact be close to that aspect of the becoming-animal's line of flight which takes it away from individuality and

148

towards 'pack modes' and similar multiplicities, on its way to
'becoming-imperceptible'.

For Deleuze and Guattari the pack 'is the path becoming-
animal takes', and the assertion that 'every animal is funda-
mentally a band, a pack' does not exclude the human.[23] This
offers its own opportunities for how art might represent the
fragility of human meaning and control: bound up with the
animal pack, the human experience of becoming-animal will
not necessarily be a comfortable or reassuring one, or go
according to plan. In Daniel Mann's film, Willard is eventu-
ally consumed by the rats with which he has entered an
alliance (as indeed is the eccentric figure of Minot, who

149

prefers the company of his rats to that of humans, in Michael Dibdin's novel *A Long Finish*). And in Sue Coe's image of *Modern Man Followed by the Ghosts of his Meat* (illus. 47), the expression on the hamburger-clutching man's face suggests not so much a sudden onset of guilt as the fear of a similar threat from the motley pack to which he has bound himself in an alliance of incorporation.

The further stage, of becoming-imperceptible, is more visually problematic. Pushed to the extreme of imperceptibility, what would the trace of the postmodern animal look like? The question is not wholly rhetorical: one answer is that it would look very much like Bacon's 1983 painting, *Sand Dune* (illus. 59). The figure, in *Sand Dune*, has ceased to be a 'well-formed subject' and has become an event. It would be hard to find a clearer image of becoming-animal.

The painting is one of a handful of late works by Bacon which do not have a central human or animal figure. Others are the 1979 *Jet of Water* (which Bacon interestingly described as having 'a sort of animal energy'),[24] and an earlier, uncaged *Sand Dune* from 1981. These two earlier paintings are mentioned in Deleuze's book on Bacon as examples of 'pure Force without object'. Deleuze certainly saw the closeness of these works to his own interests. In a subsequent short related text, published early in 1984, he described them as paintings 'wherein the Figure has in effect disappeared, leaving a trace', and he suggested that they seemed particularly rich 'in possibilities for the future'.[25]

It is not entirely clear, however, whether Deleuze had seen the 1983 version of *Sand Dune*. Unlike the jet of water and the first sand dune – remarkable as those images are – the importance of this second version lies in its record of (and its demonstration of the manner of) the Figure's escape from the cage which enclosed it. To borrow a phrase from *A Thousand Plateaus*, the dune is shown 'overspilling the limits of the signifying system'.[26] It is managing to do so precisely by 'becoming-intense, becoming-animal, becoming-imperceptible'. No longer a figure at all, the event of the painting sweeps through and up and out of the cage. It is the image of an individuality becoming-granular, becoming-flow, becoming-dune – in the place, the cage, previously occupied by a subject, a figure, a form, which is now well on its way to experimenting its way out.

150

Fascinating as this example may be (if the tentative reading offered here is allowed), it is of limited help in thinking about a more general re-imaging and re-imagining of the post-modern animal, whose line of flight will not usually take it completely out of visibility. There are other more provocative images which suggest the possibility of the animal's escape from the enclosure of human meaning while nevertheless holding-to-form.

In Caroline Tisdall's valuable book documenting Joseph Beuys's 1974 performance, *Coyote*, she records that in the René Block Gallery, where the performance took place, a 'heavy chainlink barrier separated the man and the coyote from the people who came and went all day. It came to mark an area of freedom for the protagonists, while ambiguously caging the spectators.'[27]

What is more notable now about the issue of caging in relation to *Coyote* is something which would not even have been evident to the spectators in the gallery. It is an effect of the book's extensive photographic documentation of the performance, mainly by Tisdall herself. Of over eighty photographs showing parts of the gallery space, the chainlink barrier through which the performance could be observed is visible in some form in twenty-three of them. In some it is sharply defined, but in eleven of them, on account of the depth of field

151

and point of focus, it melts away into no more than a hazy shadow, ghostly and spatially ambiguous, which wholly fails visually to keep the animal 'behind' it (illus. 61). The presence of the coyote's body is undiminished in these images; it is the defensive human barrier which will not hold.

It may well be objected that this chance photographic effect, which was entirely unintentional, is a poor basis for any kind of argument. Jaschinski's recent photographs, however, engage with just this kind of effect in a far more purposeful manner. Her own complaint about her gibbon photograph (illus. 59), which she otherwise likes, is that she 'can see the fencing'. While the high contrast employed in this and many of the other *Beast* photographs means that most background imagery is automatically bleached out, the blurry patterning across this particular creature's body is the trace of the fencing which in fact separated artist and animal, much as Tisdall was separated from the coyote.

Jaschinski is well aware that a printer would have little difficulty erasing or disguising many such minor traces of the human, but in her view such tampering would compromise the integrity of the images. Aside from her deliberate use of high contrast to achieve the basic effect of the animal's isolation from the human, she resists all further interference with the image: 'I want to be able to say that these pictures have not been manipulated, because otherwise people are going to get the wrong idea and think that everything in the image has been manipulated.' Although she therefore refers to the gibbon photograph as one with which she has problems, it is perhaps a fitting example of the difficulties faced in any artist's attempt to produce an image of *becoming*-animal. It records a moving away from the human – a process which Deleuze and Guattari certainly regard as creative, but which it might be naive to believe could be seen through to completion.

7 The Artist's Undoing

I fear that the animals consider man as a being like themselves that has lost in a most dangerous way its sound animal common sense; they consider him the insane animal, the laughing animal, the weeping animal, the miserable animal.
FRIEDRICH NIETZSCHE, *The Gay Science*[1]

Will Self's novel *Great Apes* is an exploration of the sustained and provocative reversal of certain everyday assumptions concerning the relations of humans and animals. The 'Author's note', which sets the novel in 1997, the year of its publication, begins:

> HoooGraa! We chimpanzees are now living through an era in which our perceptions of the natural world are changing more rapidly than ever before . . . Is it any wonder that in such circumstances the chimps who have given the whole question of animal rights their fullest attention have dared to consider enlarging the franchise of chimpunity to admit subordinate species, such as humans?[2]

The themes of the speed of postmodern culture, and of the ecological responsibilities which this new state of affairs entails, are therefore in place from the outset. The novel, it appears, is to be a satire on hierarchy-thinking.

THE ARTIST FACES THE ANIMAL

Many novels from the closing years of the twentieth century gave an important place to a blurring of the boundaries between humans and animals: they included Peter Høeg's *The Woman and the Ape*, Scott Bradfield's *Animal Planet*, Jeff Noon's *Automated Alice*, Marie Darrieussecq's *Pig Tales*, Kirsten Bakis's *Lives of the Monster Dogs* and Deborah Levy's *Diary of a Steak*.[3] Some of these did have isolated comments to make about the place of the artist in blurring these boundaries, but this was not their central concern. *Great Apes* addresses the question of the artist far more explicitly. It maps the postmodern artist and the postmodern animal on to each other,

not to create anything so comfortable as an identification between one and the other, but rather an uneasy alliance in which each traverses *and travesties* the other.

Simon Dykes, the book's central character, an artist who will wake one day to find himself transformed into a chimpanzee, has been working on a series of 'modern apocalyptic paintings' influenced by the nineteenth-century painter John Martin, full of bodies falling apart through disaster or disease or forgetfulness of their human status. 'In Martin's canvases', Self writes, 'the body was violate, or inviolate, but always violable. In Simon's the human bodies would be scarcely viable.' Dykes describes his iconography as 'a vile cavalcade of images . . . bodies thrown about, bodies burnt, bodies mashed and macerated'. By the time of the opening of his exhibition, well into the novel, not only the artist but also the human bodies in his paintings have mysteriously turned into chimpanzees. A chimp art dealer – for Dykes's whole world is now a chimp-world – describes the works thus: 'They're essentially paintings of bodily disintegration, destruction . . . as it were . . . *discorporation.'*[4]

The body, it seems, whether human or animal, in art or in life, will no longer imaginatively hold together, and that failure of form is perceived as infectious. The morning he wakes, still thinking himself human, to find that the world – and more particularly, his lover Sarah who lies alongside him – has turned chimp, turned into 'the beast in the bed', he is struck by a realization: 'It was the very *embodiment* of the thing that he simply couldn't stand. The very alien *embodiment* of it. The animal was upon him.' Dykes soon finds that there is no escape from this new perspective; it is 'the nightmare vision of a world gone bestial'. Most disturbing, however, is the fact that the geography and architecture of London is unchanged, the *Guardian* is still there to be read in the morning, but the clothed and civilized beings who run everything are now chimps. It is the near-familiarity of everything in this world that renders it so uncanny: 'Like a fucking P.G. Tips advert.'[5]

Beyond its clever inversions of the priorities of human and primate worlds, where postmodern chimps agonize over their politically incorrect 'primatocentrism', the novel is a more subtle analysis of identity-thinking which eschews 'presenting answers' to the questions it raises. Self has said of it: 'I think a modern satire cannot be necessarily a satire with even

a hidden moral message, but rather a modern satire has to have the message "think for yourself" lying beneath it'.[6]

It is not the main aim of the present chapter to do so, but it would be possible to offer a convincing reading of *Great Apes* as a fictional account of becoming-animal. All the key elements of Deleuze and Guattari's understanding of the process seem to be in place. It concerns an alliance between the human Simon Dykes and an animal, the chimpanzee Zack Busner, who is the doctor treating the artist's 'unusual delusion that he's a human'. Together they follow the line of flight of Dykes's becoming-animal. Busner is thus the anomalous or 'exceptional individual' (he is 'an extremely eminent chimpanzee – a great ape, in fact!', as another doctor tells Dykes) in the 'pack' of chimps which form not only Busner's extended family but also, it seems, the whole new civilized world.[7]

The alliance is quite explicit: when Busner's unconventional methods of treatment cause him to fall from favour, he acknowledges that he and Dykes 'were – in some sense – allies now, united against a hostile world, whether of apes or men'. Busner, as the anomalous animal, is also close to being a sorcerer, an artist. He explains that his work 'relates closely to the kinds of intuition and lateral reasoning employed by artists'. He likes to style himself a 'radical psychoanalyst', a 'maverick anti-psychiatrist', and an 'eminent natural philosopher'.[8] (Nothing in the novel suggests that it is deliberate, but from these descriptions his character could almost be taken as a parody of Deleuze and Guattari themselves.)

To a greater extent than Dykes, Busner therefore is (or would like to think he is) a postmodern artist in just the sense in which that term is understood by Lyotard, by Deleuze and Guattari, and perhaps most specifically by Cixous. He is, to borrow her words, one of 'those who create new values, "philosophers" in the mad Nietzschean manner, inventors and wreckers of concepts and forms, those who change life'.[9] In a sense he orchestrates the collapse of meaning in Dykes's world, revealing to him the absurdity of human pretensions. At the end of the novel they sit outside a camp in Tanzania which is running a programme to reintroduce captive humans into the wild; they share a bottle of Scotch, 'while all around them in the equatorial night, the humans yowled and yammered their near meaningless vocalisations, "Fuuuuuck-oooofff-Fuuuuuuckoooofff-Fuccckoooooofff"'.[10]

Some of the most significant ideas explored in *Great Apes*, however, take it beyond any such comparisons with the process of becoming-animal, and into areas which are arguably more central to an understanding of the postmodern condition. One of these is the theme, or motif, of 'lack-of-fit'.

LACK OF FIT

A character in a Philip Roth novel, who happens to be nicknamed 'the Monkey', declares at one point: 'that's what I really want to be: *so coherent*'.[11] Roth's novel predates *Great Apes* by almost thirty years, but the ability to cohere is exactly what Simon Dykes's experience of dislocation shows no longer to be possible for postmodern beings.

The motif of an unaccountable cultural dislocation and loss runs throughout Self's story. The realization of something being amiss comes some time before Dykes's metamorphosis: 'Whenever he stopped to contemplate his relationship to this body, this physical idiot twin, it occurred to Simon that something critical must have gone wrong without his noticing.' What he finds himself experiencing is 'the psychic and the physical ever so slightly out of registration'; this is what he calls 'that lack-of-fit'. Initially he puts it down to his systematic abuse of recreational drugs. Aware of how closely his own inner experience now mirrors the distorted attitudes of the bodies in his apocalyptic paintings, he is nevertheless unable to answer his own question: 'had the deregistration of his own body preceded, or followed from this?'[12]

If this dislocation has its most obvious source in the mind/body dualism of the Cartesian *cogito*, and therefore pervades (or at least haunts) the whole humanist tradition rather than being a specifically postmodern trauma, it is given a peculiarly postmodern twist in *Great Apes* as the human mind struggles with the unfamiliar animal form of the body in which it is only approximately housed. After his transformation into a chimp 'there was something awfully wrong with the way Simon was moving – as if his very limbs were unfamiliar to him'. But unlike the wholly alienating experience of Kafka's Gregor Samsa in the body of an insect, things here are more subtly, and thus more confusingly amiss: it was 'as if the limbs he were attempting to control were not altogether coextensive with those he actually had'.[13]

A striking moment of recognition takes place towards the end of the novel, at an exhibition opening in the Saatchi Gallery. Dykes, who has by then begun to adopt some of the mannerisms of chimp communication, comes across a display to which his initial response is '"Hooo" this is peculiar . . .' It is a display of 'various chimpikins':

> They weren't exactly statues – being constructed so far as Simon could see from plastic or latex – but nor were they conventional chimpikins. The lifesize figure nearest to them was arrested in mid-stride, attempting to depart its own plinth. White-coated, and brandishing a test tube, its scruff gave way not to a simian countenance, but an enormous, mutant, massy head . . . The other chimpikins were equally aberrant – a potato-headed figure, a Bugs Bunny mutant and a dodo. But strangest of all was the forlorn little figure of an infant human . . . It was covered with a most inhuman coat of patchy fur, and had hind paws with prehensile digits, one of which it was using to give itself an interminable mainline fix with a two-millilitre disposable insulin syringe.

Dykes remarks:

> These are all obvious remarks on the queering – as it were – of the natural pitch; the distortion of our bodily sense in response to the anti-natural way we, as chimpanzees, now live . . . like my apocalyptic paintings these chimpikins are alluding to some crucial loss of perspective, occasioned by the enforcement of a hard dividing line between chimp and beast.[14]

The particular interest of this episode, as far as understanding something of the *look* of the unfitting postmodern body is concerned, is that while Dykes's improbable images of apocalypse exist only in Self's text, these 'chimpikins' are drawn directly from works with an independent existence. They are in fact a thinly 'primatomorphized' reading of the actual pieces which John Isaacs had exhibited at the Saatchi Gallery in late 1996 and early 1997. These included *Say It Isn't So* (illus. 18) – one of the examples of 'botched taxidermy' discussed in an earlier chapter – as well as *Untitled (Dodo)* and *Untitled (Monkey)* (illus. 48 and 62).

Although Isaacs only learned later of the fictional transformation of his pieces, his interests and intentions are not

62 John Isaacs, *Untitled (Monkey)*, 1995, wax, hair, glass, syringe.

dissimilar to Self's. Unlike Self, however, he is obliged to find a suitably awkward animal form with which to give expression to the undoing of human pretension. His dodo's vestigial wings flap uselessly, as its head swings from side to side, driven by a noisy mechanism; Isaacs likes the idea of no-one now knowing exactly what the bird looked like. In *Untitled (Monkey)*, the chimpanzee's hands and 'feet' were cast from the five-year-old son of one of the artist's friends: 'The hands are really badly grafted on – there's no attempt to pretend that they're part of the same animal.'[15] These beings are in a sense a reaction against that idealized image of the animal made familiar by Hollywood's humanized animal stars, which are absurdly taken, as Margrit Brehm puts it, to 'personify the Good as such' and to stand for 'the better human being'.[16]

These creations emerge directly from what another writer calls Isaacs's engagement with 'collapsing scientific euphoria': 'For him biological and chemical weapons, nuclear catastrophe, BSE and genetic engineering are the cornerstones of a horrific edifice into which he introduces his sculptures, videos and photographic works as anti-subjects'.[17] These anti-subjects are engaged in complex work. Isaacs describes being 'utterly mesmerized by natural history' as a child, and he emphasizes, like Self's artist, the importance of recognizing the continuity – fragile and fractured as it now is – between an arrogant dominant species and the rest of the natural world:

> We are part of that, as much as we've removed ourselves from it, and in a way I want the work to be a reminder of that, because I think that a lot of the things that are done, the 'bad' things, are done out of a kind of amnesia, a sense of forgetting what life is actually about . . . I'd like the work to have this thump to it, hopefully, which kind of knocks people back to their senses. I don't like saying that, because it's like saying that I'm in a position to do that, which I'm not, but it's for me as well: I'm making it for myself too.

One of the particular reasons why animal imagery allows Isaacs to express these concerns is that while humans now live in a 'state of flux', with animals 'what you're looking at is the manifestation of a very long space of time'. Animals therefore offer something by which humans can 'measure' themselves and their actions: 'We're actually the displaced on this planet. Animals are almost part of geology.'

Certain animals invite the recognition of an alternative to the pattern and time of familiar experience more than others. Primates are not the best example. One of the reasons Britta Jaschinski does not object to the frequent misreading of her gibbon photograph (illus. 59) is that the viewers who mistake it for a frog are far less inclined to identify sentimentally with the animal. In the half-hour video which forms part of John Isaacs's 1998 installation, *The Theory of an Idea*, the eyes of a frog-like thing (the artist himself), half hidden by undergrowth, peer out through what looks like a thin mist clinging to the surface of a primeval swamp. Nothing happens; this is animal time (illus. 63).

Edwina Ashton's 1998 video, *Frog*, also explores the dislocation of familiar experience (illus. 64). Little happens in this seven-minute video other than the static frog's listing of a series

63 John Isaacs,
Video still from
The Theory of an Idea,
1998.

of unconnected objects. The ungainliness of its outfit is deliberate: 'I started off with a frogman's suit, but that was too human.' There is an attempt to put some distance between the artist and the animal: the figure in the costume is Ashton herself (but only because it turned out too tight for the person for whom it was made); the voice is someone else's. Her choice of animal protagonists, here as in *Sheep* (illus. 27), is based on what she considers to be 'very unappealing animals in the natural world'. These strange beings, which indirectly reflect her familiarity with and enthusiasm for Deleuze and Guattari's notion of becoming-animal, are deliberately without character: 'You couldn't psychoanalyze those patients, could you? The frog, or the sheep. There just isn't enough there for you to deal with.'[18] There is, however, in the frog's ping-pong ball eyes, a deliberate reference to William Wegman's version of the familiar animal made preposterously strange as a frog (illus. 32).

UNTHINKING IDENTIFICATIONS

The preposterous and arrogant assumption that humans can understand other animals is another of Self's themes in *Great Apes*. The group of Dutch 'animal rights fanatics' who visit the Tanzanian camp which is overseeing the return of captive humans to the wild are part of 'a pressure group denoted "The Human Project", the aim of which was to secure limited chimpanzee rights for wild and captive humans'.[19]

This is of course an explicit (albeit inverted) reference to the non-fictional project and organization, launched in 1993, called the Great Ape Project. Its stated purpose is 'to extend "the community of equals" beyond human beings to all of the

160

other great apes', by seeking support for a legal framework which would assure chimpanzees, bonobos, gorillas and orangutans – just like humans – 'the right to life, the right not to be tortured, and the right not to be imprisoned without due process'.[20] The project has come in for criticism, not least for what is alleged as 'a creeping speciesism' inherent in its primatocentric aims,[21] but its limited objectives are defended by its supporters as a pragmatic first step towards breaching the species barrier.

It would be very easy to read Self's satire as entirely hostile to this kind of enterprise. In fact, however, while insisting that he does not have the answers, he nevertheless believes that 'these are really vital issues that we really should be thinking about'.[22] It is the stupidity of unthinking identifications by which he seems angered. The Dutch chimpanzees from 'The Human Project' are satirized for merely *wishing away* the 'dividing line between chimp and beast':

> The Dutch chimps were grunting and pant-hooting, lip-smacking and panting, trying as best they could to impress upon the humans the joy they were experiencing at being in touch with them. While the humans, on the other hand, were merely garbling incoherently in their swinish way, 'Fuckoff-fuckoff-fuckoff-fuckoff', over and over and over.[23]

64 Edwina Ashton,
Video still from
Frog, 1998.

It is the scope for hypocrisy and delusion in the animal rights debate which Self succinctly proposes in this uncomfortable episode. His activists are so caught up in a sentimental *imitation* of the human that they fail to see that a respect for difference may depend on a certain fear of it, not on the inhumane and illusory elimination of it.

GIVING UP ART

Simon Dykes's own more imaginative response to his new animal world is marked by a more unexpected motif: giving up art. This is not exactly part of the novel's explicit plot, but it is marked unambiguously in the text. As the artist slowly and painfully comes to terms with his becoming-animal, his human artist-status is gradually sloughed.

Halfway through the book he is described as 'no longer an artist, merely a mental patient', and as 'the former artist' who must now confront 'the hell of another day among the apes'. For most of the chimps 'the former artist's spastic signing, his odd posture and lank fur, betokened mental instability'. As he gradually lets go of the self-consciousness of his former status, however, his perceived lack-of-fit (central to his identity as a postmodern artist) also goes. He starts being able to behave as a chimp. With some surprise he reports to Busner one day: 'I just "chup-chupp" swarmed up into these trees. I didn't stop to think. It was astonishing the sense of fluidity, of ease – and of power.'[24]

Self's motif of setting artist and animal apart, and of seeing art as something rather impoverished in comparison to becoming-animal, is found in other 'animal' novels of the 1990s. In Kirsten Bakis's *Lives of the Monster Dogs*, as the lives of those dogs begin to fall apart, their historian, Ludwig von Sacher, remarks: 'Perhaps if I were human I would be a painter.' Asked by a human friend why he doesn't therefore take up painting, the dog replies: 'Oh no. It is much too late for that.'[25]

Similarly, towards the end of Scott Bradfield's *Animal Planet*, Charlie the crow (an animal rights activist) and his close friend Buster the penguin are imprisoned for life for refusing to go along with an unprincipled political alliance of humans and animals. Asked by Buster, after a number of years, why as a crow he could not simply fly out of the prison,

Charlie explains that 'flight was not a function of wings, but an expression of the heart'. The crow now lacked the 'fundamental psychodynamics' required for flight: 'Belief in oneself. Belief in one's world. Belief in the abilities of language and body to carry a bird into dimensions it doesn't know about.' It is only after Charlie gives up hope of escape, of flight, and of being an animal in any meaningful sense, that he takes up oil painting, and takes on the melancholy identity of an artist.[26]

In all three novels the implication seems to be that in the 'wild' animal world, movement is embodied, unclumsy, and elegantly aesthetic. Only in the unnatural setting of the postmodern human world is art necessary as a poor approximation to this: an approximation which is echoed in the unfitting, dislocated and anomalous form of the artist's (drugged, imprisoned or monstrous) body. This sounds like a highly romanticized image, but in Self's case, at least, it may not be quite so straightforward.

MELANCHOLIA AND MOURNING

In mourning it is the world which has become poor and empty; in melancholia it is the ego itself.
SIGMUND FREUD, 'Mourning and melancholia'[27]

By the end of *Great Apes* there is an acceptance on Dykes's part, a letting-go of delusions, a realization that things won't change, either suddenly or significantly. It is a mourning for an old self that has forgotten that it *did not fit*, and which finds itself replaced by something fluent, fluid, graceful, articulate, poetic and embodied. Despite that change, this new self cannot quite overcome the perception of its body as ugly, abject and animal, and it is stuck with the sadness of knowing that *this is how it will be*.

It is because this is a sadness accepted, a mourning, that it offers a postmodern model of the artist-philosopher and not simply a return to a romantic one. Selves are undone, and cannot be put back together as they were. Dykes seeks what Gillian Rose has called 'the always missing, yet prodigiously imaginable, easy way'.[28] His is the anguish of mourning, of loss, of that which cannot be reversed: a coming-to-terms by carrying-on-becoming. The long slow process of his accepting his new animal status, and of mourning his lost human world, is inextricable from his giving up art. Self's account of the shift

from human artist to animal 'former artist' might be read as an aspect of the maturity required of the compromised beings who inhabit a postmodern world.

Freud's distinction between mourning and melancholia offers a useful way forward here, especially in Wendy Wheeler's explicitly cultural application of the distinction. 'What we call the postmodern seems to consist in the struggle between melancholia and mourning', she proposes. Summarizing Freud's understanding of the distinction, she continues:

> In melancholia, loss is perceived not merely as the loss of some other – whether a cherished person or a cherished idea – but, due to the narcissistic incorporation of the object in order to preserve it, it is perceived as *the loss of the self*. In mourning, the bereaved and shattered self learns to let go of what has made its world meaningful.

Where the melancholic, 'a *failed* mourner', experiences 'punitive and vicious self-loathing' and 'an inability to let go and move on', the mourner, 'although always utterly transformed by the loss of what was once held dear . . . is able to transform the shattered fragments of an earlier self and world, and to build something new from those fragments and ruins'.[29]

It is possible, therefore, in its broader 'cultural' application, to propose this as the distinction between a *possessive* melancholia and a *creative* mourning. On this basis it is possible provisionally to characterize some of the attitudes and practices discussed in *The Postmodern Animal* as tending towards either the melancholic or the mourningful. Positions associated with a clinging to old certainties, such as all forms of expert-thinking, are melancholic. So too, therefore, may be those stances within animal advocacy which presume to represent animals' proper interests and rights with undue inflexibility – as indeed, in their very different claims to understand the animal properly, will be the forms of arrogant bad science which so offend artists such as Isaacs. At the other extreme, the practices of abject art which (perhaps out of a desperation to express the idea of a postmodern world beyond repair) reduce the animal to a mass of bloody meat are also deeply melancholic. As Freud himself noted, the 'complex of melancholia behaves like an open wound'.[30]

If the motif of giving up art is, on the contrary, on the side of a healthy or creative mourning, it is simply because it

164

represents a preparedness to let go of something precious and self-affirming. There is nothing inherently good about giving up art; if anything, as Wheeler notes, it is 'in art that mourning is to be accomplished' in the postmodern world. In her view 'the *successful* mourner is the one who finds "the ties which bind", and who is able to re-find coherence in a shattered world. What the successful mourner discovers is the possibility of symbolizing – that is, making a meaningful language of and for – the world'.[31]

For Simon Dykes, as a postmodern artist, the old vocabularies will no longer suffice. New models of the human and the animal have to be forged or 'symbolized'. This is very much to do with finding forms that can be bound together, and will hold together, with some kind of battered integrity and dignity. Such forms refuse melancholia's draining or dissolution of the self.

The animal image can sometimes work here as a postmodern and mourningful symbolization of the contemporary fragmented self. As in Isaacs's strange and compromised beings, which acknowledge the pull of melancholia as much as the need for mourning, the animal can give concise form to the tension between the post-romantic subject's recognition of its own dividedness, and its necessary work of coming to terms with loss by drawing its new and peculiar self together in order to get on with life.

8 Fear of the Familiar

. . . take your place, a cornered
Wolf in a wreck of squealing cats.
IAN HARROW, 'Gauguin to himself' [1]

Anyone who likes cats or dogs, Deleuze and Guattari declare in *A Thousand Plateaus*, is a fool. This view should not be dismissed hurriedly. First, because its authors are among the most serious thinkers of the last few decades on the question of the animal, and second, because the statement *'anyone who likes cats or dogs is a fool'* encapsulates something close to the *orthodox* position for postmodern artists and philosophers on this question. [2]

Though fearless in many respects, following as it does in the steps of those Nietzsche called 'we fearless ones', postmodern practice cannot quite come to terms with its fear of pets. This is part and parcel of its inability to leave animals alone, and this engagement with the animal is always a matter of bringing it into meaning. This runs counter, of course, to the way in which postmodernism tends to see itself: as the scourge of anthropomorphism, anthropocentrism and all other tendencies to reduce difference to sameness, the impure to the pure, the inhuman to the human and the strange to the meaningful.

The evidence, however, is clear enough. Where a characteristically postmodern dissolution of categories and boundaries might have been expected, postmodern orthodoxy on this subject turns out to follow the rather conventional positions taken by, for example, Edmund Leach in the 1960s and John Berger in the 1970s, in which categories and boundaries remain firmly in place.

THE PERSISTENCE OF ANIMAL CATEGORIES

In his famous 1964 paper on 'Animal categories and verbal abuse', the anthropologist Edmund Leach argued that language employed animal categories to 'discriminate areas of social space' in terms of distance from the human. He proposed

166

the sequence *self, pet, livestock, 'game'* and *wild animal.*
Pursuing the thesis that 'we make binary distinctions and then
mediate the distinction by creating an ambiguous (and taboo-
loaded) intermediate category', and having noted that it is
invariably 'the ambiguous categories that attract the maxi-
mum interest and the most intense feelings of taboo', he
located pets as one such intermediate category, which he
designated with the compound term '"man-animal"'. Leach's
central theme, taboo, was defined by him as that which
'serves to separate the SELF from the world'; in these terms the
pet was set to figure as an improper or anomalous creature.[3]

This view is expressed in more emotive terms in John
Berger's essay 'Why look at animals?', initially published in
1977. Building on Lévi-Strauss's proposal that animals are
good to think, Berger argues that 'the first metaphor was
animal', and 'the first symbols were animals'. Noting the
importance of animal imagery in the *Iliad* to convey the vivid
nature of particular experiences, he suggests that *'without the
example of animals*, such moments would have remained inde-
scribable'.[4] (Derrida has more recently made a similar point
about there being a 'bestiary at the origin of philosophy',
including his own philosophy.)[5]

Berger's is a very moral essay, an ethical and proper medi-
tation on the place of the animal in relation to the human. One
of its most striking observations concerns the animal's
absolute and unbridgeable difference from the human. Berger
is adamant: 'No animal confirms man, either positively or
negatively.' In his view both the scale and the nature of
contemporary pet-keeping, however, complicate this proper
relation:

> The practice of keeping animals regardless of their useful-
> ness, the keeping, exactly, of *pets* ... is a modern innovation,
> and, on the social scale on which it exists today, is unique. It
> is part of that universal but personal withdrawal into the
> private small family unit ... which is such a distinguishing
> feature of consumer societies.

Pets 'are creatures of their owner's way of life', and Berger
says of 'the way the average owner regards his pet' that: 'The
pet *completes* him, offering responses to aspects of his
character which would otherwise remain unconfirmed.' Set
alongside the earlier assertion that 'No animal confirms man',

167

it could hardly be clearer that for Berger *the pet is not a proper animal*.[6]

There is of course an alternative view, forwarded by René Girard, that the holding of an ambiguous status is precisely the proper role of the domesticated animal. In his view domestication had its origins not in economic motives but in the desire for a ready supply of sacrificial victims for religious purposes. Leading 'a quasi-human existence', the animals chosen for sacrifice were ideally positioned to mediate 'between the community and the sacred, between the inside and the outside'. The length of time initially taken to domesticate particular species, and the unpredictable success or failure of that process, would have mattered little. All that was necessary was that the victim 'live among members of the community' and be integrated into certain of 'their customs and characteristic habits'.[7] Girard's long historical perspective has not been taken up widely, however, in the rhetoric of post-structuralism and postmodernism. The idea of the domestic animal – and most especially the pet – as an aberrant creature, a living betrayal of its properly animal potential or trajectory, is the one which has tended to hold sway.

This of course is Deleuze and Guattari's view (contemporaneous with that of Berger). Like Leach, they too have their categories. There are 'three kinds of animals', they confidently declare. Those they admire, which operate at the greatest distance from humans, in 'pack modes', are what they call 'demonic animals'. The wolf is their most frequent example. The second kind they call 'classification' or 'State animals', those whose fixed symbolic meanings serve exclusively human interests. And then there is the most contemptible kind: 'individuated animals, family pets, sentimental, Oedipal animals each with its own petty history, "my" cat, "my" dog. These animals invite us to regress, draw us into a narcissistic contemplation'. This is where they write: *'anyone who likes cats or dogs is a fool'*. The dog is the 'Oedipal animal par excellence', they say, but in a sense any individual animal is already too much a well-formed subject; thus their preference for packs and swarms.[8]

Their particular hostility to the pet stems, it seems, from how conveniently this kind of animal stands for all they despise in the expectations of an unimaginative psychoanalysis: family loyalty, obedience to the law and the possibility

of a world made meaningful by well formed and exhaustive interpretations.

Regardless of their actual familiarity with the detail of Deleuze and Guattari's writings, the attitudes of many other post-modern artists and writers play out very much the same rhetoric of the wild and the tame, the admirable wolf and the contemptible dog. It will come as no surprise that something very human is being addressed in this rhetoric.

Hélène Cixous gives her own account of the writer's proper concerns: 'The dark, wild, good-bad part in us; the beast-part in human beings.' For Martin Amis's character John Self, this dark side is also what humans seek in animals. This becomes apparent in his views on the naming of dogs: 'You don't want dogs called Spot or Pooch. You don't want dogs called Nigel or Keith. The names of dogs should salute the mystical drama of the animal life. *Shadow* – that's a *good* name.'[9]

For many contemporary artists, too, the way they deal with animals reflects the way they see themselves *as* artists: it is part of their self-image. Olly and Suzi's work, discussed in earlier chapters, combines a thrill at being in close proximity to dangerous animals ('it keeps us in check') with a genuine concern to draw attention to the plight of particular species: 'we're painters of modern *endangered* life', they have suggested. The fact that their points of reference are artists such as Joseph Beuys, rather than conventional wildlife artists, is perhaps reflected in the manner of their identification with particular kinds of animal. Explaining why domestic animals, moulded to human conditions and expectations, are of less interest to them than wild animals, they draw an analogy with the contrast between conventional and independent-minded people, distancing themselves from those who adopt a compliant '"yes, sir"' attitude in favour of a more obstreperous, or at least questioning, approach to the world around them. Some years earlier they had done some work dealing with Olly's pit bull terrier, but there, as they explain, 'we were intrigued by a domesticated animal that had a very wild nature'.[10]

What they describe is in many ways a Nietzschean attitude, though Nietzsche expresses it in less measured terms. Inciting

his readers (or at least himself) 'to *live dangerously!*', as 'preparatory human beings', his contempt is for whatever does not represent 'the wild animal in us': 'it is precisely as *tame animals* that we are a shameful sight', he insists.[11]

Unlike the romantic image of the wild animal, anthropomorphically epitomizing creativity, independent-mindedness and 'outsider' status, it is clear that the domesticated animal just *won't do* as the chosen image of the artist or philosopher, regardless of their sympathies for animals as such. Postmodern art's avant-garde roots are particularly evident here: it has no stomach for the safe, the tame. As Mark Cousins has pithily expressed it, it 'would have been the kiss of death for any avant-garde movement to announce that the subversion of traditional categories was undertaken in the interest of safety'.[12]

The result, in contemporary art dealing with what is still seen as such a riskily twee subject as the animal, often takes the form of a *lashing out* at domesticity and propriety as contemptibly safe and mediocre. This is perhaps seen most readily in the extreme (if coolly ironic) travesties of family life which Rebecca Schneider concisely names 'art bestiality'. Three examples: the kinetic figures in Paul McCarthy's 1992 tableau *Cultural Gothic* (illus. 15) have been described as follows: 'On a raised platform, a middle-class father figure stands behind his young charge, hands resting on the boy's shoulders; as Dad gives an encouraging mechanical nod, the son begins thrusting his hips at the hindquarters of a stuffed goat.'[13] Mike Kelley gives his famous 1990 photograph (illus. 40) the title *Nostalgic Depiction of the Lost Innocence of Childhood*. And Carolee Schneemann describes her 1991 video *Vesper's Stampede to My Holy Mouth*, and the related series of photographs called *Infinity Kisses* (illus. 65), in both of which her cat Vesper takes the role of her lover, as 'interspecies erotic imagery'. Schneider has suggested that despite Schneemann's long and influential career as a performance artist and filmmaker, the intimate documentary style of this imagery makes it difficult to read as art, and its force comes not from its being deliberately shocking and transgressive but rather from the fact that the 'multiplication' of possible sexualities which such work implies is 'presented as banally quotidian'.[14]

(At a more mundane level, the threat of pets to the postmodern individual's self-image can be seen in the cynical view that a sympathy for pets represents 'a "gratuitous perversion"

65–8 Carolee
Schneemann, Details
from *Infinity Kisses*, 1991,
140 photographs on
linen.

of natural behaviour',[15] in the defensive invention of mocking titles such as *Puppylove* for exhibitions of domestic animal imagery, and in an understandable desire not to be associated with the bizarre goings-on of the people who now call themselves 'furries', spend their lives dressed as cuddly animals and whose fantasies 'sometimes extend to actual bestiality' which they are keen to discuss on a growing number of internet sites.[16])

What prompts the strength of postmodern feeling against the pet? Perhaps, in part, the fact that while artists *want* art to be wild, it usually isn't. On the contrary, art domesticates the wild, and domesticates the animal. Once inside the sad safe space of the art gallery, neither Hirst's preserved tiger shark nor Beuys's live coyote can any longer carry the full weight of its wildness. And Robert Smithson's egalitarian but ludicrous question, '*Why should flies be without art?*',[17] seems only to epitomize how tame the role of the artist might be in relation to the animal.

There are of course other ways of addressing such questions. Mark Dion's anti-individualistic approach echoes work in contemporary environmentalism which has proposed, for example, that 'if the neatly edged fox is dissolved into her environment so that all we see is an ecosystem, our current ethical concepts do not really get a purchase'. Dion's perspective is also reminiscent of Beuys's insistence, in relation to his own work on bees, that 'you have to keep yourself from looking at one bee in isolation and saying "That's an individual". The bee is one cell in the whole organism.'[18]

In place of wild versus domestic as such, Dion puts the distinction between native species and what biologists classify as the 'r-selected' species. R-selected species are those often encountered in daily urban existence. They are able to move quickly into environments which have been disrupted by the arrival of humans and which no longer have many natural predators. The r-selected species themselves prey upon and displace the indigenous animal communities. They contribute, Dion notes, to the spread of disease, the destruction of crops and 'the drastic decline in biological diversity'. In the United States they include cats, rats, cockroaches, pigeons and some snakes. In terms of their contribution, along with humans, to the destruction of fragile relationships within ecosystems, he regards these creatures as 'detestable'.[19] His 1996 sculpture *Tar and Feathers* (illus. 49) appears to encapsulate this detestation.

And the definition he offered (in his 1997 lexicon) of the term 'cat' is certainly shorn of all sympathy: 'An animal which eats without labour, finds shelter without restrictions and gets affection without the slightest condition.'[20]

In contrast, it must be said, his account of the *wonder* of the wild is more conventionally romantic. In an interview he observed: 'On my first visit to a tropical rainforest, I was overwhelmed by its complexity and beauty. The alienness of the jungle, its awesome vitality – I was so impressed.' The view is perhaps surprisingly close to that of Olly and Suzi, who also speak of 'the wonder' of seeing animals in their natural environments, and who are unapologetic in their enthusiasm for the wild: 'The only thing that makes us tick is being out there in these raw environments – it's the thing that makes us want to make art.'[21]

Some sense or experience of the wild, it is clear, is still what most artists want. To put this a little flippantly, if the left-hand side of David Hockney's 1962 *Picture Emphasizing Stillness* (illus. 69) were gratuitously to be reinterpreted as showing a conversation between the postmodern artist and philosopher, the caption narrowly separating them from the leaping leopard – 'They are perfectly safe. This is a still' – might be rewritten to read: 'They are perfectly safe. This is a *wild* animal.'

69 David Hockney, *Picture Emphasizing Stillness*, 1962, oil and transfer lettering on canvas.

Although the significant rise of interest in animal rights issues in the late twentieth century (usually seen as dating from the mid-1970s) coincides historically with a growing cultural awareness of the idea of postmodernism, the politics and philosophy of animal rights have little in common with postmodern art's representation of the animal, with its apparent refusal to draw the line even at bestiality or butchery.

On the question of the wild, however, animal rights and postmodern thought increasingly find themselves in alliance. The example of two recent writers will suffice. Brian Luke complains that traditional utilitarian philosophy, on which supporters of animal rights have drawn extensively, typically pictures 'noble reason valiantly struggling to control base instinct'. He suggests that such a view risks presenting 'our sympathies for animals' as fundamentally unreliable, and animal liberation itself as 'a process of *taming* ourselves and others'. Disliking the 'authoritarian structures that promise this taming, through the domination of emotion by reason', he introduces the image of 'going feral'. For him this means humans rejecting their former 'domestication' by authority, evident in such practices as meat-eating, and instead expanding their natural human compassion for animals. They thus put themselves 'in the position of feral animals, formerly domesticated but now occupying a semiwild state on the boundaries of hierarchical civilization'.[22]

Linda Vance, too, is fascinated by such boundaries, evoking the forest both as her 'home' and as one of 'the wild places' in her life. The wild also has for her a more openly political and rhetorical role: 'what compels me to this wilder nature', she writes, 'this inaccessible or dangerous or remote nature, is indeed its wildness, its disobedience, its rowdiness, its resistance to the domination of men'. She praises the wild as 'useless, unyielding and free'.[23] In an essay specifically exploring 'the narratives imposed on animals by ethics', she sees the agendas of human meaning-making, whether or not they are sympathetic to the animal, as working against it, refusing to let it be. She explains that her concern 'is not to make us care about animals because they are like us, but to care about them because they are themselves'.[24]

It is not only in associating the animal with unmeaning that recent animal advocacy shares common ground with post-modernism. For both Vance and Luke, like postmodern artists, the rhetorical valorization of the wild is a means of outlining a space of creative freedom in which to act. Luke is quite explicit, seeing animal liberation 'as creative, not restrictive', and as extending 'possibilities for action' beyond established anthropocentric 'restrictions and controls'. Vance too is concerned to find space for the human experience of 'delight' and 'wonder' at the animal, and to argue that a proper 'ethical behaviour toward the nonhuman world is a kind of joyfulness, an embracing of possibility'. She sees it too in terms of a creative making: 'So sharpen your carving tools', she writes. '. . . Clear a space. There will be work to do.'[25]

The position both of the animal advocates and of the postmodern artists and philosophers discussed here is something like the psychoanalyst D. W. Winnicott's distinction between compliance and creative living. For all of them, it seems, the notion of domestication – for humans and animals – is redolent of externally imposed restrictions and the stifling of freedom and imagination, whereas the wild is virtually the epitome of healthy and purposeful creativity.

SENTIMENTALITY

What does it mean, exactly, to say that postmodern artists and philosophers fear pets? It is not that they fear the creatures themselves (though they may feel contempt for them). It is closer to what has been called 'anthropomorphophobia' – a fear that they 'may be accused of uncritical sentimentality'[26] in their depiction or discussion of animals. They seem almost unanimous in regarding sentimentality as a bad thing.

The sculptor and taxidermist Emily Mayer, for example, who herself has dogs, is typical in insisting that she does not feel at all sentimental about animals. And Olly and Suzi, while speaking with some affection of family pets, equally insist that 'sentimentality is baggage, and that's one of the things we want to be free of'. They also point out that when standing in front of a lion in Namibia, painting it from life, they 'don't feel very sentimental about it, it's not like a pet'. More generally, they suggest, when looking at the realities of death as well as life in the wild, 'it's hard to sentimentalize'.[27]

As with the rhetoric of the wild, the question of sentimentality reveals further common ground between animal advocacy and postmodern art. In his survey of attitudes to pets, James Serpell is one of many commentators to note that people who express concern for animal suffering or affection for companion animals are 'damned with the accusation of sentimentality, as if having sentiments or feelings for other species were a sign of weakness, intellectual flabbiness or mental disturbance'.[28]

Peter Singer and Tom Regan, figures central to the philosophy of animal rights and animal liberation in the 1970s and 1980s, were well aware of this danger, and were at pains to distance themselves from such views. In a classic Cartesian move, they set up reason and sentiment as opposing terms, and chose to side with reason. Regan stressed the need to make 'a sustained commitment to rational inquiry' rather than 'to indulge our emotions or parade our sentiments'. Singer's classic work *Animal Liberation* similarly asserted that reason was 'more compelling in its appeal' than 'kind feelings and sentiments'.[29] In the 1990s, feminist writings on animal advocacy persuasively criticized this anti-sentimentalist rhetoric. This was partly on account of the irony of its employing the same Cartesian dualism that sets up human and animal as opposing terms (to the disadvantage of the animal); partly because of its implicit sexism (Singer in particular is criticized for regarding sentiment as 'womanish'); and partly because their approach came to be seen as suppressing or denying 'emotional knowledge'.[30]

Two further points are worth making about this re-evaluation of the philosophy of animal advocacy. First, it did not so much remove the opposition of reason and sentiment as simply invert it, reversing the privileged term. Second, as has already been seen, it sometimes did so in language which valorized wildness and creativity (thus bringing it closer to postmodern orthodoxy), and which therefore still shunned the metaphor of the domestic.

In relation to art, however, the question of sentiment needs to be addressed in rather different terms. It is a matter not of sentiment versus reason but rather, to express it rather loosely, of sentiment versus seriousness. Here too, it is true, the accusation of sentimentality implies a state of being *too close* to the animal, having lost a proper sense of objectivity and distance,

but this is perceived more as a formal than an emotional problem, or at least as a rather complex combination of the two.

Sentimentality *matters*; its formal expression is a problem. Artists rightly fear appearing to be sentimental because it will be taken to indicate a lack of seriousness – a very proper concern. They demand a recognition of the seriousness of their formal concerns – even when, like Jeff Koons or Damien Hirst, they seem to adopt an ironic or detached stance. For a more self-consciously serious artist like Mark Dion, the wheelbarrow jammed full of stuffed toys in his *Survival of the Cutest (Who Gets on the Ark?)* (1990) simultaneously highlights what he calls 'the problem of charismatic megafauna' – the photogenic animals such as tigers, whales and pandas to which conservation groups tend to 'draw isolated attention' – and his own determination not to have his treatment of the theme judged sentimental in itself.[31]

Even for artists dealing directly with just such charismatic animals, however, formal rigour is central to seriousness. Olly and Suzi, questioned about their relation to established wildlife artists, acknowledge some shared concerns in terms of raising awareness of endangered species, for example, but have no wish to be confused with the many whose concern is 'to illustrate and prettify', as they put it. They also have a clear sense of what counts for them as serious subject matter: 'a woman walking down the road with a chihuahua is not really as fascinating as a white shark . . . because a pet like that seems to have become a bit "human"'.[32] The example may be clichéd but it is one which Deleuze and Guattari would recognize and approve.

Seriousness, then, is to be understood here in a Nietzschean sense. It is not, of course, the 'burdensome' academicism which he mocked: 'The lovely human beast always seems to lose its good spirits when it thinks well; it becomes "serious".' It is rather the 'good spirits' or 'gay science' of the inquiring mind, living dangerously, unfettered by moralities. As he contemptuously observes: 'It is not the ferocity of the beast of prey that requires a moral disguise but the herd animal with its profound mediocrity, timidity and boredom with itself.'[33]

Sentiment seems to go hand in hand with moralizing. In an inadvertent echo of Derrida's warning of the dangers of 'good conscience' in the philosopher's dealings with the animal, Roger Scruton emphasizes the selfishness lurking in

sentimentality, calling it 'another excuse for the noble ges-
ture'.[34] Not to sentimentalize; not to moralize; these are the
imperatives for the postmodern artist and philosopher.

Again, at least for the artist, this seems to be more a matter
of style than of subject matter. Compare, for example, the
work of Paula Rego and of Sue Coe. Rego's family subject
matter (illus. 70) – full of just the kind of Oedipal tensions for
which Deleuze and Guattari have so little time – has generally
been seen as neither sentimental nor moralizing.[35] Coe's far
more brutal subject matter (illus. 50) is frequently drawn
directly from life, in abattoirs and meat-packing plants. Her
drawings are, in Tom Regan's words, 'stark but compassion-
ate'.[36] In formal terms, that is no easy balance to hold. They
constantly risk being drawn close to a stylistic sentimentality
in order to express the artist's moral and political outrage
(illus. 71).

Coe suggests, entirely reasonably, that in this context the
accusation of sentimentality is typically used 'to prevent an
outcry against cruelty, to silence criticism against bad sci-
ence'.[37] But this view does not in itself necessarily aid the
difficult task – vital to an artist such as Coe if the seriousness
of her political analysis is to be recognized – of devising

70 Paula Rego,
*Wife Cuts Off Red
Monkey's Tail*, 1981,
acrylic on paper.

178

71 Sue Coe, *Parched Sheep* (page from *Porkopolis Sketchbook*), 1993.

animal representations which might be acknowledged, with some degree of reliability, as *being* ethically responsible without *looking* aesthetically sentimental. This opens, of course, far wider questions about the applicability of such regulatory notions as ethics and aesthetics to something as provisional and 'inexpert' as the postmodern animal.

LIVING INEXPERTLY WITH ANIMALS

People live inexpertly with animals. And if the postmodern condition does, among other things, signal a change in artists' relation to animals, it may leave such works as Hockney's recent and entirely sincere paintings of his pet dogs (illus. 72) looking, in some sense or other, like an outmoded expression of that relation. The problem may in one respect lie not so much with their admitted sentimentality ('These two dear little creatures are my friends', writes Hockney)[38] as with their particularity.

Most forms of contemporary animal representation, whether or not in lens-based media, fail effectively to communicate an animal's individuality, singularity or particularity (and this is generally not because such representations are intended to

72 David Hockney,
Dog Painting 25,
1995, oil on canvas.

reflect a postmodern mistrust of the very notion of individuality). There are two areas of image-making where this creates acute difficulties.

The first is the case of artists such as Hockney, Dave White or Judy Chicago drawing or painting their own pets, directly from life. Hockney explains of his dog paintings that 'everything was made from observation', and White similarly stresses that it is the 'contact' of direct observation which 'fuels the works' in his own case (illus. 73), though it is perhaps less evident in his finished pieces than in Hockney's.[39] The second is the case of artists such as Sue Coe, whose concern is truthfully and directly to record the conditions of animal suffering. Unlike an artist's pet, the particular suffering animal will probably not previously have been known to the image-maker but – as for all those who acknowledge a relationship between animal rights and animal representations – its independent individual existence is an important issue. Linda Vance argues in this context that any form of human meaning-making which leads to 'animals' particularity' becoming obscured 'is cause for concern to all of us who care for animals as individual entities and not abstractions'.[40]

Images produced in these two areas might be regarded, if the term is taken very loosely, as a form of portraiture. Their concern with the particular rather than the general or the ideal certainly seems to align them with such a genre. There are two significant differences, however, both of which are located at the viewer's end of the experience. One is that almost all

viewers, not knowing the particular depicted animal, and being able to make few effective distinctions between the physiognomic and pathognomic characteristics of individuals in *any* non-human species, may fail to take on trust the image's 'portrait' status. It may look to them like any dog asleep on a cushion, or any primate strapped up in a laboratory.

The second difference, following on from the first, is that the artist's insistence on the creature's individuality may be read as a kind of over-investment in the animal's appearance, and this in itself (almost regardless of the style of the image) may be taken by viewers as a sign of the artist's sentimentality. The outcome, ironically, is that viewers may see little effective difference between the 'particular' form of Hockney's or White's animals and, say, the playfully kitsch reading of 'ideal' form in some of Jeff Koons's puppy or poodle sculptures. (It is all too easy, of course, to overstate such differences: White, for example, expresses a definite interest in Koons's project, despite the apparent dissimilarity of their approaches.)[41]

Whatever the reasons, the postmodern audience for adventurous or challenging art has rather little time for animal imagery which is marked by sincerity, compassion and directness. Viewers' distaste or discomfort is not necessarily with those notions themselves, but with the formal vocabularies in which they are expressed. This may have less to do with elitist

73 Dave White, *Twiglet is a Scaredy Cat*, 1996, oil and chrome on canvas.

expectations than with an intuition that other vocabularies might be better suited to the expression of the animal's place in the fractured and inexpert practice of ordinary postmodern domestic life.

The critique of expertise presented in an earlier chapter, which saw it as an uncreative practice, is again relevant here. Living inexpertly with animals involves operating (though not necessarily consciously 'thinking') outside expert categories, and allowing that the animal may be doing so too. Academic studies of pet-keeping sometimes founder on exactly this point. In his important and influential article on 'The family pet', for example, Marc Shell assumes from the outset that the categories 'human' and 'animal' are distinct and secure, and that any conception of the pet must fit one or the other. 'For pet lovers', he writes, the 'interspecies transformation of the particular animal into a kind of human being is the familiar rule.'[42]

Popular books with titles such as *Pet-Love* lead Shell also to assume that the term 'love' best expresses the attitude of most contemporary pet-keeping humans towards their pets, and he ends up reading the relation of humans and their pets as both familial and sexual. By failing seriously to consider other looser (though possibly equally anthropomorphic) forms of association between humans and pets – notions of friendship or companionship might be the most obvious examples – his heavily category-dependent thinking leads him to propose bizarre rhetorical questions such as 'Is not bestiality better than incest?'[43] Shell's determination to cling so firmly to his human/animal distinction seems (in the terminology adopted in the previous chapter) unhelpfully and unhealthily melancholic.

Does contemporary art deal better, or differently, with these questions? Possibly so. Hockney's dog paintings – fine examples of a tradition of confident animal representations which continues to be popular and reassuring – nevertheless seem like the end of something. In contrast, it may be that the so-called 'botched taxidermy' examples discussed earlier in the book offer a glimpse of a way forward, an alternative to Deleuze and Guattari's image of the Oedipal animal.

The botched taxidermy animals do not seem to *know* what they are doing, what beliefs or attitudes they stand for, let alone what categories they do or do not fit. Of the examples

discussed, at least one was a pet: Wegman's dog Man Ray, in the preposterous guise of a frog (illus. 32). The crucial point here is that unlike Hockney's sleeping dogs, Man Ray is not seen there as a pet. He is not placed in a hierarchical relationship with the artist. Anthropomorphic as the observation may be, the dog's role seems often to be (at the very least) that of co-conspirator. His identity, his status, refuses to settle. As Wegman has said of just such deliberately disturbed identities in his work, 'I like things that fluctuate'.[44]

Wegman has also suggested that Man Ray 'diverted' the artist's narcissism, offering him the opportunity (as Craig Owens put it) 'of another, non-narcissistic mode of relating to the Other'.[45] This other mode, generally overlooked by those who are contemptuous of pets and sceptical of the motives for keeping them, may in fact be very close to that 'alliance' between human and animal which Deleuze and Guattari see as constituting the process of becoming-animal. It is an alliance which, above all else, has no interest in fixed identities and has the effect of doing away with them: an inexpert alliance, forgetful of such 'expert' categories as the human, the artist and the animal.

Such an alliance may be one in which people find themselves, inexpertly, to be operating without needing consciously to think about it. For those who do, however, there is some evidence that the alliance may – like Winnicott's account of the 'potential space' which opens up the experience of 'creative living'[46] – offer a singularly productive (while endlessly difficult) space not only for thinking the postmodern animal, but simply for *thinking*.

PHILOSOPHERS AND THEIR CATS

le chat dont je parle est un chat réel, vraiment, croyez-moi, un petit chat.
Ce n'est pas une figure du chat.
JACQUES DERRIDA, 'L'Animal que donc je suis'[47]

In an image at once homely and uncanny (illus. 74), Mark Dion puts a stuffed domestic cat immediately below the bust of Aristotle at the top of the staircase in *Scala Naturae* (1994), his ironic debunking of Aristotle's hierarchical systematizing of the natural world, and of all the similar accounts of a 'ladder of evolutionary progress' or 'chain of being' which have followed it.[48]

Philosophers and their relation to domestic animals are perhaps an easy target. In a style reminiscent of John Berger's views on pets, a strikingly aggressive image in Keith Tester's book *Society and Animals* proposes that the nineteenth-century English rural population continued to have an authentically 'direct, personal relationship with animals', while the self-deluding urban middle class intellectual typically 'sat by the fireside, examining fossils and stroking the dog'.[49] Knowledge of pets, in this view, is seen as a lesser, inferior knowledge to that of farm or wild animals. This has not, despite Deleuze and Guattari's strident words, been the view of a number of continental philosophers and theorists in recent times. The cat has more often been their animal of choice – Deleuze himself in fact kept cats throughout his life[50] – and for some of them it has served as a kind of touchstone of their being-in-the-world.

Lévi-Strauss's autobiographical *Tristes Tropiques* is perhaps the best known example. His final sentence proposes that every society searches for that which might 'show us the opposite course to that leading to enslavement', and that one of the places it may be found is 'in the brief glance, heavy with patience, serenity and mutual forgiveness, that, through some involuntary understanding, one can sometimes exchange with a cat'.[51] David Wood – the philosopher who as early as the 1970s had tried unsuccessfully to persuade Derrida to become vegetarian – also offers an image of the cat having a place of value in the philosopher's life through the animal's very ordinariness, its simply being there. At the start of one essay, Wood seeks to establish the particularity and reality of his own position with the observation: 'I am, "here and now", my ginger cat purring at my feet, in England, writing these words.'[52] More recently, in the final paragraph of one of Lyotard's last works, there is an evocation of the cat as that which might link the mundane and the profound. The cat is there in the very shape of the writer's signature, Lyotard suggests. But more than this, and more than the creatures' comforting desire to share human warmth, cats stop 'at thresholds that we do not see, where they sniff some "present beyond"'. It is in living this life at the threshold – in living this 'questioning', as he calls it – that Lyotard seems to locate the cat's particular value to the writer and philosopher.[53]

In his 1999 essay 'L'Animal que donc je suis', Derrida puts

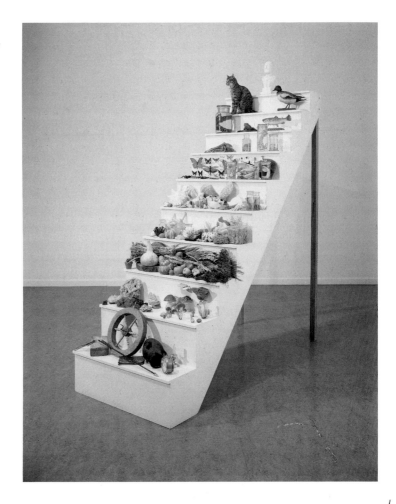

74 Mark Dion,
Scala Naturae, 1994,
mixed media.

his cat at the heart of his own exploration of 'the animal which is me'. His position, it seems, is the contrary of Berger's insistence that the animal cannot 'confirm' the human. It is in being seen (and in particular in being seen *naked*) by his cat that Derrida claims to experience self-consciousness and shame. In the course of this long essay he links this personal experience to the themes of nakedness and shame in Genesis, but repeatedly insists on the specificity of his own domestic experience and of his cat's 'irreplaceable singularity' in it. (After over thirty years of his making sophisticated deconstructive moves in his writing, it is both instructive and extremely funny to observe Derrida's desperation to assure his readers that there really is nothing like irony, double-bluff or hidden significance behind his references to this 'real'

cat, 'his' cat.) The eyes of his cat, he suggests, provide his own I's first mirror, reflecting the naked truth of the autobiographical 'I'.[54]

This real, singular cat occupies a crucial threshold in Derrida's philosophical knowledge. She (for this cat is in fact *une chatte*) allows him to see something of the otherness of *all* non-human animals. It is perhaps what he glimpses there more than what he finds in arguments for animal rights (to which he nevertheless seems increasingly sympathetic) which leads him to speak of a 'fundamental compassion which, if it was taken seriously, would change the very basis . . . of the philosophical problem of the animal'. The cat offers Derrida access to a philosophy and a self-knowledge which is neither abstract nor self-centred, but embodied and intimately related to an other. Precisely as an alternative to Descartes's 'I think therefore I am', Derrida proposes the formulation: 'The animal looks at us, and we are naked before it. And thinking perhaps begins there.'[55] If in parts of this essay he seems to move surprisingly close to an uncritical humanism (as in his sympathetic reading of Bentham's famous question of animals: 'Can they suffer?'), it is under the pressure of grounding his philosophical thought in the 'truth' of his own experience, and of insisting on philosophy's responsibility to 'real' living beings, human or animal.

Sincere as the foregoing examples undoubtedly are, they may look a little contrived in comparison to the startling honesty of a brief story of shared domesticity by Hélène Cixous, in which the narrowness of the line dividing the wild and the domestic is brought into sharp focus. It begins: 'We search in vain for quiescence. My cat and I', and it is presented as a reflection on an actual event. Dating from 1996, the story is out of alignment with the ecstatic animal rhetoric of much of Cixous's writing. It is immediate, grounded, and alludes only awkwardly to the liberatingly non-human flight of her earlier figurative creatures. It tells of a bird which has become trapped during the night in the lattice-work of the balcony of the narrator's house, and which is the object of the narrator's and her cat's curiosity and concern. The bird is described as 'that immobile thing in my lattice-work', and as 'the thing and its threatening strangeness'. The alignment, the identification, is between 'my cat and I', and not, as so emphatically elsewhere in Cixous's work, between women and birds.[56]

186

Here the bird is 'the impossible': 'There I was holding the impossible in my hands . . .' The narrator's fear may be more of its deadness than of its birdness, but the one is wholly exemplified by and embodied in the other. It gives her the sense 'of being violently attacked', and she describes death as having given the creature 'a monstrous force'. Borders and distinctions, as almost nowhere else in Cixous's work, are called on to shield the woman from this. Wearing rubber gloves and carrying a stick to poke out the wedged corpse, she ventures on to the balcony only to find the stick useless, as the bulk of the intruding body is in fact on the inside – her side – of the lattice-work, where 'the presence of this spectre seems even more uncanny inside than out'. The wild and impossible thing is in domestic space, the space proper to the woman and her cat.

The cat, as pet, and *insider*, has certain freedoms in the space of the house. It pulls the bird free and sets it down on the carpet inside the house. The action is indulged as part of the woman's recognition of the cat's otherness. The bird cannot be removed until the cat's inspection of the lifeless body is complete: 'I don't dare go ahead of the cat. For I recognize the rights animals have among themselves.' The animality of the pet remains unknowable.

When the bird turns out not to be dead at all, and flies off (to the cat's considerable distress), the woman finds in her sympathy for the cat the means of taking on its own cold fearlessness. If the bird would only come back, 'I too would play with its lukewarm body, I'd give it sharp little blows with my paw and I'd slit its throat cheerfully'. A celebratory rhetoric of the bird's flight and freedom has no place here. Where Cixous had previously often associated women and birds ('women take after birds . . . They go by, fly the coop, take pleasure in jumbling the order of space . . . turning propriety upside down'),[57] the narrator in this story can only lament the bird's escape: 'It's not what I wanted.'

Is it the cat which has provoked this honesty, and unsettled the rhetoric? Is this what the postmodern animal does? There on her carpet, the alliance of cat and bird, an uncomfortable and untidy assemblage of the wild and the domestic, will not be ignored. The reason the narrator is thrown into such mental disarray by the incident is perhaps precisely because of Cixous's recognition of the extent to which this 'reality' is

at odds with the animal rhetoric of her own writing. The domestic animal's ordinary habits open up a truth which the imagery of the wild had overlooked.

Cixous's story is exemplary not as a model of how to think about animals but as an instance of not allowing rhetoric or theory to disguise the contradictory and compromised manner in which people live with animals. They do live inexpertly with animals, and this is a truth which postmodern art and philosophy need to be able to articulate. (An art or philosophy which fails to address how ordinary lives *are* led will certainly be found wanting.) To live inexpertly is sometimes to live uncomfortably, the alliance with the animal sweeping the human off into the unfamiliar. Cixous's story gives some sense of this. Neither Hockney's dogs nor Dion's cats quite manage to do so.

It may be possible to account for this precisely in terms of the 'love' viewed so sceptically by Marc Shell – not love of the animal itself in this case, but love of the work (art, literature, philosophy) to be done in taking the animal seriously, in thinking and rethinking it seriously. Luce Irigaray makes the relation of love and philosophy explicit, arguing that 'contrary to the usual methods of dialectic, one should not have to give up love in order to become wise or learned. It is love that leads to knowledge, whether in art or more metaphysical learning'. This calls for a different understanding of philosophy: 'Philosophy is not a formal learning, fixed and rigid, abstracted from all feeling. It is a quest for love, love of beauty, love of wisdom, which is one of the most beautiful things.' The philosopher – like the figure of Jeff Noon's reverse butcher – is in this account someone 'rather down-and-out, always unhoused, sleeping beneath the stars, but very curious, skilled in ruses and tricks of all kinds, constantly reflecting'.[58]

The importance of these views is that they enable an account of love – and of 'love's work', to use the term which Gillian Rose employed in a similar way – which is entirely concerned with seriousness rather than sentiment. It consists in a fiercely experimental attitude, and in an ability (which is in the broadest sense the artist's ability) 'to go on getting it all wrong, more or less all the time'.[59] This is entirely pertinent to artists' dealings with animals, and could not be further from notions (ironic or otherwise) of 'puppylove' and suchlike.

Postmodern art's struggle with the animal is all about distance. ('If we work on a text we don't love', Cixous has said, 'we are automatically at the wrong distance.')[60] It is about establishing a serious relation to the work. In seeking to create a particular distance from what, for example, may be judged to be an *unavoidable* sentimentalization of the pet, or in choosing to work on particular (and thus get closer to particular) kinds of animal such as predators, which may be judged to be representable with a *necessary* seriousness, the artist is acting with a certain integrity. It is essentially the same integrity as that which leads others to choose instead to draw the viewer closer to the animals in the artist's own domestic life, or to face the viewer with truths about the farm or laboratory animals which are the focus of a particular artist's ethical or political concern.

Some of the resulting imagery may be judged to sentimentalize the animal; some of it may romanticize the wild and betray a fear of the familiar. Much of it may in this sense be judged to have got the animal 'wrong', while nevertheless having been part of an determinedly serious attempt to figure out the right distance between the animal and its postmodern representation. In the position of a philosopher, as Lyotard has it, the postmodern artist's quest for what Irigaray so disarmingly calls the love of beauty and wisdom might more familiarly be seen as a quest for new vocabularies, new forms of openness – in this case, openness to the animal. It is, in a sense, entirely appropriate that most of the time artists (and writers and philosophers) continue to get it wrong, to botch it and to bind the animal inexpertly to their own inexpert lives.

Whether or not he is regarded as a satirical creation, Will Self's character Simon Dykes serves well enough to epitomize these figures. Beleaguered by a pervasive sense of his own lack of fit, Dykes is described as having been 'once an artist, then a mental patient, and now a chimp with a most unusual quest'.[61] Here in preposterously summary form (botched only by the cliché of artists' madness) is something which parallels the argument of the present book: the postmodern artist is in the position of the questing philosopher, but this appears to entail that artist's also being in the position of a postmodern animal.

This would be far too convenient and complacent a note on which to end. Better, perhaps, to heed Nietzsche's warning

against the imposition of meaning on the nonhuman world – an inevitably anthropomorphic exercise. Nature, he observes, 'does not by any means strive to imitate man. None of our aesthetic and moral judgements apply to it'. What is striking here, however, is how closely his list of dubious human projections corresponds to what Irigaray sees as the proper aims of the philosopher's quest. The things precisely not to be found in nature, according to Nietzsche, are 'form, beauty, wisdom, and whatever other names there are for our aesthetic anthropomorphisms'.[62]

It is clear too that an aesthetic preference or ethical tolerance for the unsuccessful and the botched, of the kind proposed in relation to the postmodern animal, would strike him as little better: 'ultimately even the phrase "unsuccessful attempt" is too anthropomorphic and reproachful'.[63] From such a perspective the animal seems, in effect, to be philosophically unthinkable, and visually unrepresentable. For those artists and philosophers who continue the attempt, the very difficulty of the exercise – which is perhaps what renders it serious – will on occasion leave them looking or feeling very much like the fools of whom Deleuze and Guattari complain.

References

1 WHAT IS THE POSTMODERN ANIMAL?

1 Jacques Derrida, 'L'Animal que donc je suis (à suivre)', in *L'Animal auto-biographique: Autour de Jacques Derrida*, ed. M.-L. Mallet (Paris, 1999), p. 271.
2 Joshua Decter, 'General Idea: The Sensuous Whiteness of Life's Interruptions', in *General Idea*, exh. cat.: Camden Arts Centre, London (London, 1998), unpaginated.
3 Gilles Deleuze, 'Postscript on the Societies of Control', *October*, LIX (1992), pp. 7, 4.
4 Donna J. Haraway, *Simians, Cyborgs, and Women: The Reinvention of Nature* (New York, 1991), p. 150.
5 Kate Soper, *What is Nature?: Culture, Politics and the non-Human* (Oxford and Cambridge, MA, 1995), pp. 3–4.
6 See *Natural History and Other Fictions: An Exhibition by Mark Dion*, exh. cat. by J. Leslie: Ikon Gallery, Birmingham; Kunstverein, Hamburg; De Appel Foundation, Amsterdam (Birmingham, Hamburg and Amsterdam, 1997); and *Raw: Olly and Suzi*, exh. cat. by K. Pierrepont: Blains Fine Art, London (London, 1998).
7 Richard Rorty, *Contingency, Irony, and Solidarity* (Cambridge and New York, 1989), p. 96.
8 Lisa Graziose Corrin, 'Mark Dion's Project: A Natural History of Wonder and a Wonderful History of Nature', in Lisa Graziose Corrin, Miwon Kwon and Norman Bryson, *Mark Dion* (London, 1997), pp. 39, 47.
9 Mark Dion, conversation with the author, May 1998. See *What is an Animal?*, ed. T. Ingold (London, 1988).
10 Corrin, 'Mark Dion's Project', pp. 55–7.
11 Mark Dion, 'Interview', in Corrin, Kwon and Bryson, *Mark Dion*, p. 33.
12 Olly and Suzi, unpublished interview with the author, London, August 1998. All further quotations from the artists are from this interview.
13 Dion, 'Interview', pp. 17–18.
14 *Ibid.*, p. 17.
15 *Ibid.*, p. 22.
16 See Corrin, 'Mark Dion's Project', pp. 49, 46, 50.
17 Richard Johnson, 'Complex Authorships: Intellectual Coproduction as a Strategy for the Times', *Angelaki*, III/3, (1998).
18 Norman Bryson, 'Mark Dion and the Birds of Antwerp', in Corrin, Kwon and Bryson, *Mark Dion*, pp. 92, 96–7.
19 Olly and Suzi, interview with the author, August 1998, and correspondence with the author, September 1998.
20 Wendy Wheeler, *A New Modernity?: Change in Science, Literature and Politics* (London, 1999), pp. 7, 5.
21 Jean-François Lyotard, *The Postmodern Condition: A Report on Knowledge*, trans. G. Bennington and B. Massumi (Manchester, 1984), p. 81.
22 Michel Foucault, *The Order of Things: An Archaeology of the Human Sciences* (London, 1970), p. 344; Robert Pepperell, *The Post-Human Condition* (Oxford, 1995), passim.
23 Tony Davies, *Humanism* (London and New York, 1997), p. 135.
24 Donna Haraway, 'Ecce Homo, Ain't (Ar'n't) I a Woman, and

Inappropriate/d Others: The Human in a Post-humanist Landscape', in *Feminists Theorize the Political*, eds J. Butler and J. W. Scott (New York and London, 1992), p. 88.

25 Mary Midgley, *Utopias, Dolphins and Computers: Problems of Philosophical Plumbing* (London and New York, 1996), p. 25; Martin Heidegger, quoted in Will McNeill, *Heidegger: Visions: Of Animals, Others and the Divine* (Warwick, 1993), p. 40; Albrecht Wellmer, *The Persistence of Modernity: Essays on Aesthetics, Ethics, and Postmodernism*, trans. D. Midgley (Cambridge, Mass, 1991), p. 7.

26 Jean-François Lyotard, *The Postmodern Condition*, pp. 71, 73, 81.

27 Dion, 'Interview', p. 8; Olly and Suzi, artists' statement, 1998.

28 Maurice Denis, 'Definition of Neotraditionism' (1890), in *Theories of Modern Art: A Source Book by Artists and Critics*, ed. H. B. Chipp (Berkeley, Los Angeles and London, 1968), p. 94: 'It is well to remember that a picture – before being a battle horse, a nude woman, or some anecdote – is essentially a plane surface covered with colours assembled in a certain order'.

29 Clement Greenberg, 'Avant-Garde and Kitsch' (1939), in *Art in Theory 1900–1990: An Anthology of Changing Ideas*, eds C. Harrison and P. Wood (Oxford, 1992), p. 532.

30 Constantin Brancusi, 'Aphorisms (ca. 1957)', in *Theories of Modern Art*, ed. H. B. Chipp, p. 365.

31 Franz Marc, 'How Does a Horse See the World?', in *Theories of Modern Art*, pp. 178–9.

32 Franz Marc, 'Aphorisms, 1914–1915', in *Theories of Modern Art*, p. 181.

33 W. J. Strachan, *Henry Moore: Animals* (London, 1983), p. 75; Roger Berthoud, *The Life of Henry Moore* (London and Boston, 1987), p. 344.

34 Peter Fuller, *Henry Moore: An Interpretation* (London, 1993), p. 54; Strachan, *Henry Moore: Animals*, p. 10; Berthoud, *The Life of Henry Moore*, p. 344.

35 Strachan, *Henry Moore: Animals*, pp. 9 (quoting Moore), 75; Berthoud, *The Life of Henry Moore*, p. 344.

36 Edwina Ashton, unpublished interview with the author, London, April 1999.

37 Hal Foster, *The Return of the Real: The Avant-Garde at the End of the Century* (Cambridge, Mass and London, 1996), p. 165.

38 Wheeler, *A New Modernity?*, pp. 90, 8, 74.

2 ANIMALS AND IRONIES

1 Julian Barnes, *Flaubert's Parrot* (London, 1984), p. 68.

2 Mary Lemley, conversation with the author, May 1998; Richard Rorty, *Contingency, Irony, and Solidarity* (Cambridge and New York, 1989), pp. 120, 94; Lisa Graziose Corrin, 'Mark Dion's project: A natural history of wonder and a wonderful history of nature', in Lisa Graziose Corrin, Miwon Kwon and Norman Bryson, *Mark Dion* (London, 1997), p. 84.

3 Linda Hutcheon, *A Poetics of Postmodernism: History, Theory, Fiction* (New York and London, 1988), p. 4.

4 Subsequent exhibition catalogues of Morley's work give the title of this second painting as *Christmas Tree – The Lonely Ranger Lost in the Jungle of Erotic Desires*.

5 Christos M. Joachimides, 'A New Spirit in Painting', in *A New Spirit in Painting*, exh. cat. by C. M. Joachimides, N. Rosenthal and N. Serota: Royal Academy of Arts, London (London, 1981), p. 15.

6 Michael Compton, 'Introduction', in *Malcolm Morley: Paintings 1965–82*, exh. cat. by N. Serota: Whitechapel Art Gallery, London (London, 1983), pp. 15–16.

7 Lynne Cooke, 'The Resurgence of the Night-mind: Primitivist Revivals in Recent Art', in *The Myth of Primitivism: Perspectives on Art*, ed. S. Hiller (London and New York, 1991), p. 147; Malcolm Morley, 'Showing the View to a Blind Man', in *Malcolm Morley*, exh. cat. by R. Violette: Anthony

d'Offay Gallery, London (London, 1990), p. 16.

8 Gustave Flaubert, quoted in Barnes, *Flaubert's Parrot*, p. 184.
9 Gustave Flaubert, quoted in Marian Scholtmeijer, 'What is "Human"?:
 Metaphysics and Zoontology in Flaubert and Kafka', in *Animal Acts:
 Configuring the Human in Western History*, eds J. Ham and M. Senior (New
 York and London, 1997), p. 130.
10 Gustave Flaubert, quoted in Barnes, *Flaubert's Parrot*, p. 150.
11 *Ibid.*, pp. 86, 19–20, 22, 84.
12 *Ibid.*, pp. 76–7.
13 *Ibid.*, pp. 63, 18–19.
14 *Ibid.*, p. 112; Alan Liu, 'Local Transcendence: Cultural Criticism, Post-
 modernism, and the Romanticism of Detail', *Representations*, XXXII (1990), p. 97.
15 Barnes, *Flaubert's Parrot*, p. 50 (quoting Flaubert).
16 *Ibid.*, pp. 50, 49, 18.
17 Scholtmeijer, 'What is "Human"?', pp. 131–2.
18 Dialogue and commentary from Peter Greenaway's film *The Falls* (London,
 1980), from biographies 19 and 88.
19 Alan Woods, *Being Naked – Playing Dead: The Art of Peter Greenaway*
 (Manchester and New York, 1996), p. 136.
20 Woods, *Being Naked – Playing Dead*, pp. 128, 243 (quoting Greenaway).
21 Greenaway, *The Falls*, biographies 1, 2, 4, 24, 30, 32, 34, 45, 55, 59, 77, 81, 87, 90.
22 *Ibid.*, biographies 75, 10 and 35.
23 *Ibid.*, biography 30.
24 *Ibid.*, biography 7.
25 Adam Phillips, 'Just Rage', in *The Beast in the Nursery* (London, 1998), pp.
 95, 96.
26 Theodor W. Adorno, *Minima Moralia: Reflections from Damaged Life*, trans.
 E. F. N. Jephcott (London, 1974), p. 15.
27 Phillips, 'Just Rage', pp. 97–8.
28 *Ibid.*, p. 100.
29 Alan Wilde, *Horizons of Assent: Modernism, Postmodernism and the Ironic
 Imagination* (Baltimore and London, 1981), p. 131.

3 THE HUMAN, MADE STRANGE

1 Kirsten Bakis, *Lives of the Monster Dogs* (London, 1997), p. 147.
2 Jean-François Lyotard, *The Postmodern Condition: A Report on Knowledge*,
 trans. G. Bennington and B. Massumi (Manchester, 1984), p. xxv; Adam
 Phillips, *Terrors and Experts* (London and Boston, 1995), pp. 1, 104.
3 See Marion Milner, *On Not Being Able to Paint*, 2nd edn (London, 1957);
 Hélène Cixous, *'Coming to Writing' and Other Essays*, ed. D. Jenson
 (Cambridge, Mass and London, 1991), p. 110; and Michel Foucault, *The
 Foucault Reader*, ed. P. Rabinow (Harmondsworth, 1984), p. 350.
4 Phillips, *Terrors and Experts*, p. 7.
5 Mihaly Csikszentmihalyi, *Creativity: Flow and the Psychology of Discovery
 and Invention* (New York, 1996), p. 27.
6 *Ibid.*, pp. 125, 112 and 53 (quoting Davis).
7 Joseph Beuys, quoted in Caroline Tisdall, *Joseph Beuys: Coyote* (Munich,
 1980), p. 27; Damien Hirst, *i want to spend the rest of my life everywhere, with
 everyone, one to one, always, forever, now.* (London, 1997), p. 298.
8 Lyotard, *The Postmodern Condition*, p. xxv.
9 Phillips, *Terrors and Experts*, p. 7, quoting Mark Edmundson; Jacques
 Derrida, 'Psyche: Invention of the Other', in *Jacques Derrida: Acts of
 Literature*, ed. D. Attridge (New York and London, 1992), p. 312.
10 Lyotard, *The Postmodern Condition*, p. 81.
11 Phillips, *Terrors and Experts*, p. 65.
12 Matthew Goulish, speaking at the Writing Research Associates' conference,

Performance Writing, Dartington College of Arts, April 1996; on Heidegger's distinction, see Will McNeill, *Heidegger: Visions: Of Animals, Others and the Divine* (Warwick, 1993), pp. 43–4.

13 D. W. Winnicott, *Playing and Reality* (London, 1971), pp. 100, 65.

14 Richard Rorty, *Contingency, Irony, and Solidarity* (Cambridge and New York, 1989), passim. In contrast to the ironic detachment discussed in the previous chapter, Rorty envisages the ironist-theorist as engaged and innovative: 'Only metaphysicians think that our present genres and criteria exhaust the realm of possibility. Ironists continue to expand that realm'. (p. 135).

15 Luce Irigaray, *An Ethics of Sexual Difference*, trans. C. Burke and G. C. Gill (London, 1993), p. 24.

16 Barnes, *Flaubert's Parrot* (London, 1984), p. 53; Jeff Noon, *Automated Alice* (London and New York, 1996), p. 47.

17 Phillips, *Terrors and Experts*, p. 47.

18 For the full transcript, see *William Wegman: Paintings, Drawings, Photographs, Videotapes*, ed. M. Kunz (New York, 1990), p. 38.

19 Joseph Beuys, quoted in Tisdall, *Joseph Beuys: Coyote*, pp. 24, 27.

20 Jeff Koons, speaking on the television programme *The South Bank Show*: 'The World of Jeff Koons', ITV, 13 December 1992.

21 See Fiona Bradley, 'Introduction: Automatic Narrative', and Ruth Rosengarten, 'Home Truths: The Work of Paula Rego', in *Paula Rego*, exh. cat. by F. Bradley *et al.*: Tate Gallery Liverpool and Centro Cultural de Belém, Lisbon (London, 1997), pp. 13, 68, 88.

22 Paula Rego, quoted in Judith Collins, 'Paula Rego's Drawings', in *Paula Rego*, exh. cat. by F. Bradley *et al.*, p. 125.

23 Paula Rego, quoted in John McEwen, *Paula Rego*, 2nd edn (London, 1997), p. 212.

24 Joseph Beuys, quoted in Tisdall, *Joseph Beuys: Coyote*, pp. 28, 26.

25 Jean-François Lyotard, *The Inhuman: Reflections on Time*, trans. G. Bennington and R. Bowlby (Cambridge, 1991), p. 182.

26 Lyotard, *The Postmodern Condition*, pp. 71, 76, 81, including inset quotation.

27 Albrecht Wellmer, *The Persistence of Modernity: Essays on Aesthetics, Ethics, and Postmodernism*, trans. D. Midgley (Cambridge, Mass, 1991), pp. 42, vii–viii.

28 Adorno's views are summarized in J. M. Bernstein, *The Fate of Art: Aesthetic Alienation from Kant to Derrida and Adorno* (Cambridge, 1992), p. 190.

29 Wellmer, *The Persistence of Modernity*, p. 48.

30 Viktor Shklovsky, quoted in Carlo Ginzburg, 'Making Things Strange: The Prehistory of a Literary Device', *Representations*, LVI (1996), p. 8.

31 Ginzburg, 'Making Things Strange', pp. 16, 18, 20, 22.

32 Mark Dion, 'Interview', in Lisa Graziose Corrin, Miwon Kwon and Norman Bryson, *Mark Dion* (London, 1997), p. 30.

33 Joseph Beuys, quoted in Heiner Stachelhaus, *Joseph Beuys*, trans. D. Britt (New York, 1991), p. 59; Franz Marc, quoted in Peter-Klaus Schuster, *Franz Marc: Postcards to Prince Jussuf* (Munich, 1988), pp. 94–5.

34 Jana Sterbak, quoted in *Rites of Passage: Art for the End of the Century*, exh. cat. by S. Morgan and F. Morris: Tate Gallery, London (London, 1995), p. 130.

35 See Lawrence Alloway, 'Rauschenberg's Development', in *Robert Rauschenberg*, exh. cat. by W. Hopps: National Collection of Fine Arts, Smithsonian Institution, Washington, DC (Washington, DC, 1976), p. 6.

36 Diane Hill, 'From Real Art to *Real Art*: De-traditionalization, Reflexivity and Value', in *De-Traditionalization and Art: Aesthetic, Authority, Authenticity*, ed. N. Whiteley (London, 2000).

37 Michael Fried, 'Art and Objecthood', in *Minimal Art: A Critical Anthology*, ed. G. Battcock (New York, 1968), pp. 124–5, 141.

38 *Ibid.*, pp. 125, 127.

39 *Ibid.*, pp. 140, 127.

40 Edward Lucie-Smith, *Zoo: Animals in Art* (London, 1998).

41 Wendy Wheeler, *A New Modernity?: Change in Science, Literature and Politics* (London, 1999), p. 87.

42 Peter Høeg, *The Woman and the Ape* (London, 1996), pp. 49, 193, 209, 215.

43 Donna Haraway, 'A Cyborg Manifesto', in *Simians, Cyborgs, and Women: The Reinvention of Nature* (New York, 1991), p. 181.

44 Ralph Rugoff, 'Survey', in Ralph Rugoff, Kristine Stiles and Giacinto Di Pietrantonio, *Paul McCarthy* (London, 1996), p. 66.

45 The dialogue used in this 1991 performance was published earlier as Mike Kelley, 'Theory, Garbage, Stuffed Animals, Christ (Dinner Conversation Overheard at a Romantic French Restaurant)', *Forehead*, II (1989), pp. 12–21.

46 Robert Hughes, speaking on *The South Bank Show*: 'The World of Jeff Koons', ITV, 13 December 1992.

47 This description is based on the version of this piece which was shown in the group exhibition *The Lost Ark*, Centre for Contemporary Arts, Glasgow, January–March 1997.

48 On Waterton's taxidermy, see Stephen Bann, *The Clothing of Clio: A Study of the Representation of History in Nineteenth-Century Britain and France* (Cambridge, 1984), and Stephen Bann, 'Introduction', in *Frankenstein, Creation and Monstrosity*, ed. S. Bann (London, 1994).

49 Neal Benezra, 'Surveying Nauman', in *Bruce Nauman*, exh. cat. by J. Simon: Walker Art Center, Minneapolis (Minneapolis, 1994), p. 39.

50 Hirst, *i want to spend the rest of my life everywhere . . .*, p. 282.

51 Fiona Russell, conversation with the author, January 1999.

52 Kitty Hauser, 'Coming Apart at the Seams: Taxidermy and Contemporary Photography', *Make: The Magazine of Women's Art*, LXXXII (1998–9), pp. 10–11.

53 Robert Rauschenberg, quoted in Mary Lynn Kotz, *Rauschenberg: Art and Life* (New York, 1990), p. 90.

54 Pablo Picasso, quoted in John Golding, *Cubism: A History and an Analysis* (London, 1959), pp. 103–4.

55 Gilles Deleuze and Félix Guattari, *A Thousand Plateaus: Capitalism and Schizophrenia*, trans. B. Massumi (London, 1988), p. 149. For the original, see *Mille plateaux* (Paris, 1980), p. 185.

56 Alloway, 'Rauschenberg's Development', p. 6.

57 Allan Kaprow, *Assemblage, Environments and Happenings* (New York, 1965), p. 168.

58 Gilles Deleuze and Félix Guattari, *Kafka: Toward a Minor Literature*, trans. D. Polan (Minneapolis and London, 1987), p. 83, and *A Thousand Plateaus*, p. 242.

59 Phillips, *Terrors and Experts*, p. 32.

60 Noon, *Automated Alice*, pp. 77–9, 83, 89.

61 Emily Mayer, conversation with the author, March 1999.

62 Emily Mayer, artist's statement, in *Emily Mayer: Material Evidence* (Kenninghall, Norfolk, 1995), unpaginated; and Emily Mayer, quoted in Alexandra Buxton, 'Life after Death', *Country Living*, October 1995, pp. 94–5.

63 Jacques Derrida, '"Eating Well", or the Calculation of the Subject', in *Who Comes After the Subject?*, eds E. Cadava, P. Connor and J.-L. Nancy (New York and London, 1991), p. 104.

64 Carolyn Christov Bakargiev, 'Ursus maritimus', in *Natural History and Other Fictions: An Exhibition by Mark Dion*, exh. cat. by J. Leslie: Ikon Gallery, Birmingham; Kunstverein, Hamburg; De Appel Foundation, Amsterdam (Birmingham, Hamburg and Amsterdam, 1997), p. 49.

65 Dion, 'Interview', p. 29.

66 Derrida, 'L'Animal que donc je suis (à suivre)', *L'Animal autobiographique: Autour de Jacques Derrida*, ed. M.-L. Mallet (Paris, 1999), pp. 264, 285, 290, 292.

67 *Ibid.*, pp. 292, 296–8.

68 *Ibid.*, p. 292.

69 John Isaacs, unpublished interview with the author, London, March 1999.

70 Fried, 'Art and Objecthood', p. 128.

195

71 John Isaacs, unpublished interview with the author, March 1999.
72 Peter Høeg, *The Woman and the Ape*, p. 31.
73 Derrida, '"Eating Well", or the Calculation of the Subject', pp. 108, 113.
74 *Ibid.*, pp. 108, 111, 118.
75 *Ibid.*, pp. 108, 118, 112.
76 David Wood, 'Comment ne pas manger: Deconstruction and Humanism', unpublished paper for the conference *The Death of the Animal*, Centre for Research in Philosophy and Literature, University of Warwick, November 1993.
77 John Rajchman, 'Jean-François Lyotard's Underground Aesthetics', *October*, LXXXVI (1998), p. 13; Lyotard, *The Postmodern Condition*, p. 82.

4 THE UNMEANING OF ANIMALS

1 Deborah Levy, *Diary of a Steak* (London, 1997), p. 11.
2 Germano Celant, untitled text in *Art Povera: Conceptual, Actual or Impossible Art?*, ed. G. Celant (London, 1969), p. 225.
3 Bruno Corà, 'Jannis Kounellis: The Future of Form in the Quality of Love', in *Kounellis*, exh. cat. by G. Moure: Espai Poblenou, Barcelona (Barcelona, 1990), p. 19.
4 Susan Shaw Sailer, 'On the Redness of Salmon Bones, the Communicative Potential of Conger Eels, and Standing Tails of Air: Reading Postmodern Images', *Word and Image*, XII / 3 (1996), p. 308.
5 Marie-Laure Bernadac, 'Behind the Tapestry', in *Louise Bourgeois: Recent Work*, exh. cat. by L. G. Corrin: Serpentine Gallery, London (London, 1998), unpaginated; Stuart Morgan, 'Louise Bourgeois', *Frieze*, XLV (1999), p. 79.
6 Robert Hughes, *The Shock of the New* (London, 1991), p. 335; Robert Rauschenberg, quoted in Mary Lynn Kotz, *Rauschenberg: Art and Life* (New York, 1990), p. 90; Robert Hughes, *American Visions: The Epic History of Art in America* (London, 1997), p. 518.
7 Sarah Kent, 'Jordan Baseman: Hair Pieces', in *Young British Artists VI*, exh. cat. by S. Kent: Saatchi Gallery, London (London, 1996), unpaginated.
8 Joseph Beuys, 'The Cultural-historical Tragedy of the European Continent' (1986), in *Art in Theory 1900–1990: An Anthology of Changing Ideas*, eds C. Harrison and P. Wood (Oxford, 1992), p. 1035.
9 Robert Rauschenberg, in Dorothy Gees Seckler, 'The Artist Speaks: Robert Rauschenberg', *Art in America*, May–June 1966, p. 76.
10 Christian Besson, 'Caddis Worm, Marvel and Monument', in *Hubert Duprat*, exh. cat. by C. Besson, C. Perret and J.-M. Poinsot: Hôtel des arts – Fondation nationale des arts, Paris (Paris, 1991), pp. 88–90.
11 Milan Kundera, *Testaments Betrayed* (London and Boston, 1996), pp. 145–6.
12 Brian Luke, 'Taming Ourselves or Going Feral?: Toward a Nonpatriarchal Metaethic of Animal Liberation', in *Animals and Women: Feminist Theoretical Explorations*, eds C. J. Adams and J. Donovan (Durham, NC and London, 1995), p. 312. See also Marion W. Copeland, 'Nonhuman Animals: A Review Essay', *Society and Animals*, VI / 1 (1998), passim.
13 Will McNeill, *Heidegger: Visions: Of Animals, Others and the Divine* (Warwick, 1993), p. 25.
14 W. S. Graham, *Aimed at Nobody: Poems from Notebooks*, eds M. Blackwood and R. Skelton (London, 1993), p. 6.
15 Luce Irigaray, *An Ethics of Sexual Difference*, trans. C. Burke and G. C. Gill (London, 1993), p. 168.
16 Damien Hirst, *i want to spend the rest of my life everywhere, with everyone, one to one, always, forever, now* (London, 1997), p. 32.
17 *Ibid.*, p. 290.
18 Gilles Deleuze and Félix Guattari, *A Thousand Plateaus: Capitalism and Schizophrenia*, trans. B. Massumi (London, 1988), p. 309.

196

19 Heiner Stachelhaus, *Joseph Beuys*, trans. D. Britt (New York, 1991), pp. 71–2; Rosalind Krauss, 'The originality of the avant-garde' (1981), in *Art in Theory 1900–1990: An Anthology of Changing Ideas*, eds C. Harrison and P. Wood (Oxford, 1992), p. 1061.

20 Francis Bacon, quoted in David Sylvester, *The Brutality of Fact: Interviews with Francis Bacon* (London, 1987), p. 46.

21 Damien Hirst, speaking on Waldemar Januszczak's *The Truth About Art*, part I: 'Animals', Channel 4 television, 6 December 1998, and quoted in *i want to spend the rest of my life everywhere . . .*, p. 21.

22 Emily Mayer, conversation with the author, March 1999.

23 Carolee Schneemann, *More Than Meat Joy: Complete Performance Works and Selected Writings*, ed. B. McPherson (New York, 1979), pp. 62, 63, 65.

24 Lewis Johnson, 'More and Less than Objects: Unapproachable Alterity and the Work of Jana Sterbak and Rosemarie Trockel', in *Other Than Identity: The Subject, Politics and Art*, ed. J. Steyn (Manchester and New York, 1997), pp. 175–6.

25 Jeff Koons, *The Jeff Koons Handbook* (London, 1992), p. 90.

26 Simon Taylor, 'The Phobic Object: Abjection in Contemporary Art', in *Abject Art: Repulsion and Desire in American Art*, exh. cat. by C. Houser, L. C. Jones and S. Taylor: Whitney Museum of American Art (New York, 1993), pp. 59, 81.

27 Julia Kristeva, *Powers of Horror: An Essay on Abjection*, trans. Leon S. Roudiez (New York, 1982), pp. 1–2; Hal Foster, *The Return of the Real: The Avant-Garde at the End of the Century* (Cambridge, Mass. and London, 1996), p. 153.

28 Kiki Smith, quoted in Simon Taylor, 'The Phobic Object', p. 65; Julia Kristeva, 'Of Word and Flesh', in *Rites of Passage: Art for the End of the Century*, exh. cat. by S. Morgan and F. Morris: Tate Gallery (London, 1995), pp. 21–2, 27.

29 Hermann Nitsch, quoted in Adrian Henri, *Environments and Happenings* (London, 1974), p. 168; Elisabeth Sussman, 'Introduction', in *Mike Kelley: Catholic Tastes*, exh. cat. by E. Sussman: Whitney Museum of American Art (New York, 1994), p. 21.

30 See *Mike Kelley: Catholic Tastes*, exh. cat. by E. Sussman, p. 181; Foster, *The Return of the Real*, p. 163; and Taylor, 'The Phobic Object', p. 58.

31 The dialogue used in this 1991 performance was published earlier as Mike Kelley, 'Theory, Garbage, Stuffed Animals, Christ (dinner conversation overheard at a romantic French restaurant)', *Forehead*, II (1989); see pp. 17–18.

32 Foster, *The Return of the Real*, p. 164; Kelley, 'Theory, Garbage, Stuffed Animals, Christ', p. 13.

33 Peter Greenaway, director, *The Baby of Mâcon* (London, 1993); Kristeva, 'Of Word and Flesh', p. 26.

34 Joseph Beuys, interviewed by Achille Bonito Oliva, in *Art Talk: The Early 80s*, ed. J. Siegel (New York, 1988), p. 81.

35 Peter Singer, interviewed on *Start the Week*, BBC Radio 4, 11 May 1998.

36 Elizabeth S. Paul, 'Us and Them: Scientists' and Animal Rights Campaigners' Views on the Animal Experimentation Debate', *Society and Animals*, III/1 (1995), pp. 8, 10 and 17.

37 McNeill, *Heidegger: Visions*, p. 42.

38 Martin Heidegger, *The Fundamental Concepts of Metaphysics: World, Finitude, Solitude*, trans. W. McNeill and N. Walker (Bloomington and Indianapolis, 1995), pp. 184 and 270.

39 Jacques Derrida, '*Geschlecht* II: Heidegger's Hand', trans. J. P. Leavey, in *Deconstruction and Philosophy: The Texts of Jacques Derrida*, ed. J. Sallis (Chicago and London, 1987), p. 174.

40 Jacques Derrida, *Of Spirit: Heidegger and the Question*, trans. G. Bennington and R. Bowlby (Chicago and London, 1987), p. 56; Martin Heidegger, *The Fundamental Concepts of Metaphysics*, pp. 192 and 194.

41 McNeill, *Heidegger: Visions*, p. 26; Heidegger, *The Fundamental Concepts of*

197

Metaphysics, pp. 202–3.

42 Derrida, '*Geschlecht* II: Heidegger's Hand', p. 173; the sentence is from Heidegger's 1947 'Letter on Humanism'.

43 Thierry Lenain, *Monkey Painting*, trans. C. Beamish (London, 1997), pp. 177–8, 183.

44 Ted Hughes, 'View of a Pig', in *The Faber Book of Beasts*, ed. P. Muldoon (London, 1997), p. 276.

45 Kelley, 'Theory, Garbage, Stuffed Animals, Christ', p. 14.

46 Irigaray, *An Ethics of Sexual Difference*, pp. 74 and 77.

47 Hirst, *i want to spend the rest of my life everywhere . . .*, pp. 298–9.

48 Marion Milner, *On Not Being Able to Paint*, 2nd edn (London, 1957), pp. 75–6.

49 Damien Hirst, speaking on *The Truth About Art*, part I: 'Animals', Channel 4 Television, 6 December 1998.

5 LEOPARDS IN THE TEMPLE

1 Gilles Deleuze and Félix Guattari, *A Thousand Plateaus: Capitalism and Schizophrenia*, trans. B. Massumi (London, 1988), p. 237.

2 Nina Lykke, 'Between Monsters, Goddesses and Cyborgs: Feminist Confrontations with Science', in *Between Monsters, Goddesses and Cyborgs: Feminist Confrontations with Science, Medecine and Cyberspace*, eds N. Lykke and R. Braidotti (London and New Jersey, 1996), pp. 16–17.

3 Lynda Birke, Mike Michael and Nik Brown, 'The Heart of the Matter: Animal Bodies, Ethics, and Species Boundaries', *Society and Animals*, VI/3 (1998), p. 255.

4 Margrit Shildrick, 'Posthumanism and the Monstrous Body', *Body and Society*, II/1 (1996), pp. 2, 8; Lykke, 'Between Monsters, Goddesses and Cyborgs', p. 13; Mozaffar Qizilbash, 'Editorial Introduction', *Angelaki*, III/1 (1998), p. 1.

5 Haraway, 'Ecce Homo, ain't (ar'n't) I a woman, and inappropriate/d others: The human in a post-humanist landscape', in *Feminists Theorize the Political*, ed. J. Butler and J. W. Scott (New York and London, 1992), p. 86; Donna J. Haraway, 'A cyborg manifesto' in *Simians, Cyborgs, and Women: The Reinvention of Nature* (New York, 1991), p. 150.

6 Donna J. Haraway, 'Cyborgs and Symbionts: Living Together in the New World Order', in *The Cyborg Handbook*, ed. C. H. Gray (New York and London, 1995), p. xi; and 'A Cyborg Manifesto', pp. 149, 181.

7 Mark Hutchinson, 'Of Monsterology', in *Occupational Hazard: Critical Writing on Recent British Art*, eds D. McCorquodale, N. Siderfin and J. Stallabrass (London, 1998), pp. 144, 147–8, 155–6.

8 Haraway, 'A Cyborg Manifesto', p. 181; Donna J. Haraway, *Modest_Witness @Second_Millennium.FemaleMan©__Meets_OncoMouse™: Feminism and Technoscience* (New York and London, 1997), pp. 47, 79.

9 Lykke, 'Between Monsters, Goddesses and Cyborgs', p. 8; Hutchinson, 'Of Monsterology', p. 147.

10 Juliet Steyn, 'Introduction', in *Other Than Identity: The Subject, Politics and Art*, ed. J. Steyn (Manchester and New York, 1997), pp. 1–2.

11 Steyn, 'Introduction', pp. 3, 5.

12 Gilles Deleuze and Félix Guattari, *Kafka: Toward a Minor Literature*, trans. D. Polan (Minneapolis and London, 1987) p. 35.

13 Hélène Cixous, *Three Steps on the Ladder of Writing*, trans. S. Cornell and S. Sellers (New York, 1993), p. 38.

14 Deleuze and Guattari, *A Thousand Plateaus*, p. 292.

15 Ronald Bogue, *Deleuze and Guattari* (London and New York, 1989), p. 150.

16 Gilles Deleuze, quoted in Bogue, *Deleuze and Guattari*, p. 178.

17 Deleuze and Guattari, *Kafka*, p. 36.

18 *Ibid.*, p. 7.

19 *Ibid.*, p. 7.

20 Deleuze and Guattari, *A Thousand Plateaus*, pp. 291–2.

21 *Ibid.*, p. 292, and *Kafka*, p. 42.

22 Deleuze and Guattari, *A Thousand Plateaus*, pp. 259, 251, 240.

23 Jacques Derrida, *The Truth in Painting*, trans. G. Bennington and I. McLeod (Chicago and London, 1987), pp. 162, 158.

24 See Sue Coe, *Dead Meat* (New York and London, 1996), pp. 51–7.

25 Derrida, *The Truth in Painting*, p. 8.

26 *Ibid.*, p. 157; Sue Coe, quoted in Hank Burchard, 'Capitalizing on Capitalism', *Washington Post*, 'Weekend' section, 25 March 1994, p. 57, and in Martha Sherrill, 'Painting Herself into a Corner', *Washington Post*, 'Style' section, 19 March 1994, p. 1.

27 Derrida, *The Truth in Painting*, p. 160.

28 Deleuze and Guattari, *Kafka*, p. 18.

29 *Ibid.*, p. 22.

30 Brian Massumi, 'Notes on the Translation', in Deleuze and Guattari, *A Thousand Plateaus*, p. xvi.

31 Deleuze and Guattari, *Kafka*, pp. 34–5.

32 *Ibid.*, p. 12.

33 Peter Høeg, *The Woman and the Ape* (London, 1996), pp. 138–9, 141–2.

34 Franz Kafka, *The Transformation ('Metamorphosis') and Other Stories*, trans. M. Pasley (London, 1992), p. 76; Deleuze and Guattari, *Kafka*, pp. 36, 39, 33.

35 Deleuze and Guattari, *A Thousand Plateaus*, p. 233.

36 Deleuze and Guattari, *Kafka*, pp. 35–6, including inset quotation.

37 Deleuze and Guattari, *A Thousand Plateaus*, p. 233.

38 Deleuze and Guattari, *Kafka*, pp. 35–6, and *A Thousand Plateaus*, p. 259.

39 Deleuze and Guattari, *A Thousand Plateaus*, pp. 237–8.

40 *Ibid.*, p. 238.

41 *Ibid.*, p. 238.

42 Newton Harrison, quoted in *AN Magazine*, August 1998, p. 14.

43 This is drawn from the wall-mounted texts which formed part of the exhibition, at the Bluecoat Gallery, Liverpool, May–August 1998, as are all subsequent quotations from the Harrisons.

44 Elizabeth Mayes, 'The Fantasy of Internalization in the Theoretical Imaginary', *Representations*, LXII (1998), pp. 101–2.

45 Sigmund Freud, quoted in Elizabeth Mayes, 'The Fantasy of Internalization in the Theoretical Imaginary', p. 100; D. W. Winnicott, *Playing and Reality*, (London, 1971), p. 96.

46 Michel de Certeau, 'Pay Attention: To Make Art', in *Helen Mayer Harrison and Newton Harrison: The Lagoon Cycle*, exh. cat. by T. W. Leavitt and P. Bealle: Herbert F. Johnson Museum of Art, Cornell University, Ithaca, New York (New York, 1985), pp. 18–19.

47 Mayes, 'The Fantasy of Internalization', p. 110.

48 Deleuze and Guattari, *A Thousand Plateaus*, pp. 239–41.

49 Deleuze and Guattari, *Kafka*, pp. 37–8, and *A Thousand Plateaus*, pp. 239–40.

50 Deleuze and Guattari, *A Thousand Plateaus*, pp. 238, 241, 242.

51 Deleuze, quoted in Bogue, *Deleuze and Guattari*, p. 111 (inset quotation); Deleuze and Guattari, *A Thousand Plateaus*, pp. 238–9.

52 Deleuze and Guattari, *A Thousand Plateaus*, p. 239.

53 *Ibid.*, pp. 241, 243, including inset quotation.

54 *Ibid.*, p. 274.

55 *Ibid.*, p. 243.

56 *Ibid.*, pp. 244, 234, 291–2.

57 *Ibid.*, pp. 244–5.

58 *Ibid.*, pp. 244, 246.

59 Franz Kafka, *The Collected Aphorisms*, trans. M. Pasley (London, 1994), p. 6.

60 Deleuze and Guattari, *Kafka*, p. 35, and *A Thousand Plateaus*, pp. 272, 284.

61 W. S. Graham, 'The Beast in the Space', in *Selected Poems* (London, 1996), p. 48.

62 Francis Bacon, quoted in David Sylvester, *Interviews with Francis Bacon* (New York, 1981), p. 23.

63 Damien Hirst, *i want to spend the rest of my life everywhere, with everyone, one to one, always, forever, now* (London, 1997), pp. 32, 279, 285.

64 Deleuze and Guattari, *A Thousand Plateaus*, p. 156.

65 Olly and Suzi, unpublished interview with the author, London, August 1998.

66 Hirst, *i want to spend the rest of my life everywhere . . .*, p. 289.

67 This image appears on the cover of Haraway's *Simians, Cyborgs, and Women* – the book which includes 'A Cyborg Manifesto'.

68 Kafka, *The Collected Aphorisms*, p. 7.

69 Adam Phillips, *Terrors and Experts* (London and Boston, 1995), p. 68.

6 THE ANIMAL'S LINE OF FLIGHT

1 Britta Jaschinski, unpublished interview with the author, London, April 1999.

2 Gilles Deleuze and Félix Guattari, *Kafka: Toward a Minor Literature*, trans. D. Polan (Minneapolis and London, 1987), pp. 13, 15; and *A Thousand Plateaus: Capitalism and Schizophrenia*, trans. B. Massumi (London, 1988), pp. 257, 254.

3 Deleuze and Guattari, *A Thousand Plateaus*, p. 187.

4 *Ibid.*, pp. 253, 261–2.

5 *Ibid.*, pp. 232, 281.

6 *Ibid.*, pp. 237, 279, 292.

7 *Ibid.*, pp. 300–1, 187 (inset quotation), 272.

8 Hélène Cixous, *'Coming to Writing' and Other Essays*, ed. D. Jenson (Cambridge, MA and London, 1991), pp. 10–11.

9 Deleuze and Guattari, *A Thousand Plateaus*, p. 305.

10 Deleuze and Guattari, quoted in Ronald Bogue, *Deleuze and Guattari*, (London and New York, 1989), p. 109.

11 Deleuze and Guattari, *A Thousand Plateaus*, p. 305.

12 Adam Phillips, 'The Disorder of Uses: A Case History of Clutter', paper for the conference *Clutter: Disorder in the Spaces of Design, the Text and the Imagination*, The Art Workers Guild, London, February 1996.

13 Gilles Deleuze, *Francis Bacon: Logique de la sensation*, vol. 1 (Paris, 1981), p. 9; Ernst van Alphen, *Francis Bacon and the Loss of Self* (London, 1992), p. 28.

14 Deleuze, *Francis Bacon*, pp. 16, 18.

15 Deleuze and Guattari, *A Thousand Plateaus*, p. 237.

16 V. J. Staněk, *Introducing Monkeys*, trans. G. Theiner (London, n.d.). The book is held in the Tate Gallery Archive, London, in file '9810 BACON'.

17 Deleuze, *Francis Bacon*, p. 19.

18 Deleuze and Guattari, *Kafka*, p. 7.

19 Britta Jaschinski, 'Postscript', in *Zoo* (London, 1996), unpaginated.

20 Britta Jaschinski, unpublished interview with the author, April 1999. All further quotations from the artist are from this interview.

21 Deleuze, *Francis Bacon*, p. 19.

22 *Ibid.*, p. 19.

23 Deleuze and Guattari, *A Thousand Plateaus*, pp. 243, 239.

24 Francis Bacon, quoted in David Sylvester, *Interviews with Francis Bacon* (New York, 1981), p. 168.

25 Deleuze, *Francis Bacon*, p. 25; Gilles Deleuze, untitled essay in the book reviews section of *Artforum*, January 1984, p. 68.

26 Deleuze and Guattari, *A Thousand Plateaus*, p. 115.

27 Caroline Tisdall, *Joseph Beuys: Coyote* (Munich, 1980), p. 20.

7 THE ARTIST'S UNDOING

1 Friedrich Nietzsche, *The Gay Science*, trans. W. Kaufmann (New York, 1974), section 224.

2 Will Self, *Great Apes* (London, 1997), p. vii.
3 Peter Høeg, *The Woman and the Ape* (London, 1996); Scott Bradfield, *Animal Planet* (London, 1996); Jeff Noon, *Automated Alice* (London and New York, 1996); Marie Darrieussecq, *Pig Tales*, trans. L. Coverdale (London, 1997); Kirsten Bakis, *Lives of the Monster Dogs* (London, 1997); Deborah Levy, *Diary of a Steak* (London, 1997).
4 Self, *Great Apes*, pp. 24, 182, 137.
5 *Ibid.*, pp. 100, 350, 111.
6 Will Self, speaking on *The South Bank Show*: 'Will Self', ITV, 5 July 1998.
7 Self, *Great Apes*, pp. 90, 168.
8 *Ibid.*, pp. 352, 76–7, 333, 368, 377.
9 Hélène Cixous, 'Sorties', in Hélène Cixous and Catherine Clément, *The Newly Born Woman*, trans. B. Wing (Manchester, 1986), p. 84.
10 Self, *Great Apes*, p. 404.
11 Philip Roth, *Portnoy's Complaint* (London, 1995), p. 198.
12 Self, *Great Apes*, pp. 11–12, 25.
13 *Ibid.*, pp. 101, 126.
14 *Ibid.*, pp. 341–2, includes preceding quotation.
15 John Isaacs, unpublished interview with the author, London, March 1999. All further quotations from the artist are from this interview.
16 Margrit Brehm, 'Synthetic Thinking', in John Isaacs, *The Matrix of Amnesia* (London, 1998), unpaginated.
17 Martin Hentschel, 'Passage', in *Passage*, exh. cat. by M. Hentschel: Kunsthaus, Hamburg (Hamburg, 1998), p. 6.
18 Edwina Ashton, unpublished interview with the author, London, April 1999.
19 Self, *Great Apes*, pp. 398, 393.
20 Peter Singer, 'The Great Ape Project', *The Animals' Agenda*, XVI/3 (1996), pp. 12–13. See also *The Great Ape Project: Equality Beyond Humanity*, eds P. Cavalieri and P. Singer (London, 1993).
21 Gordon M. Burghardt, review of *The Great Ape Project*, *Society and Animals*, V/1 (1997), p. 84.
22 Will Self, speaking on *The South Bank Show*: 'Will Self', ITV, 5 July 1998.
23 Self, *Great Apes*, pp. 342, 400.
24 *Ibid.*, pp. 210, 237, 258, 292.
25 Bakis, *Lives of the Monster Dogs*, p. 225.
26 Bradfield, *Animal Planet*, pp. 213–15.
27 Sigmund Freud, 'Mourning and Melancholia', in *On Metapsychology: The Theory of Psychoanalysis* (Harmondsworth, 1984), p. 254.
28 Gillian Rose, *Love's Work* (London, 1995), p. 116.
29 Wendy Wheeler, *A New Modernity? Change in Science, Literature and Politics* (London, 1999), pp. 74 (inset quotation), 20, 165.
30 Freud, 'Mourning and Melancholia', p. 262.
31 Wheeler, *A New Modernity?*, pp. 73, 133.

8 FEAR OF THE FAMILIAR

1 Ian Harrow, 'Gauguin to Himself', in *Polemos* (Lancaster, 1998), p. 43.
2 Deleuze and Guattari, *A Thousand Plateaus*, p. 240. The more strongly worded original, in *Mille plateaux* (Paris, 1980), p. 294, reads: '*tous ceux qui aiment les chats, les chiens, sont des cons*'.
3 Edmund Leach, 'Anthropological Aspects of Language: Animal Categories and Verbal Abuse', in *New Directions in the Study of Language*, ed. E. H. Lenneberg (Cambridge, Mass., 1964), pp. 36, 37, 39, 45, 53.
4 John Berger, 'Why Look at Animals?', in *About Looking* (London, 1980), pp. 5, 7–8. The essay was first published in three sections in issues of *New Society* in 1977.
5 Jacques Derrida, 'L'Animal que donc je suis (à suivre)' in *L'Animal auto-*

biographique: Autour de Jacques Derrida, ed. M.-L. Mallet (Paris, 1999), p. 290.

6 Berger, 'Why Look at Animals?', pp. 3, 12, including inset quotation.

7 René Girard, *Things Hidden Since the Foundation of the World,* trans. S. Bann and M. Metteer (London, 1987), p. 69.

8 Gilles Deleuze and Félix Guattari, *A Thousand Plateaus,* pp. 240–1; and *Kafka: Toward a Minor Literature,* trans. D. Polan (Minneapolis and London, 1987), p. 15.

9 Hélène Cixous, *Three Steps on the Ladder of Writing,* trans. S. Cornell and S. Sellers, (New York, 1993), p. 43; Martin Amis, *Money: A Suicide Note* (London, 1984), p. 268.

10 Olly and Suzi, unpublished interview with the author, London, August 1998.

11 Friedrich Nietzsche, *The Gay Science,* trans. W. Kaufmann (New York, 1974), sections 283 and 352.

12 Mark Cousins, 'Danger and Safety', *Art History,* XVII/3 (1994), p. 418.

13 Ralph Rugoff, 'Survey', in Ralph Rugoff, Kristine Stiles and Giacinto Di Pietrantonio, *Paul McCarthy* (London, 1996), p. 65.

14 Rebecca Schneider, *The Explicit Body in Performance* (London and New York), pp. 47, 49.

15 This view is quoted (and contested) in James Serpell, *In the Company of Animals: A Study of Human-Animal Relationships* (Oxford and New York, 1986), p. 20.

16 *Puppylove,* a touring exhibition from the Ikon Gallery, Birmingham, was shown at the Barbican Centre, London, in March 1999; on 'furries', see Steven Stern, 'Bright Eyes', *Frieze,* XLV (1999), pp. 45–6.

17 Robert Smithson, quoted in Yve-Alain Bois and Rosalind E. Krauss, *Formless: A User's Guide* (New York, 1997), p. 170.

18 Kate Rawles, 'Editorial', *Environmental Values,* 6, no. 4 (1997), special issue: 'Animals', p. 376; Joseph Beuys, quoted in Heiner Stachelhaus, *Joseph Beuys,* trans. D. Britt (New York, 1991), p. 59.

19 Mark Dion, quoted in Lisa Graziose Corrin, Miwon Kwon and Norman Bryson, *Mark Dion* (London, 1997), pp. 116–18, 120.

20 Mark Dion, 'The Lexicon of Relevant Terms', in *Natural History and Other Fictions: An Exhibition by Mark Dion,* exh. cat. by J. Leslie: Ikon Gallery, Birmingham; Kunstverein, Hamburg; De Appel Foundation, Amsterdam (Birmingham, Hamburg and Amsterdam, 1997), p. 56.

21 Mark Dion, 'Interview', in Corrin, Kwon and Bryson, *Mark Dion,* p. 10; Olly and Suzi, unpublished interview with the author, August 1998.

22 Brian Luke, 'Taming ourselves or going feral?: Toward a nonpatriarchal metaethic of animal liberation', in *Animals and Women: Feminist Theoretical Explorations,* ed. C. J. Adams and J. Donovan (Durham, NC and London, 1995), pp. 302, 311, 313.

23 Linda Vance, 'Ecofeminism and the Politics of Reality', in *Ecofeminism: Women, Animals, Nature,* ed. G. Gaard (Philadelphia, 1993), pp. 118, 141.

24 Linda Vance, 'Beyond Just-So Stories: Narrative, Animals, and Ethics', in *Animals and Women: Feminist Theoretical Explorations,* pp. 166, 185.

25 Luke, 'Taming Ourselves or Going Feral?', pp. 291 and 315; Vance, 'Beyond Just-So Stories', pp. 172, 181, 166.

26 Donald Griffin, quoted in Carol J. Adams, *Neither Man Nor Beast: Feminism and the Defense of Animals* (New York, 1994), p. 236.

27 Emily Mayer, conversation with the author, March 1999; Olly and Suzi, unpublished interview with the author, August 1998.

28 Serpell, *In the Company of Animals,* p. 170.

29 Tom Regan, quoted in Josephine Donovan, 'Animal Rights and Feminist Theory', *Signs,* XV/2 (1990), p. 351; Peter Singer, quoted in Luke, 'Taming Ourselves or Going Feral?', p. 301.

30 See Donovan, 'Animal Rights and Feminist Theory', pp. 351, 365, and Luke, 'Taming Ourselves or Going Feral?', passim. Alongside such criticisms,

however, Donovan in particular acknowledges the historical importance of these earlier contributions to 'animal rights theory', calling Regan's work 'impressive' and Singer's 'admirable and courageous' (pp. 353, 355).

31 Mark Dion, 'Interview', p. 18.

32 Olly and Suzi, unpublished interview with the author, August 1998.

33 Nietzsche, *The Gay Science*, sections 327 and 352.

34 Roger Scruton, quoted in John Simons, 'The Longest Revolution: Cultural Studies after Speciesism', *Environmental Values*, vi/4 (1997), p. 487.

35 See for example *Paula Rego*, exh. cat. by F. Bradley *et al.*: Tate Gallery Liverpool and Centro Cultural de Belém, Lisbon (London, 1997), pp. 52, 68.

36 Tom Regan, 'The Burden of Complicity', in Sue Coe, *Dead Meat* (New York and London, 1996), p. 3.

37 Sue Coe, correspondence with the author, March 1999.

38 David Hockney, *David Hockney's Dog Days* (London, 1998), unpaginated.

39 Hockney, *David Hockney's Dog Days*, unpaginated; Dave White, unpublished interview with the author, Liverpool, August 1998.

40 Vance, 'Beyond Just-So Stories', p. 166.

41 Dave White, unpublished interview with the author, August 1998.

42 Marc Shell, 'The Family Pet', *Representations*, xv (1986), p. 122.

43 *Ibid.*, p. 127.

44 William Wegman, quoted in Peter Weiermair, 'Photographs: Subversion Through the Camera', in *William Wegman: Paintings, Drawings, Photographs, Videotapes*, ed. M. Kunz (New York, 1990), p. 45.

45 Craig Owens, 'William Wegman's Psychoanalytic Vaudeville', *Art in America*, March 1983, pp. 106, 108.

46 D. W. Winnicott, *Playing and Reality* (London, 1971), p. 103. On Winnicott's 'quintessentially *creative* spaces', see also Wendy Wheeler, *A New Modernity? Change in Science, Literature and Politics* (London, 1999) p. 23.

47 Derrida, 'L'Animal que donc je suis', p. 255.

48 See *Natural History and Other Fictions: An Exhibition by Mark Dion*, p. 34; and Stephen Jay Gould, 'Ladders and Cones: Constraining Evolution by Canonical Icons', in *Hidden Histories of Science*, ed. R. B. Silvers (London, 1997).

49 Keith Tester, *Animals and Society: The Humanity of Animal Rights* (London and New York, 1991), p. 54.

50 Simon Critchley generously informed the author that Deleuze revealed this surprising fact in a television interview towards the end of his life.

51 Claude Lévi-Strauss, *Tristes Tropiques*, trans. J. and D. Weightman (London, 1973), p. 544.

52 David Wood, 'Following Derrida', in *Deconstruction and Philosophy: The Texts of Jacques Derrida*, ed. J. Sallis (Chicago and London, 1987), p. 143.

53 Jean-François Lyotard, *Signé Malraux* (Paris, 1996), p. 250.

54 Derrida, 'L'animal que donc je suis', pp. 253–4, 260, 300–1.

55 *Ibid.*, pp. 263, 265, 277, 279.

56 Hélène Cixous, 'Shared at Dawn', trans. K. Cohen, in *Stigmata: Escaping Texts* (London and New York, 1998). Quotations in the following paragraphs are from pp. 175–80 of this short piece.

57 Hélène Cixous, 'The Laugh of the Medusa', trans. K. Cohen and P. Cohen, *Signs*, 1/4 (1976), p. 887.

58 Luce Irigaray, *An Ethics of Sexual Difference*, trans. C. Burke and G. C. Gill (London, 1993), pp. 21, 24.

59 Gillian Rose, *Love's Work* (London, 1995), pp. 6, 99.

60 Hélène Cixous, quoted in *The Body and the Text: Hélène Cixous, Reading and Teaching*, ed. H. Wilcox *et al.* (New York and London, 1990), p. 187.

61 Self, *Great Apes* (London, 1997), p. 378.

62 Nietzsche, *The Gay Science*, section 109.

63 *Ibid.*, section 109.

List of Illustrations

Photo: Dorothee Fischer © ARS, NY and DACS, London 1999.

22 Dorothy Cross, *Amazon*, 1992, cow skin, dressmaker's dummy. Private collection. Photo: courtesy of the Frith Street Gallery, London.

23 Damien Hirst, *The Physical Impossibility of Death in the Mind of Someone Living*, 1991, tiger shark, glass, steel, 5 per cent formaldehyde solution. Saatchi Gallery, London. Photo: Anthony Oliver.

24 Pablo Picasso, *Bull's Head*, 1942, leather and metal. Musée Picasso, Paris. Photo: RMN – Béatrice Hatala. © Succession Picasso/DACS, 1999.

25 General Idea, *Fin de Siècle*, 1990, expanded polystyrene, three stuffed harp seal pups (acrylic fake fur, straw); view of installation at the Württemergischer Kunstverein. Private collection. Photo: courtesy of General Idea.

26 Olly and Suzi, *Deer for Beuys*, 1998, acrylic and ink on paper. Photo: courtesy of the artists.

27 Edwina Ashton, Video still from *Sheep*, 1997. Photo: courtesy of the artist.

28 Jeff Koons, *Bear and Policeman*, 1988, polychromed wood. Photo: © Jeff Koons/courtesy of the Anthony d'Offay Gallery, London.

29 Paula Rego, *Dog Woman*, 1994, pastel on canvas. Saatchi Gallery, London. Photo: Prudence Cuming Associates.

30 Robert Rauschenberg, *Monogram*, 1955–9, angora goat with painted nose and ears, painted tyre, painted hinged wood, tennis ball, collage and newspaper. Moderna Museet, Stockholm. Photo: © Robert Rauschenberg/VAGA, NY/DACS, London 1999.

31 Hubert Duprat, *Caddis Fly Larvæ with Cases*, 1980–99, caddis fly larvæ with cases made from gold, pearls and precious stones. Photo: Jean-Luc Fournier.

32 William Wegman, *Frog/Frog II*, 1982, polaroid photograph. Private collection.

33 Jannis Kounellis, *Horses*, as installed at Galleria L'Attico, Rome, 1969.

34 Louise Bourgeois, *Spider*, 1997, steel and mixed media; view of installation at Serpentine Gallery, London, 1998. Photo: Stephen White, courtesy of the Serpentine Gallery. © Louise Bourgeois/VAGA, NY/DACS, London 1999.

35 Siobhán Hapaska, *Mule*, 1997, fibreglass, two-pack acrylic lacquer, upholstery, electronic and audio components. Photo: courtesy of the Bonakdar Jancou Gallery, New York.

36 Bruce Nauman, *Learned Helplessness in Rats (Rock and Roll Drummer)*, 1988, installation (plexiglass maze, closed-circuit video camera, scanner and mount, switcher, colour monitor, black-and-white monitor, video projector, two videotapes [colour, sound]). Private collection. Photo: Dorothee Fischer. © ARS, NY and DACS, London 1999.

37 Helen Chadwick, *Meat Abstract No. 6*, 1989, polaroid mounted on silk mat and framed. Photo: courtesy of the Zelda Cheatle Gallery, London. © The Estate of Helen Chadwick.

38 Emily Mayer with erosion cast of severed cow's head made for Damien Hirst's *A Thousand Years*). Photo: James Dickinson.

39 Carolee Schneemann, *Meat Joy*, Judson Church, New York, 1964. Photo: Al Giese.

40 Mike Kelley, *Nostalgic Depiction of the Innocence of Childhood*, 1990, sepia photograph. Photo: Courtesy of Metro Pictures, New York.

41 Britta Jaschinski, *Untitled* (1996), from the series *Animal*, photograph. Photo: courtesy of the artist.

42 Emily Mayer, *Corvus corium*, 1995, leather, steel, wood, rubber. Photo: Ben Taylor.

43 Jordan Baseman, *The Cat and the Dog*, 1995, skinned cat and dog with modelled heads. Saatchi Gallery, London. Photo: Jordan Baseman.

44 Damien Hirst, *This Little Piggy Went to Market, This Little Piggy Stayed at Home*, 1996, steel, GRP composites, glass, pig and formaldehyde solution, electric motor, two glass tanks. Saatchi Gallery, London. Photo: Stephen White.

45 Julian Schnabel, *Untitled*, 1990, marker, oil and photograph by Jean kallina on paper. Photo: courtesy of the Timothy Taylor Gallery, © Julian Schnabel.

46 Helen Mayer Harrison and Newton Harrison, Installation shot of 'The Eco-Urban Edge', from *Casting a Green Net: Can It Be We Are Seeing a Dragon?*, 1998, mixed media. Photo: Anne Gold.

47 Sue Coe, *Modern Man Followed by the Ghosts of his Meat*, 1988, gouache, watercolour and graphite. © 1988 Sue Coe. Photo: courtesy Galerie St Etienne, New York.

48 John Isaacs, *Untitled (Dodo)*, 1994, fibreglass, silicone rubber, electric mechanism, glass, acrylic paint. Saatchi Gallery, London. Photo: Stephen White.

49 Mark Dion, *Tar and Feathers*, 1996, tree, wooden base, tar, feathers, various taxidermic animals. Photo: courtesy of the artist and London Projects.

50 Sue Coe, *Montreal, May '91* (page from *Porkopolis Sketchbook*), 1991. © 1991 Sue Coe. Photo: courtesy Galerie St Etienne, New York.

51 Valerio Adami, *Study for a drawing after 'Glas'*, 1975. Photo: © ADAGP, Paris and DACS, London 1999.

52 Olly and Suzi at work in the shark cage (i), 1997. Photo: Greg Williams; © growbag.com.

53 Olly and Suzi at work in the shark cage (ii), 1997. Photo: Greg Williams; © growbag.com.

54 Lynn M. Randolph, *Cyborg*, 1989, oil on canvas. The Bunting Institute of Radcliffe College/Harvard University, Cambridge, MA.

55 Britta Jaschinski, *Spheniscus demersus* (1994), from the series *Zoo*, photograph. Photo: courtesy of the artist.

56 Lucy Gunning, video still from *The Horse Impressionists*, 1994. Photo: Tate Gallery, London, 1999.

57 Francis Bacon, *Man with Dog*, 1953, oil on canvas. Albright-Knox Art Gallery, Buffalo, New York. Photo: © ARS, NY and DACS, London 1999.

58 Britta Jaschinski, *Untitled* (1996), from the series *Animal*, photograph. Photo: courtesy of the artist.

59 Britta Jaschinski, *Hylobates lar* (1998), from the series *Beast*, photograph. Photo: courtesy of the artist.

60 Francis Bacon, *Sand Dune*, 1983, oil and pastel on canvas. Fondation Beyeler, Riehen/Basel. Photo: ARS, NY and DACS, London 1999.

61 Joseph Beuys, *Coyote: I Like America and America Likes Me*, 1974. Photo: © DACS, 1999.

62 John Isaacs, *Untitled (Monkey)*, 1995, wax, hair, glass, syringe. Arts Council Collection, Hayward Gallery, London (gift of Charles Saatchi). Photo: Stephen White.

63 John Isaacs, video still from *The Theory of an Idea*, 1998. Photo: Martin Kreyssig.

64 Edwina Ashton, video still from *Frog*, 1998. Photo: courtesy of the artist.

65–8 Carolee Schneemann, Details from *Infinity Kisses*, 1991, 140 photographs on linen. Photos: courtesy of the artist.

69 David Hockney, *Picture Emphasizing Stillness*, 1962, oil and transfer lettering on canvas. Photo: © David Hockney.

70 Paula Rego, *Wife Cuts Off Red Monkey's Tail*, 1981, acrylic on paper. Private collection. Photo: courtesy of Marlborough Fine Art, London.

71 Sue Coe, *Parched Sheep* (page from *Porkopolis Sketchbook*), 1993. © 1993 Sue Coe. Photo: Courtesy Galerie St Etienne, New York.

72 David Hockney, *Dog Painting 25*, 1995, oil on canvas. Photo: Steve Oliver/© David Hockney.

73 Dave White, *Twiglet is a Scaredy Cat*, 1996, oil and chrome on canvas. Photo: courtesy of the artist.

74 Mark Dion, *Scala Naturae*, 1994, mixed media. Photo: courtesy of the artist and London Projects.

Acknowledgements

I am grateful to the Arts and Humanities Research Board, and to the Department of Historical and Critical Studies at the University of Central Lancashire, for the research leave which enabled me to complete this project. Among many friends and colleagues who generously shared ideas and offered assistance, my particular thanks go to the three attentive readers of the completed manuscript – Stephen Bann, John Calcutt and Linden Reilly – for their valuable criticisms and their encouragement. I am also grateful to Diana Donald and Kenneth Shapiro for their support from an early stage, to Harry Gilonis for all his help with the illustrations, and to Wendy Wheeler for allowing me to read and to quote from the manuscript of her book. One particular pleasure of the research was the generosity and interest of artists who allowed me to see their work and to interview them: they included Olly and Suzi, Edwina Ashton, John Isaacs, Britta Jaschinski, Emily Mayer and Dave White.